in camera

An Hachette UK Company
www.hachette.co.uk

First published in the United Kingdom in 2016 by
Ilex Press, a division of Octopus Publishing Group Ltd
Carmelite House
50 Victoria Embankment
London EC4Y 0DZ
www.octopusbooks.co.uk

Distributed in the US by
Hachette Book Group
1290 Avenue of the Americas
4th and 5th Floors
New York, NY 10020

Distributed in Canada by
Canadian Manda Group
664 Annette St.
Toronto, Ontario, Canada M6S 2C8

Publisher: Roly Allen
Publisher, Photography: Adam Juniper
Managing Specialist Editor: Frank Gallaugher
Senior Project Editor: Natalia Price-Cabrera
Editors: Rachel Silverlight & Francesca Leung
Art Director: Julie Weir
Designer: Paul Palmer-Edwards, Grade Design
Senior Production Manager: Peter Hunt

ISBN 978-1-78157-361-7

A CIP catalogue record for this book
is available from the British Library.

Printed and bound in China

10 9 8 7 6 5 4 3 2 1

GORDON LAING

in camera

HOW TO GET PERFECT PICTURES STRAIGHT OUT OF THE CAMERA

Contents

Foreword

Some people say you need to master Manual mode to be a proper photographer. Some say you must shoot in RAW to be taken seriously. Some say you need a big camera to take great photos or you're just messing around. Me? I say nonsense to all of that, and in this book I'll show you why.

These 100 photographs all have one thing in common: They're all JPEGs taken straight out of the camera. Not a single one was modified or manipulated with a computer or mobile app. All were also taken with compact mirrorless cameras, although every single tip and technique can equally be applied to DSLRs, not to mention many point-and-shoot cameras and camera phones, too.

My philosophy is that great photos can be created in camera at the point of capture. Composing in Live View or reviewing images straight after taking them allows you to check your results and correct your technique in the field; there's literally no excuse for getting it wrong. If it doesn't look right, don't walk away thinking you'll simply fix it in post-processing. Stick around and try again with a different approach—maybe an alternative angle, adjusting the settings, or waiting to see if the light improves.

If you're determined to achieve the desired result in camera, you'll hone your technique, perfect your art, and save a lot of time. For the majority of the images here, I was sufficiently happy with the result that I copied them from my camera to my phone over Wi-Fi and shared them socially moments after taking them. There's a simplicity and honesty to completing the job on location that really appeals to me.

Don't get me wrong, I know some styles of photography demand post-processing and I equally understand some photographers simply enjoy the process, but more can be achieved in camera than many people realize. Some of it is down to simple technique and careful composition, or the use of physical filters. Equally, though, it's about embracing the latest technologies inside your camera and getting to know your camera's picture styles and effects.

Most cameras offer a selection of presets that can boost the color and contrast for a vibrant result, mute them for a vintage style, or dispense with color altogether for a black-and-white image. Indeed, in-camera black-and-white conversions have come a long way with digital filter and toning simulations. Try them out! You may be surprised how good they are and don't forget you can tweak them, too. As I've discovered, they can deliver the results I desire without external modification.

For me, it's also about mastering a handful of techniques and approaches you can apply to different situations — like tried-and-trusted recipes when you're faced with certain ingredients. If it's overcast or gloomy, I generally shoot in black and white. If the sky is featureless, I make it disappear altogether by overexposing. If there's water — be it a canal, river, waterfall, the sea, or even just a puddle — always look for a reflection. For an ethereal look, consider blurring the surface with a long exposure.

If a location or the weather lacks inspiration during the daytime, revisit it at night when the lights and a dark sky can bring it to life. You don't need to always use the same techniques in a given situation, but having a bunch of reliable approaches at your disposal lets you hit the ground running. Most modern cameras allow you to process RAW files during playback too, facilitating your ability to try out different styles and effects after the event, but still without touching a computer or mobile app.

Each image in this book is presented as a standalone story. I've described the where and why, as well as the techniques behind each composition. My favorite photography books are full of images I want to try for myself, and I really hope you'll find some here that inspire you to experiment with something new. I'd love to hear what you think, so please connect with me on Twitter, Instagram, Facebook, or YouTube, and don't forget to check out my reviews at cameralabs.com!

Gordon Laing / @cameralabs

The abstract roof

EXIF Data

📷 Fujifilm X-T1

🎞 Fujinon XF 16mm *f*/1.4

◁ 16mm (24mm equivalent)

⚙ *f*/11

⬤ 14 seconds

▣ -0.67 EV

ⓘⓢⓞ ISO 100

◉ Monochrome

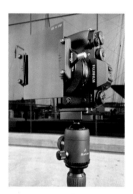

Here's my Fujifilm X-T1 fitted with the Lee Seven5 filter holder and Big Stopper Neutral Density filter. This is my go-to kit for long exposures.

This is the zigzagged roof of Glasgow's Riverside Museum, designed by Zaha Hadid Architects and opened in 2011. I visited it as one of the locations of a Euro Photowalk organized by Athena Carey, John Dunne, and Andy Bitterer. (Follow them on social media for great inspiration!)

I'm fond of abstract shapes, be they natural or manmade. I particularly like shooting them at an angle where it's not always clear what you're looking at or their scale. Long-exposure photography is also a great technique to apply here when there's visible water or clouds, as their blurring can further enhance the ethereal effect of your image.

When we arrived at the Riverside Museum it was drizzling and gray, but that's not unusual for this part of the world and shouldn't prevent you from taking photos. It may, however, influence your position. I took shelter under the canopy of a ship entrance opposite and began to set up my composition assuming I'd either wait for a window in the weather or adjust my position to avoid the roof directly overhead.

As I tried to work out what to do about the mostly white expanse of sky in the top part of the frame, I realized the sheltering roof could actually become a handy part of the composition. Not just to shelter the camera from the rain and fill the blank space, but also to provide some tension in the image with its sharp angle. So I adjusted the camera's position allowing the canopy to jut prominently into view.

As for the remaining sky, I combined a Neutral Density (ND) filter, small aperture, and a low ISO sensitivity to force a fairly long exposure (for daytime anyway) of 14 seconds. This allowed the dark clouds to scoot in front of the overcast sky and lend a little motion to the strip between the buildings.

TIP When the conditions are dull and overcast, I turn to black-and-white photography for a moody effect. Most modern cameras offer great-looking black-and-white modes, many with additional filter effects. Where available, I choose red filter effects to darken any blue in the sky, and if the mode hasn't already, I further boost the contrast for maximum drama. Black-and-white modes also work well with long exposures, allowing you to ignore the colorcasts of some ND filters.

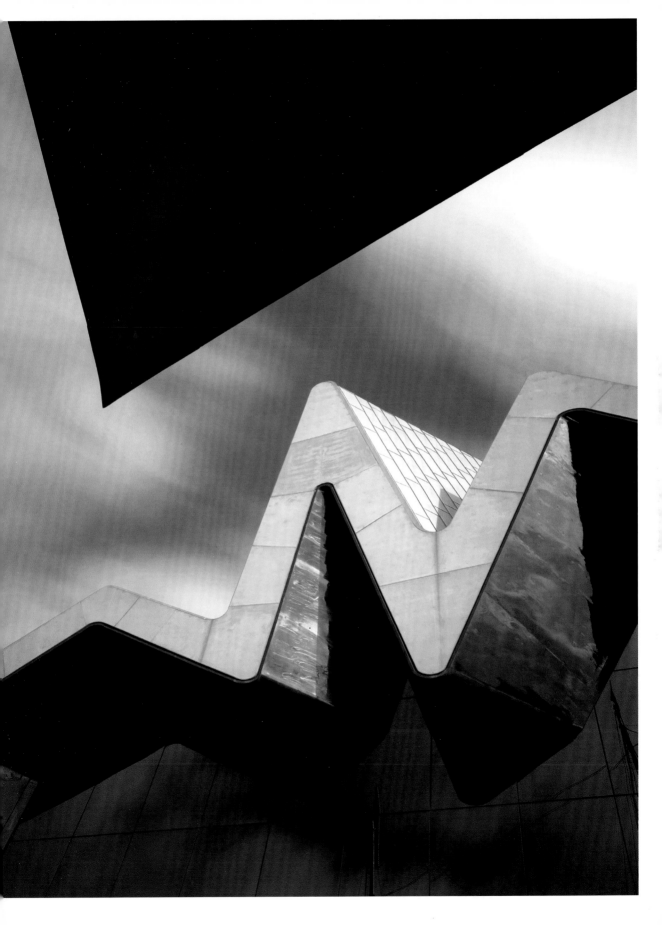

The aircraft view

EXIF Data

📷 Panasonic Lumix GX1

▤ Lumix 7–14mm $f/4$

◁ 14mm (28mm equivalent)

◎ $f/11$

● 1/200 second

▣ –0.3 EV

ISO ISO 160

◐ Daylight white balance

Aerial imagery can look spectacular and most of us have seen some lovely views from aircraft windows. They're easy to capture if you follow a few simple rules for photographing through windows, with a couple of extra considerations for the aircraft.

I've gone into detail about shooting through windows elsewhere in this book (see The East River and The city's veins on pages 102 and 74 respectively), and the same basics apply here. Most importantly, minimize reflections by pressing your camera against the window, taking care not to scratch the front of your lens. If you angle the camera for the best composition, be sure to plug any gaps with your hands or an item of clothing. You can do this effectively if you're careful to make a clean join without the "shield" protruding into your view.

Aircraft windows add some extra challenges. First, they're often dirtier and the gap between the two materials means marks on the outside surface could appear in your photo. The trick is to shoot with larger apertures (smaller $f/$ numbers) to minimize the depth of field and hopefully render any marks way out of focus. If the window is irretrievably dirty and you can't move the camera to avoid the marks, I've often gone on the hunt for a cleaner one on a spare row elsewhere in the aircraft.

The edges of the window can sometimes creep into the frame and spoil the illusion of an exterior view, although you can of course embrace this framing if desired, especially with an ultra-wide lens. While I prefer to make the window look invisible, I do like to include part of the plane if possible, such as the wing seen opposite; it's even better if the plane mirrors some part of the landscape.

The materials and construction of aircraft windows can greatly reduce the contrast of a scene, so I often boost the contrast in camera to compensate. You may also like to underexpose a little and fix the white balance, perhaps set it to Daylight if the Auto setting is suffering from a cast. Oh, and be sure to follow all instructions from the cabin crew. If they ask you to turn off your camera, just enjoy the view with your eyes.

TIP If you know a particular route will yield good views — such as West Coast USA to Las Vegas as seen here — see if you can book yourself onto a window seat, but be careful to ensure it's not directly above the wing or your view will be blocked. The seats in front of the wing may seem best as they avoid the heat shimmers from the engines, but I often prefer those behind because they give you the chance to include the wing itself in the composition if desired.

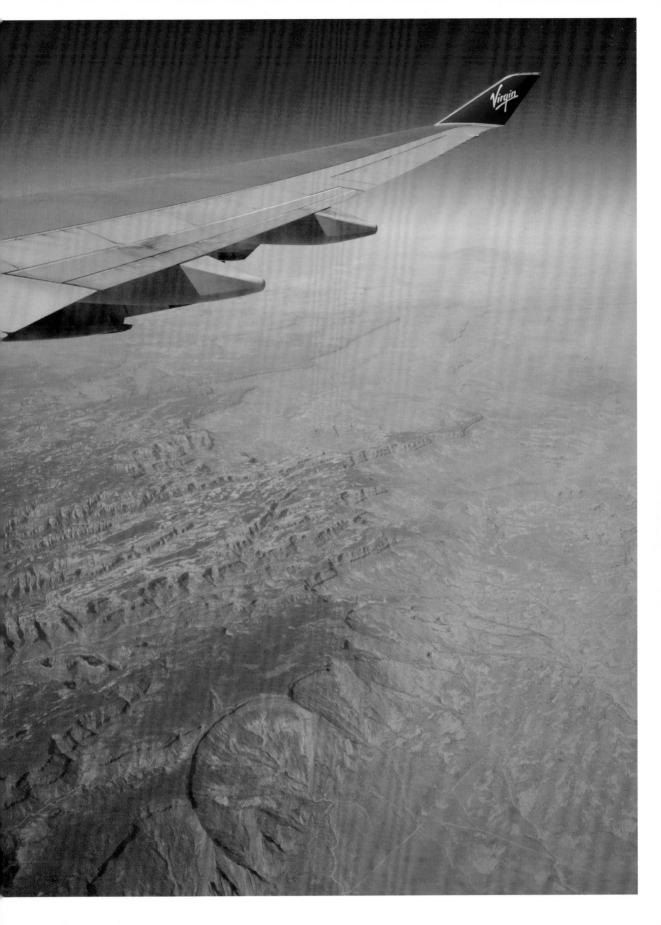

The arch

EXIF Data

📷 Fujifilm X-T1

🎞 Fujinon XF 10–24mm f/4

◁ 10mm (15mm equivalent)

◇ f/10

● 1/180 second

⊡ 0 EV

ISO ISO 200

◉ Monochrome with red filter

I often find myself shooting in the middle of the day under a dull, overcast sky. The absence of much color or shadows can be off putting to many photographers, but there are techniques that make the most of these conditions.

If the sky is a vast expanse of white, I always try and find something to fill it, such as an overhanging tree branch (see the foggy church image on page 120) or, in this case, the arch of New York's Washington Square Park. If there's nothing suitable, I'll opt for a high-key approach, deliberately overexposing the sky and everything around the subject (see The high key on page 126).

If there's not much color, I'll often dispense with it altogether, shooting in black and white using one of the camera's monochrome modes. Here, I used the Monochrome Film Simulation of the Fujifilm X-T1 with the digital red filter for higher contrast.

For the composition, I tried several approaches including some with the whole arch and the sky above it. In others, I used it to occupy the top of the frame and blot out as much of the featureless sky as possible. Given the conditions, I inevitably preferred the latter approach, particularly with a very wide lens from up close. I used the Fujinon XF 10–24mm zoom here at 10mm for a 15mm equivalent field of view. I closed the aperture to f/10 for a large depth of field to ensure the closest and farthest details were all in focus.

I angled up for deliberate converging lines and adjusted my distance back and forth to frame the buildings in the background and the posts in the foreground. The X-T1 captures images in a wider (or taller) 3:2 shape than what we're presenting here; for this book, I cropped the image to 4:3 to best feature the photo. This cut off the posts at the bottom of the frame, but if I originally shot in 4:3 I'd have adjusted my position to include them.

As always, getting the geometry squared away is critical to a shot like this, especially if you're not wrangling it on your computer later. Position yourself directly in the middle and use any onscreen guides to line up as many sections as possible.

TIP It's a useful exercise in perspective to compare the effect of zooming a lens or adjusting your position back and forth — aka "zooming" with your feet! In this example, it's possible to use both to keep the arch the same size while adjusting the relative scale of the buildings in the distance. It's surprising how much impact even small adjustments in distance and focal length can make, so experiment until you see the balance you like.

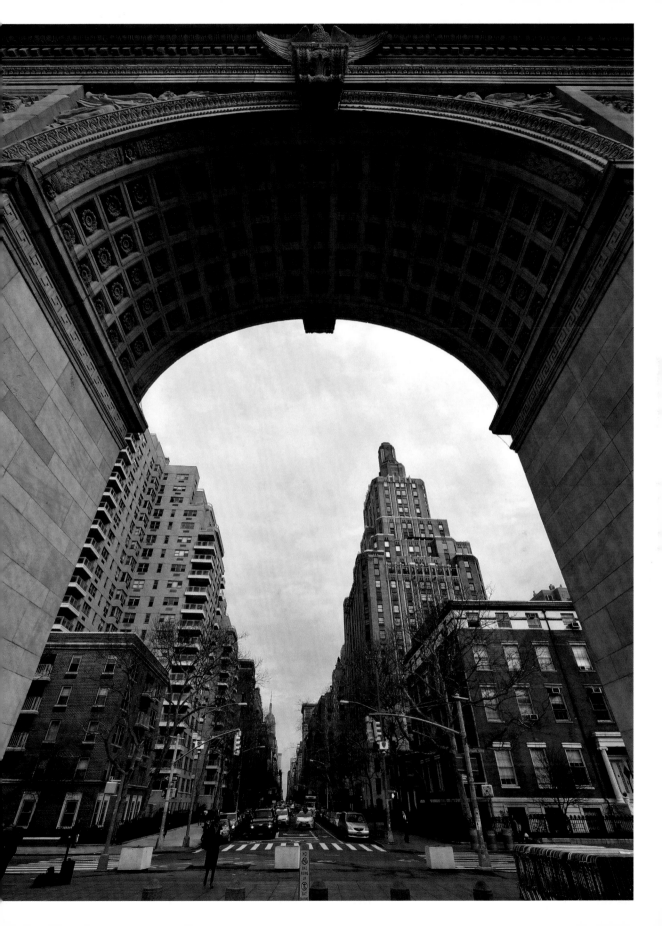

The autumnal veil

EXIF Data

📷 Fujifilm X-T10

🎞 Fujinon XF 16mm f/1.4

◁ 16mm (24mm equivalent)

⭕ f/16

⬤ 1/60 second

▣ −0.67 EV

ISO ISO 200

◉ Velvia

When I see autumnal leaves, I want to capture maximum color! One of the best ways of achieving this is to shoot the leaves while they are backlit by a bright light, and what better light than the setting sun? It naturally adds a warm, yellow glow to your photographs.

I took this during a brief stop at the lovely Nyman's Gardens, a National Trust property in Sussex, located in southern England. It was an unscheduled visit made toward the end of a long drive back from the North of England. It's normally dark by the time I pass the exit, but that day I had made good time. A quick detour later and I was surrounded by colorful foliage.

I'm fond of photographing leaves at every distance, whether capturing their intricate veins in a macro environment or their swathes of color in a distant landscape... and pretty much everything in-between! I started up close on these specimens, examining their structure with the sun providing illumination from behind. This yielded some nice images, but it was as I moved on that I noticed the branches full of leaves hanging like a natural veil.

I shot with a Fujifilm X-T10 fitted with an XF 16mm f/1.4 lens and closed the aperture down to f/16 to achieve the spiked effect (see the Tip below). To intensify the leaves, I chose the Velvia Film Simulation, which nicely saturates the colors without producing an over-the-top effect. The camera metered an exposure in Aperture Priority, which yielded an image that was a little too bright. To ensure deep blacks, I dialed in −2/3 EV of exposure compensation.

The spike effect on the sun works best with well-defined point sources of light, but here, the sun was a little fuzzy and not yielding sharp spikes when viewed directly. The trick for better definition was to allow only a tiny portion of its disc to peek through the leaves. As the branches and I swayed a little from side to side, the spikes would grow and shrink back again, so it was simply a case of waiting for the ideal moment. In stronger wind you could exploit a continuous burst to capture a sequence and choose the best-looking result.

TIP Closing the aperture in a lens not only reduces the amount of light passing through and increases the depth of field, but it can also cause bright point sources of light to grow spikes. This is an optical effect of diffraction as the aperture opening becomes very small. Depending on their optical design, some lenses produce better-looking spikes than others, but I'd recommend trying f/11 or f/16. I'd avoid the minimum aperture though, such as f/22, as another impact of diffraction is a softer-looking image. The key is finding a balance between the spikes you want without compromising the overall quality.

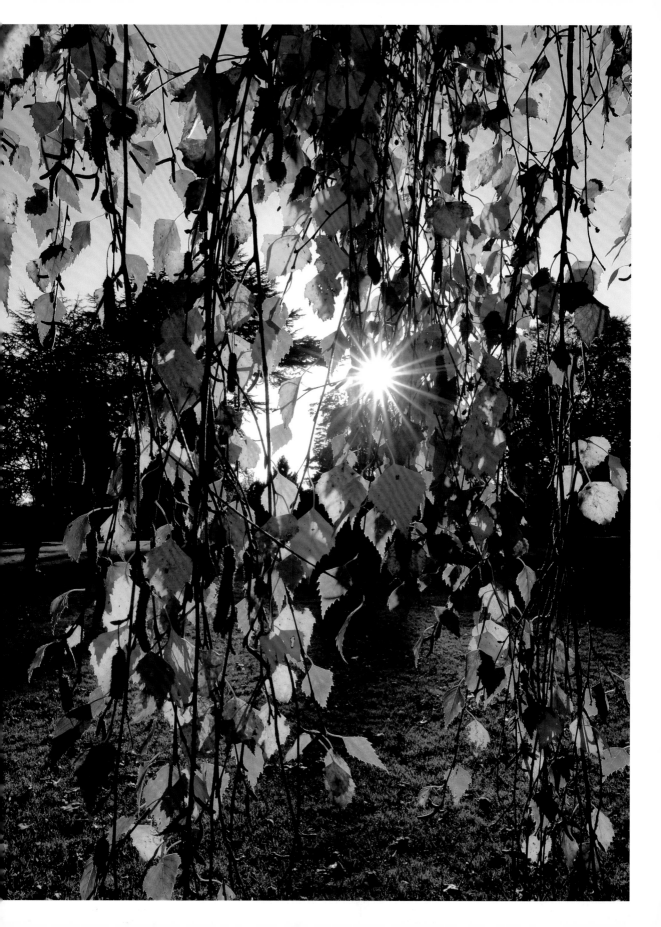

The back street

EXIF Data

📷 Fujifilm X-Pro2

🎞 Fujinon XF 56mm *f*/1.2

◁ 56mm (84mm equivalent)

🔆 *f*/11

⬤ 1/60 second

⚡ 0 EV

ISO 400

📷 Classic Chrome

This is a back street in Kaysersberg, a small town in the Alsace region of France. It's one of a group of well-preserved medieval towns and villages in the area with their distinctive painted half-timber houses. While it's hard to resist taking photos of the River Weiss from a 16th-century fortified bridge in the middle of town, I was drawn to one of the quieter streets nearby.

When faced with a row of buildings like this, I always prefer to shoot with a short telephoto lens for a number of reasons. First, I prefer the perspective. If you shot this with a wider lens, the nearest building would be dominant in the frame, while those at the end would be tiny. Shooting with a telephoto keeps the relative sizes of the buildings closer, allowing you to enjoy the details on all of them.

Second, it lets you minimize the amount of sky and road in the corners, which with a wide lens would have been large, featureless areas in the frame. Third, it gives you more control over what's in the frame and what's excluded. With a wide lens, I'd have found it hard to eliminate the parked cars on the road. With a telephoto, I could more easily crop them out of the composition when framing.

I fitted the Fujifilm X-Pro2 with an XF 56mm lens for an 84mm equivalent field of view and adjusted my position to not only avoid any evidence of modern cars, but also to include a handy streetlamp in the otherwise overcast triangle of sky in the corner. I love the colors of the buildings, but didn't want them to look too vibrant, so chose the camera's Classic Chrome film simulation for nice muted colors. On other cameras, you could simply turn down the saturation for a similar effect.

TIP As the lens focal length increases, the depth of field (or the amount of the picture that's in focus near and far) shrinks. This is one reason telephoto lenses are preferred for portraits as they facilitate making the subjects sharp and blurring everything in front of and behind them. However, they make shots like this one more difficult if you want everything sharp from near to far. I had to close the lens aperture to *f*/11 to achieve a sufficient depth of field. I then focused roughly one third of the way between the nearest and farthest subject to extend it in both directions.

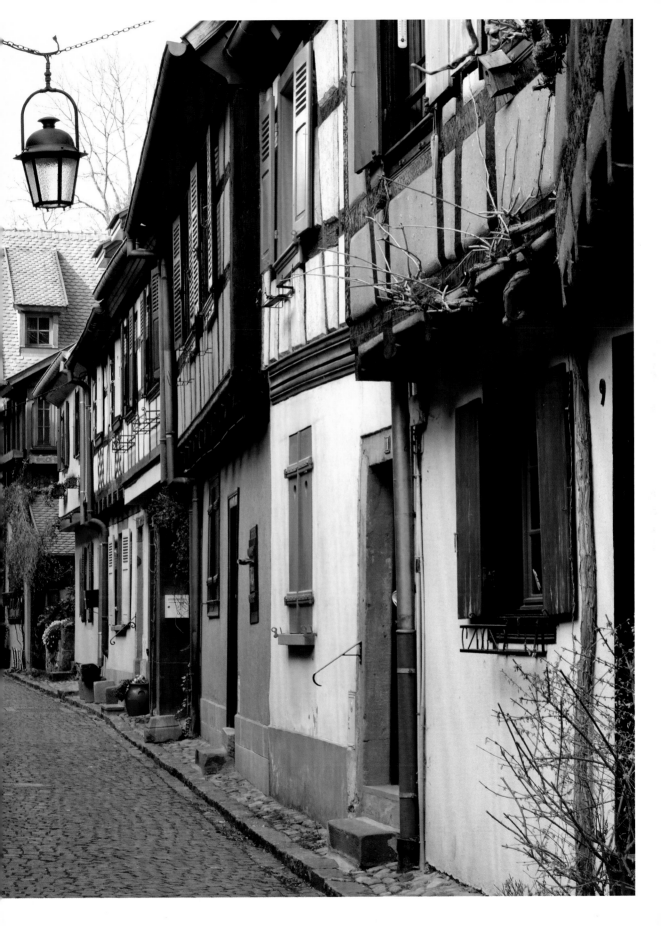

The backpack tripod

EXIF Data

📷 Panasonic Lumix G3

🎞 Lumix 7–14mm *f*/4

◁) 7mm (14mm equivalent)

⚙ *f*/5.6

● 1.6 seconds

▣ –0.3 EV

ⓘⓢⓞ ISO 160

◉ Standard

Here's a version I shot from the same position but using a fisheye lens. Notice the curved distortion. It's extreme but sometimes fun when used sparingly.

Here's the spectacularly detailed interior of Albi Cathedral in Southern France. Albi Cathedral, built between 1287 and 1480, is a building with two identities. The intimidating exterior is built like an enormous fortress with towers that look like rockets. It is said to be the largest brick building in the world and it's certainly the biggest I've ever seen by far, dwarfing other European giants including the iconic power stations of London.

Enter inside and the sheer muscle of the exterior gives way to an unbelievable display of frescoes covering almost every surface. Indeed, in yet another superlative, it is said to be the largest and oldest collection of Italian Renaissance paintings in the whole of France.

Albi Cathedral turned out to be surprisingly tripod friendly, but having left mine in the car I opted for a more ad-hoc stand: my backpack. I like a dead-central view for this kind of shot, so placed my F-Stop Loka Backpack on the ground and rested my Lumix G3 on top.

It was proving almost impossible to angle the camera sufficiently upward without it toppling over until I realized I could flip out the screen and twist it around until it acted like a stand, allowing the camera to point upward at about 45 degrees — a benefit of a fully articulated screen over one that just tilts vertically. A little shuffling around and the view was pretty square, too.

I captured this image with my Lumix 7–14mm *f*/4 ultra-wide zoom at 7mm for a 14mm equivalent field of view. With the aperture closed a stop to *f*/5.6 for sharp corners and -0.3 EV of exposure compensation applied for a slightly moodier look, the camera metered a shutter speed of 1.6 seconds at the base sensitivity of ISO 160. I used the self-timer to trigger the shot without wobbling the camera.

I was very lucky with the clear view, too. The cathedral was fairly busy the day I visited, but I was able to find a few moments when there was no one in front of the camera.

TIP During this trip, I was excited to use a new fisheye lens, the Samyang 7.5mm, which delivered a distorted, but attractive alternative to this composition, as seen left. Using extreme lenses, filters, or other techniques can certainly be fun, but I find I often tire of the effect later, so I always shoot a standard version during the same session, just in case. As predicted, I preferred the fisheye version on the day of the shoot (left), but now I'm more drawn to the straighter ultra-wide version (right). Which do you prefer?

The beach huts

EXIF Data

📷 Fujifilm X-T1

🎞 Fujinon XF 90mm ƒ/2

◁ 90mm (135mm equivalent)

⚙ ƒ/2

● 1/11000 second

⊡ 0 EV

ISO ISO 200

🅿 Provia

I love the rows of colorful beach huts with their lovely pastel doors that you find in many English seaside resorts. I'm also fascinated by what people store in them. Naturally, most will contain the sort of things you'd like to have easy access to on a beach front, like chairs, games, books, and various shelters and clothes for all weather. That said, many also have a variety of cooking appliances at the ready to prepare a nice toasted bun or a hot cup of tea—all very satisfying!

Whenever I see a row of beach huts I want to capture as many of the colors as possible, which simply means shooting along the row into the distance. In terms of composition, I'll pick the closest and nearest huts I like the look of and adjust my angle so they're touching opposite sides of the frame. I'll then look out for any nice details on the closest hut that I want to include—like a door handle, a lock, or a number—and ensure they're not awkwardly cropped. I also personally prefer lowering my position a little so the camera is at the same height as the middle of the doors. I prefer this squarer perspective to shooting at head height looking slightly down.

As for lenses, I like to use short to mid telephotos in this situation for several reasons. First, they ensure the subject is rendered naturally in terms of scale, whereas a wide-angle would make the hut in the foreground dominate the frame and render those in the background very small. Second, telephoto lenses deliver a flattened perspective that appeals to me for this kind of subject. Third, they give a greater opportunity for a shallow depth of field if desired.

Here, I used the Fujinon XF 90mm ƒ/2 telephoto on a Fujifilm X-T1 body, upon which it delivers coverage equivalent to 135mm. I opened the aperture to ƒ/2 for the shallowest depth of field possible and focused on the lock on the closest pink door. I also shot a version with a smaller aperture so more of the doors were focused into the distance, but I prefer the version here.

The base sensitivity of the X-T1 is ISO 200, which when shooting in bright daylight at ƒ/2 can require a very fast shutter speed to balance the exposure. For this image, I had to deploy the optional electronic shutter mode to achieve a speed of 1/11000. Even if I'd reduced the sensitivity to ISO 100, I'd still have needed the electronic shutter as the top speed of the mechanical shutter on this model is only 1/4000.

TIP When faced with bright colors, I normally either choose a preset to further saturate them or one to mute them (Velvia or Classic Chrome on the Fujifilm bodies, respectively). If you have time, try them all. Depending on the subject and lighting, you may be surprised by the result. In the end, the colors were popping so much in real life that I opted for the most natural-looking preset (Provia).

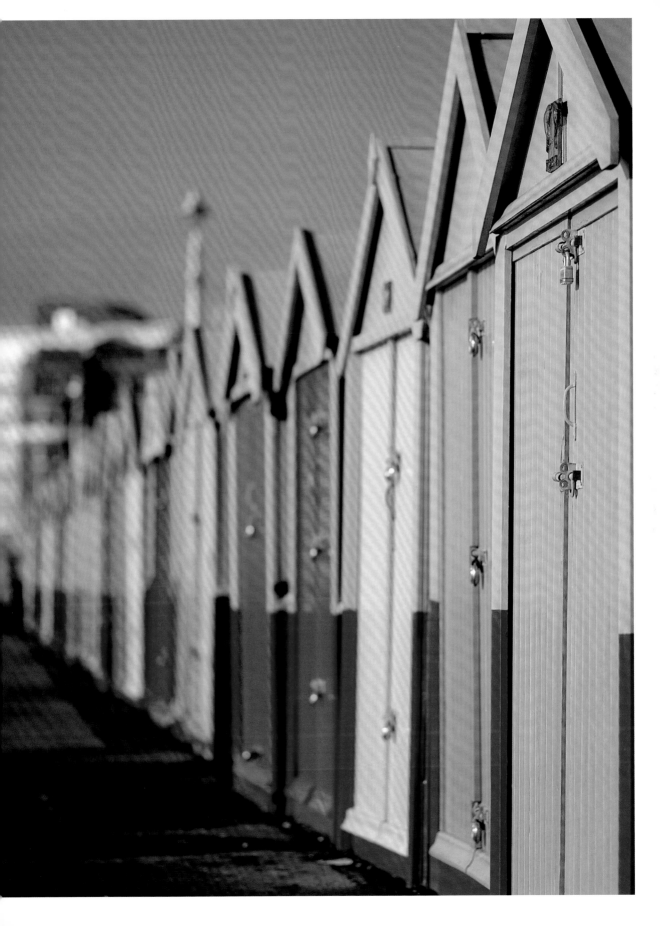

The beach umbrellas

EXIF Data

- Fujifilm X-Pro2
- Fujinon XF 35mm f/2
- 35mm (53mm equivalent)
- f/7.1
- 1/140 second
- −0.3 EV
- ISO 200
- Provia

I'm always on the lookout for interesting shapes to photograph and these umbrellas on Miami's South Beach really caught my eye. I loved the way they were packed away into the cabin like a bunch of cocktail sticks at a giant's bar. Compositionally, the crisscross of stands are interesting to look at, while their sharp points give the image some tension. I'm also always looking for natural frames. Here, the doorway to the cabin worked well, both to give some contrast to the dark interior as well as to lend a claustrophobic feel to the contents packed inside.

I wanted a natural perspective here, so I opted for a lens equivalent of around 50mm: the Fujinon XF 35mm f/2 mounted on an X-Pro2 body. I stood back far enough to use the doorway as a thick frame, but not so far that I could see anything behind it to distract me. I then adjusted my height and angled the camera carefully so it was squared to the center of the subject, ensuring that the tops and sides weren't squint or sloping, and using the onscreen gridlines as a guide. I feel a simple shot like this can succeed or fail based on things like geometry, so it's important to get it right. The gridlines can make it easy to line up as you take the shot.

This shot is also about the colors. For a seaside scene, I normally like to either go for a heavily saturated, gaudy effect or a subdued, muted approach. I felt the latter suited the subject here, giving it a dated, almost melancholy feel. Had the colors in real life been bright, I'd have gone for the Classic Chrome film simulation on the Fuji, but since they were already quite faded, I simply went for the standard style, Provia. Sometimes, it's worth shooting several versions using different processing styles, as one may look better than another once you're reviewing your images later.

TIP Most cameras offer a choice of color processing styles from muted to vibrant, allowing you to achieve the saturation effect you want in camera. If you can't decide what style works best at the time of shooting though, there's no need to shoot multiple versions. If you shoot the scene in RAW, you have the chance to apply different styles later. You don't even necessarily need to do this on a computer. Many cameras now allow you to process RAW files in camera using the Playback menu. I often exploit these to generate new JPEGs, trying out different processing styles.

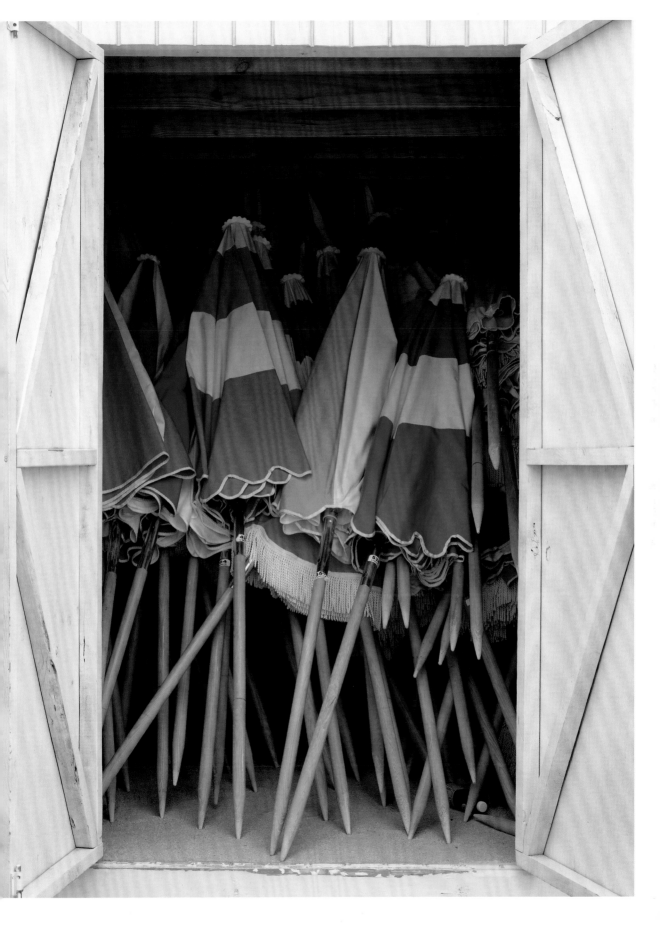

The beating heart of Paris

EXIF Data

📷 Olympus OM-D EM-1

🎞 Lumix 7–14mm *f*/4

◁ 7mm (14mm equivalent)

⚙ *f*/4

● 1/640 second

▣ 0 EV

ISO ISO 200

◉ Monotone with extra contrast

Here's the Eiffel Tower in Paris, photographed from below with an ultra-wide-angle lens. I took it with an Olympus OM-D EM-1 fitted with a Lumix 7–14mm lens at 7mm for a 14mm equivalent field of view.

You can count on a lot of things in life, but good weather isn't one of them — at least not in northern or western Europe! So, what happens when you're on a trip, visiting an interesting location for a brief period, and the weather decides not to play ball? Some revise their plans for museums, galleries, and other attractions inside. Others may go for an extended meal, some drinks, or perhaps catch a show. I enjoy all these things, but if I only have one chance at photographing a given location on a trip, I'll take it regardless of the conditions.

I've become a big fan of shooting cities at night, where illuminated skylines look much the same regardless of the weather above them. Meanwhile, when the conditions aren't great in the middle of the day, I often turn to a high-contrast, black-and-white approach. After all, if the sky is already a blank expanse of white, you can either try to avoid getting too much of it in the frame or simply embrace it for a stark effect.

So there I was, driving north through France when a last-minute change of plans gave us the chance to spend the night in Paris. The weather wasn't great, but you can't turn down opportunities like that. Should I take it? Bien sur! A few hours later, I was standing under the Eiffel Tower shuffling around with the other tourists, all of us keeping our backpacks on our fronts, keeping one eye on the view and the other on any suspicious characters looking to pickpocket the unwitting!

Picture it: me trying to line up this shot directly above, concentrating hard on the geometry while trying to be aware of my surroundings. Tricky business! Pointing upward with an ultra-wide lens is one of my favorite techniques and it resulted in some lovely shapes and patterns on the lower section of the tower. I knew if I put my camera into a high-contrast, black-and-white mode I'd be able to pretty much render the overcast drizzly sky as a pure-white background against which the black skeleton would really stand out.

TIP During my last visit to Paris, I was alarmed by the increase of petty crime around the major tourist areas. As photographers, we're particularly at risk with the many small and highly valuable items we carry. Try to spend a few minutes getting a feel for the area and those working it before getting your camera out, and when you do, hold tight, be vigilant, and put it away immediately afterward. Don't be distracted by potential scams and beware of "students" with clipboards.

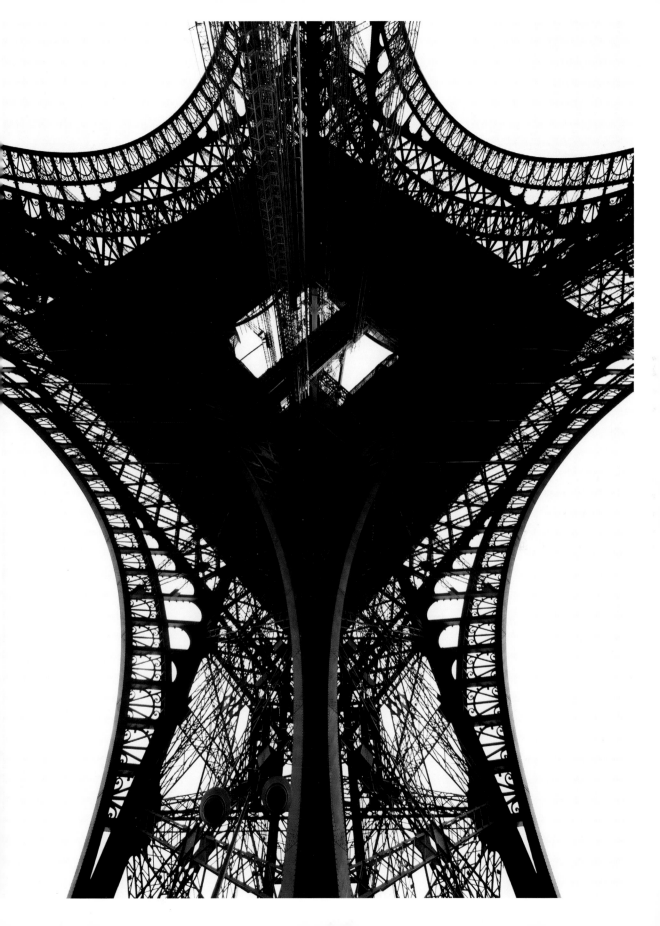

The beckoning cave

EXIF Data

📷 Olympus OM-D EM-1

🎞 Lumix 7–14mm ƒ/4

◁ 7mm (14mm equivalent)

⬡ ƒ/4.5

⬤ 1/10 second

▣ –1 EV

ISO ISO 400

◉ Monotone

It's safe to say I'm not a beach person. While everyone else seems to be having endless fun in the sun, I'm the one seeking the shade or searching for some kind of activity that won't get sand in my toes. (No wonder I subconsciously gravitated toward Brighton in the UK for a home with its pebbled seafront!)

This photo was taken at As Catedrais beach in northwest Spain, a location famed for its caves and arches. Most people stand in the entrance of the caves and stretch out for a fun portrait before moving on, but not me! Delving deeper inside and turning to look back out transformed the scene from cheerful to eerie and I knew right then I had a much more interesting composition.

To be perfectly honest, this cave wasn't all that deep and, for this shot, I was almost at the very rear among the flotsam and jetsam. I wanted it to look deeper though, so to render the entrance smaller and accentuate the depth, I needed a wide-angle lens. I captured this image with my Olympus OM-D EM-1 and a Lumix 7–14mm lens set at 7mm.

After adjusting my position, I applied –1 EV of exposure compensation to make the blacks truly black while being careful not to retrieve any saturated highlights. I wanted the exterior to look almost magically bright as a stark contrast to the dark interior.

I waited for gaps in the constant stream of tourists posing at the entrance to capture my spooky image, but then I realized it looked much better with someone in the frame. The distant figure would be rendered black against a bright light with a long shadow pointing back toward me, a little like Hollywood aliens emerging from a spaceship. In this respect, I feel it works both ways: either with the viewer being trapped with nowhere to go as something approaches, or with them being the predator, watching people outside from the safety of the shadowy interior, perhaps beckoning them to enter.

TIP I shot this photograph using my camera's Monotone preset for a moody black-and-white effect. I always had this in mind for the composition, but it also resolved an optical issue with my particular lens and body combination that sometimes results in flare. There were undesirable, colored flare blobs in this image when shooting directly at a high-contrast scene in color, but they're effectively hidden when shooting in black and white.

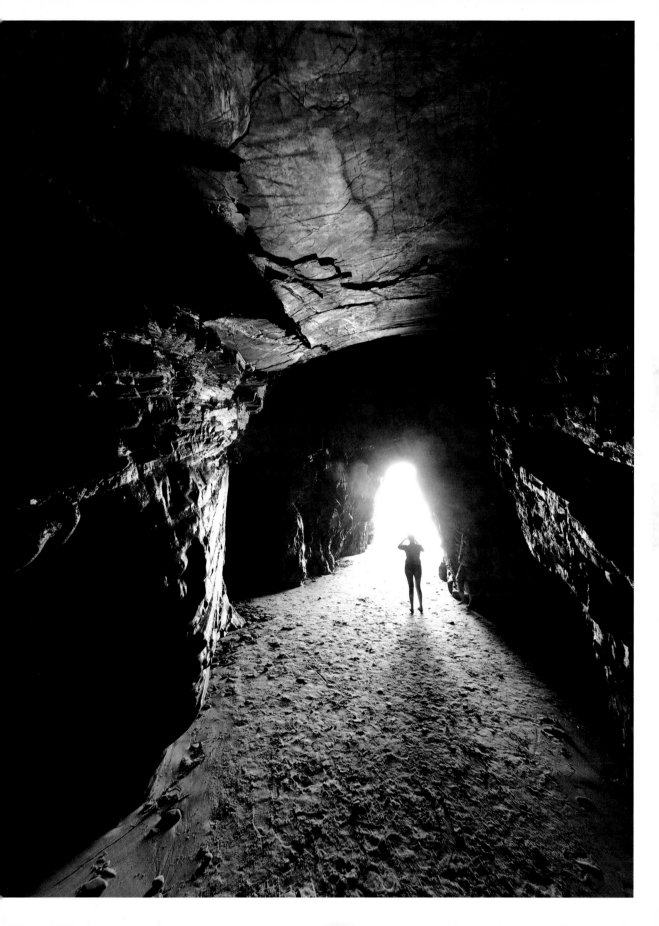

The best taco in New York

EXIF Data

📷 Fujifilm X-T1

🎞 Fujinon XF 10–24mm $f/4$

◁ 24mm (36mm equivalent)

🔆 $f/4$

⬤ 1/60 second

▣ +0.3 EV

ISO ISO 800

◉ Provia

In the bustling heart of Chelsea Market in New York, you'll find Los Tacos No.1 dishing up the best tacos and quesadillas I've ever had. I'm conservatively titling this as the best in New York, but they're better than anything I've had anywhere to date, and you'll get change from a five-dollar bill, too.

This is a photo of the third serving of the marinated pork quesadilla on a flour tortilla I had within half an hour, and I'm not ashamed to say I scarfed a fourth shortly afterward! It was my last day in New York after all, and I didn't see any reason to save space for airport food later. I obviously had to take a photo, and this shot illustrates a number of techniques I use when shooting food.

First, the lens: I normally shoot food with either a bright, standard 50mm-equivalent lens to achieve a natural perspective and a shallow depth-of-field effect. Or, I use a wide-angle lens to capture more of the surroundings. I went for the latter here, using an XF 10–24mm on my Fujifilm X-T1. As a small takeout restaurant, there was only a minimal counter to stand at so I positioned myself away from the sauces opposite a basket decorated with Mexican banknotes. I thought this would make a fun background to give the food some context.

I adjusted the zoom until I liked the balance between the food and the basket, then repositioned the AF area to fall above the food. The lens may not be able to deliver very shallow depth-of-field effects, but I opened it to the maximum $f/4$ aperture nonetheless for a small amount of separation.

While modern cameras offer a wealth of processing styles, I find the standard ones are best for food, as too much or too little color or contrast can look unnatural and unappetizing. I selected Provia here, the X-T1's standard style. I also try to shoot by a window (or as close to one as possible) for natural light.

P.S. If you're visiting Chelsea Market, I can also recommend the Cambodian sandwiches of Num Pang, the Korean ramen of Mok Bar, and the coffee at Ninth Street Espresso.

TIP When shooting food on a tiled surface, the OCD in me always aims for symmetry. So here I positioned the plate on the cross formed by four tiles. I then used the gaps between the tiles as a guide to ensure the composition was square and centered. It's little details like these that please me when done correctly, but annoy me if they're slightly off. If I can't get it right, I prefer to go way off.

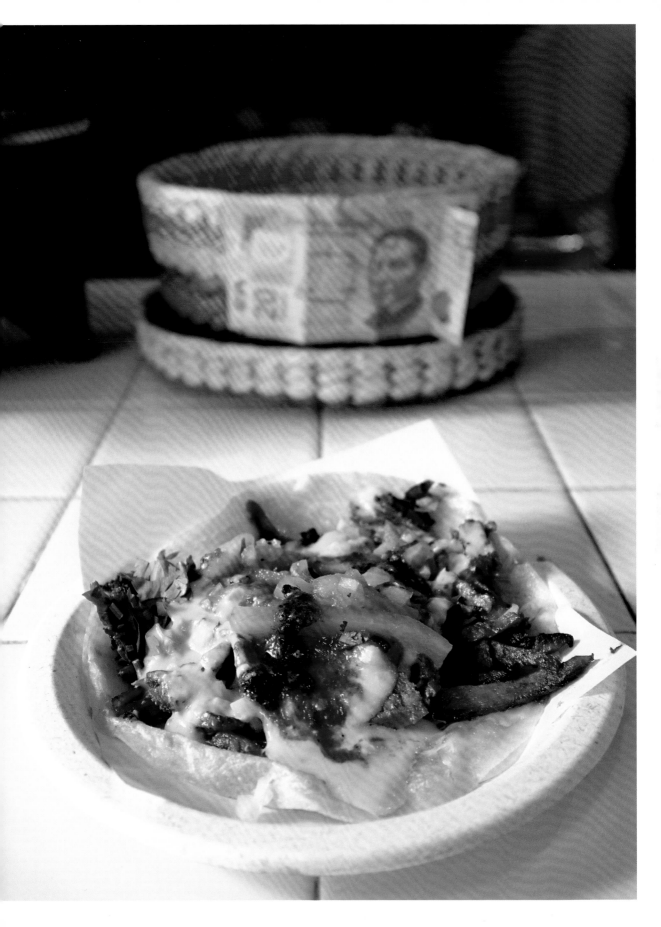

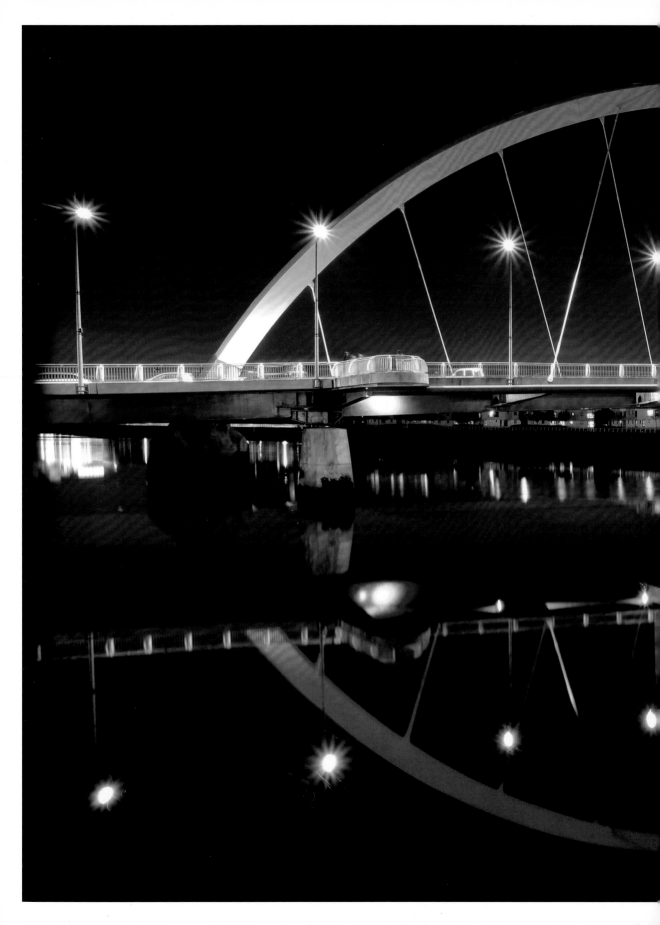

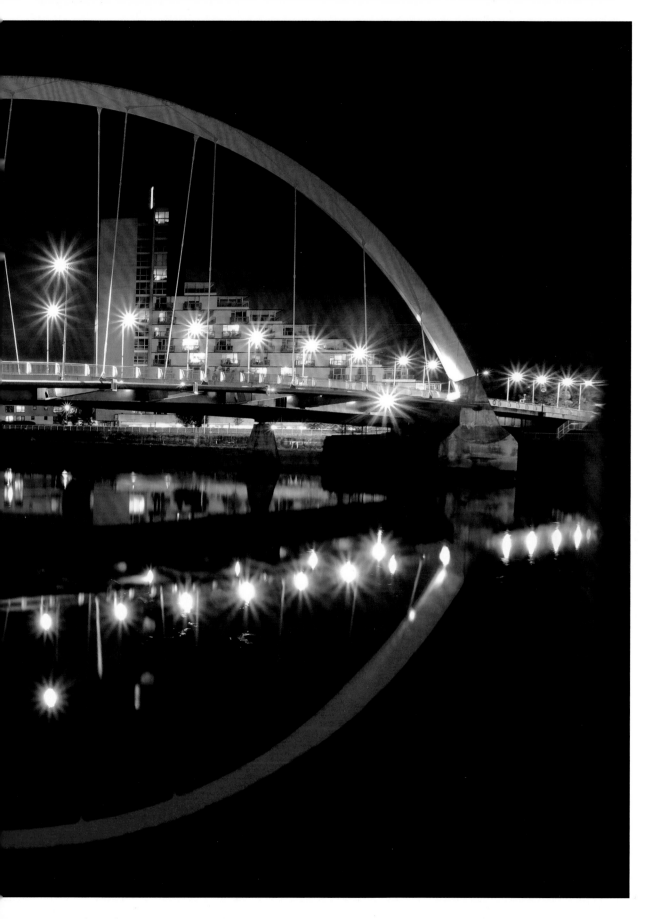

(All aboard) the Clyde Arc

EXIF Data

📷 Fujifilm X-T1

📦 Fujinon XF 10–24mm *f*/4

◁ 10mm (15mm equivalent)

✪ *f*/11

⬤ 58 seconds

▣ 0 EV

ISO ISO 200

◉ Velvia

The Clyde Arc, or "Squinty Bridge" as it's fondly known by locals, spans the River Clyde in Glasgow, Scotland at a jaunty angle. Opened in 2006, it was one of the locations selected by my good friends Athena, John, and Andy for their 2015 Euro photo walk. (You can search for the images we took across various social networks by using the hashtag #europhotowalk.)

Some photo walks are heavily guided. Others encourage greater independence to find your own angles and compositions. In this instance, most of the group headed onto the bridge itself or onto the opposite bank and came back with some really nice reflections of the buildings behind me. For me, though, there was just one view to target and that was the arc of the bridge and its reflection in the Clyde.

I gradually made my way along the bank closer to the bridge until I could go no farther, finding a nice corner just outside the Hilton Garden Inn. Here, I could shoot almost square on to the structure while avoiding any ground in the lower portion or side of my image. It involved placing my tripod precariously on the other side of some railings, but I kept hold of my camera strap in case it toppled toward the river. Fortunately, it stayed put.

I used my Fujifilm X-T1 fitted with the XF 10–24mm lens, here at 10mm for a 15mm equivalent field of view. I closed the aperture to *f*/11, partly to extend the exposure time, but also to render the streetlamps into spiked star shapes, an effect due to diffraction that this lens does very nicely. I also mounted one of my Lee neutral density filters to soak up some light to farther extend the exposure here to one minute. I was initially shooting with my Big Stopper (10 stops), but switched to my three-stop filter here as the conditions grew darker. I use the Lee Seven5 system, which employs smaller filters for smaller-format cameras. It suffers from a little vignetting on the XF 10–24mm below around 13mm, but I just cropped the sides a little here.

TIP For the one-minute exposure, I set the X-T1 to Bulb mode and used Triggertrap to control the process. Triggertrap involves a cable and app that lets you use your phone as a sophisticated cable release and timer. One end of the cable connects to your phone's headphone jack and the other is customized to your particular camera, in my case for the X-T1's USB port. For the cable to work, the headphone volume needs to be at its maximum, and while dismissing my phone's warning I lost the first two seconds of the exposure time (hence 58 rather than 60 seconds in the EXIF data). I'd also like the opportunity to thank my friend Matthieu Oostveen for the loan of his cable that evening and continued inspiration on long-exposure photography.

The light painting

EXIF Data

📷 Olympus OM–D EM–5 Mark II

🎞 M.Zuiko 12–40mm $f/2.8$

◁ 12mm (24mm equivalent)

⚙ $f/8$

⬤ 5-second refresh

⊡ 0 EV

ISO ISO 100

◉ Live Composite mode

One of my earliest memories of 35mm film photography was the joy of Bulb exposures — keeping the shutter open for seconds, minutes, even hours to record surreal effects. Most of my early experiments were in pitch dark rooms, using a manually fired flash to illuminate and freeze moments of action, like a balloon full of water exploding as a dart hit. I later realized the same technique could be used to capture the same person multiple times on a single frame. Then there was light painting — writing words in the air with a light shining directly at the camera during a long exposure, then magically seeing the completed shapes on the processed film.

I enjoyed light painting, but soon found other subjects to photograph and techniques to adopt. Others have turned it into an art form. I was lucky to meet Zolaq, a professional light-painting team, at an Olympus event. They demonstrated their amazing techniques in a number of darkened locations.

Previously, I'd use the Bulb mode to simply keep the shutter open until a light painting was completed, but doing so would mean the entire frame would receive the same exposure, which could result in brighter areas becoming severely over-exposed. One solution to these and similar problems is to capture multiple frames of different exposures and combine them later, but the latest Olympus cameras now offer a means to do it in camera.

Here, I used the Live Composite mode introduced on the OM–D EM–5 Mark II, which first exposes for the background, then waits for any new light to appear in the composition. When new light does appear, such as a fireworks explosion or a new section of a light painting, the camera will resume the exposure, but crucially only in the area where the new light is. This allows the frame to record the new area of light, without affecting the existing exposure underneath. In situations like these, there's typically a great deal of experimenting required. For this particular image, however, Zolaq recommended setting Live Composite to a five-second cycle at $f/8$ and ISO 100. The entire process took about five minutes to complete.

TIP Modes similar to Live Composite are appearing on more new cameras, but if yours doesn't have it, you could first try a single Bulb exposure to see what needs modifying on subsequent attempts. Like fireworks, you use the aperture and sensitivity to control the brightness of the trails. Once the trails look good for the exposure length required to complete the painting, you can address things like the brightness of buildings, trees, and the ground. If these are still too dark by the end of the process, consider waving a flashlight at them or firing a flash during the exposure. If they're too bright, try using a graduated ND filter or combining multiple exposures.

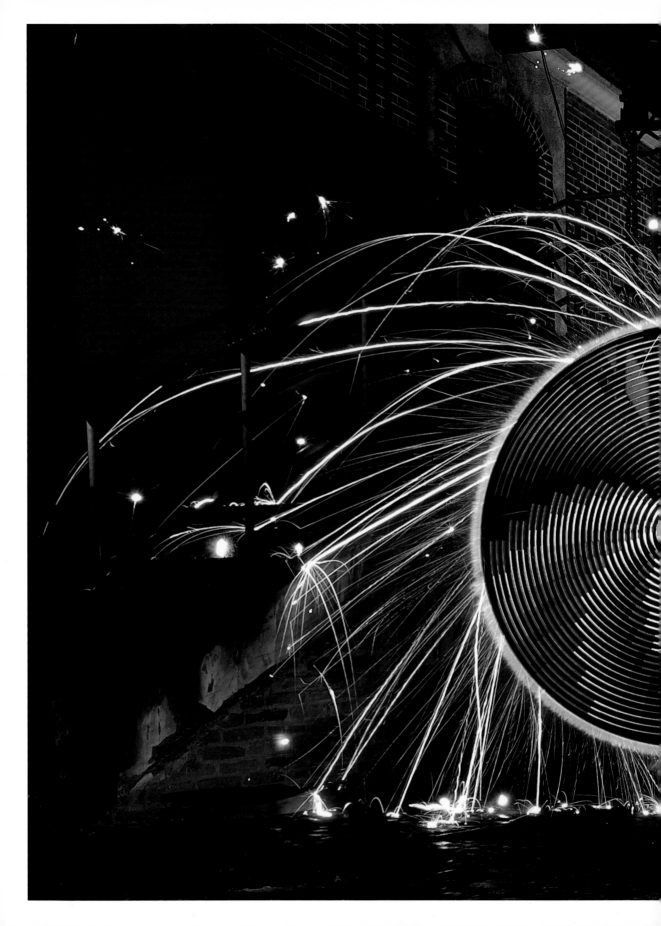

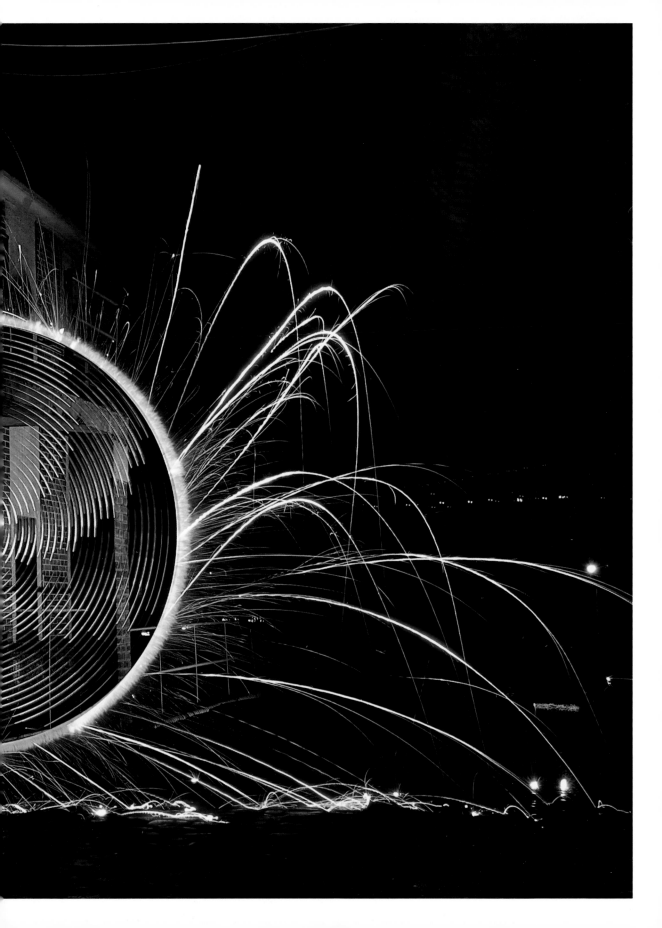

The cathedral dome

EXIF Data

📷 Olympus OM-D EM-1

🎞 Lumix G 7–14mm *f*/4

🔊 10mm (20mm equivalent)

🌀 *f*/5.6

⚫ 2.5 seconds

☑ 0 EV

ISO 200

🌐 Natural

Here's an alternative angle with the same lens. The seating at the bottom provides some context, but for me, detracts from the majesty of the roof in the main image, opposite.

You're looking at the famous dome of St Paul's Cathedral in London, designed by Sir Christopher Wren in the late 1600s. The cathedral, which remains a prominent feature on the London skyline, was designed by Wren following the destruction of the previous building in the Great Fire of London. Ironically, Wren's proposal to add a dome to the previous building had been approved just one week before the great fire in August 1666.

The "new" St Paul's Cathedral took nine years of planning, with construction starting in 1675 and the building finally completed 35 years later. Since then, it has enjoyed many enhancements to its interior decoration, not to mention structural reinforcements, particularly between 1925 and 1930 when it was closed for strengthening. Some of the strengthening was considered excessive at the time, but turned out fortuitous when the cathedral survived two bomb strikes during the Second World War.

There's no doubt St Paul's is a spectacular building, but while it's one of London's most photographed subjects from the outside, a number of restrictions prevent visitors from using cameras inside. If you'd like to shoot the interior, though, don't give up hope. In 2014 and 2015, the cathedral held fundraisers that opened its doors to 300 photographers in return for a reasonably priced entry ticket. The events were promoted with the hashtag #SurpriseStPauls so if you're interested, see if a future event coincides with a visit to London.

I bagged a ticket for the 2015 event and enjoyed two hours of unrestricted shooting with 299 others, including tripod use. The image featured here was captured using a 2.5-second exposure with my Olympus OM-D EM-1 and Lumix 7–14mm lens at 10mm for a 20mm equivalent field of view. As with all wide-angle architectural compositions, use the on-screen or viewfinder gridlines to avoid skews and ensure symmetry.

TIP In a shot like this, I like to capture the maximum amount of detail. To do so involves learning about the optimal aperture settings for your lenses. Each lens has a sweet spot for resolution across the frame, but it varies between lenses and systems, so don't assume what worked for one will be best for another. Try shooting a distant scene from a tripod at each aperture setting and compare the details across the frame to discover the optimal aperture for sharpness for a particular lens and body. For my combination here, it involved closing the lens by one stop to *f*/5.6.

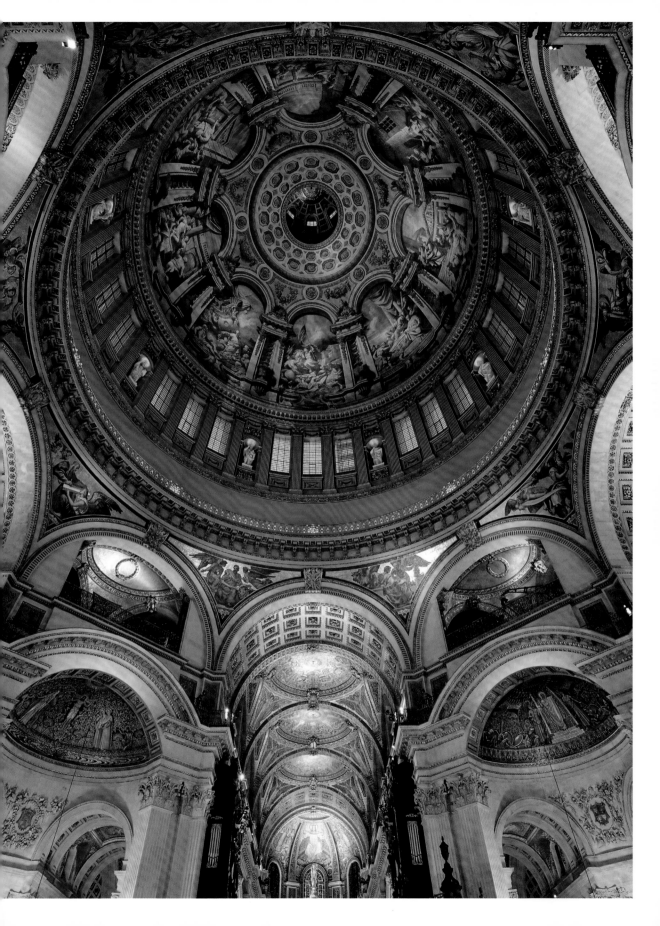

The cathedral floor

EXIF Data

📷 Olympus OM-D EM-1

🎞 M.Zuiko 8mm f/1.8 Fisheye

◁ 8mm (16mm)

⟳ f/1.8

⬤ 1/8 second

⊞ -0.67 EV

ISO 200

Natural

Here's the vast interior of Liverpool's Church of England Cathedral, one of the largest Anglican cathedrals in the world. At 188 meters in length and sporting a tower just over 100 meters tall, it certainly enjoys a dominant presence on Liverpool's skyline. The classic design is in some contrast to the very modern-styled Metropolitan Cathedral about half a mile away (see page 164), although the Church of England Cathedral was actually completed over ten years later, opening in 1978.

The enormous central space, pictured here, is normally packed with seating for worship or other events, but during one of my visits it had been temporarily cleared. It was a great opportunity to shoot the building and capture the scale of its interior. I had to shoot carefully, however, so as not to end up capturing an image that portrayed a vast expanse of nothing.

This is a particular risk when shooting with an ultra wide-angle lens, as I did here. The perspective of wide-angle lenses means objects in the distance appear smaller than normal while those nearby appear larger. This means the floors in such shots can appear disproportionately big, so the key when shooting wide is to find a nearby subject to occupy the foreground. (I faced and solved the same problem on page 118 with The fire station, using the logo of the service to fill the foreground.) Here, I positioned myself to feature the plaque dedicated to the architect of the building, Sir Giles Gilbert Scott.

I shot this with a fisheye lens, which squeezes a 180° field of view across the diagonal corners of the frame. Doing so introduces significant geometric distortion, hence the side walls curving inward. I was careful to position the "horizon" of the building across the middle of the frame where the lens would render it as a straight line. I don't mind some curves, but for traditional architecture, too many can be off putting.

TIP Photographing large buildings with ultra-wide lenses has several advantages beyond simply squeezing a lot into the frame. They're a lot more forgiving on camera shake, allowing you to handhold relatively slow shutter speeds without having to boost the ISO and lose quality. Their depth of field is also inherently large, allowing you to get lots in focus even with large apertures (small f/numbers). Just keep an eye on the geometry and symmetry of the subject, as small movements can cause noticeable skewing.

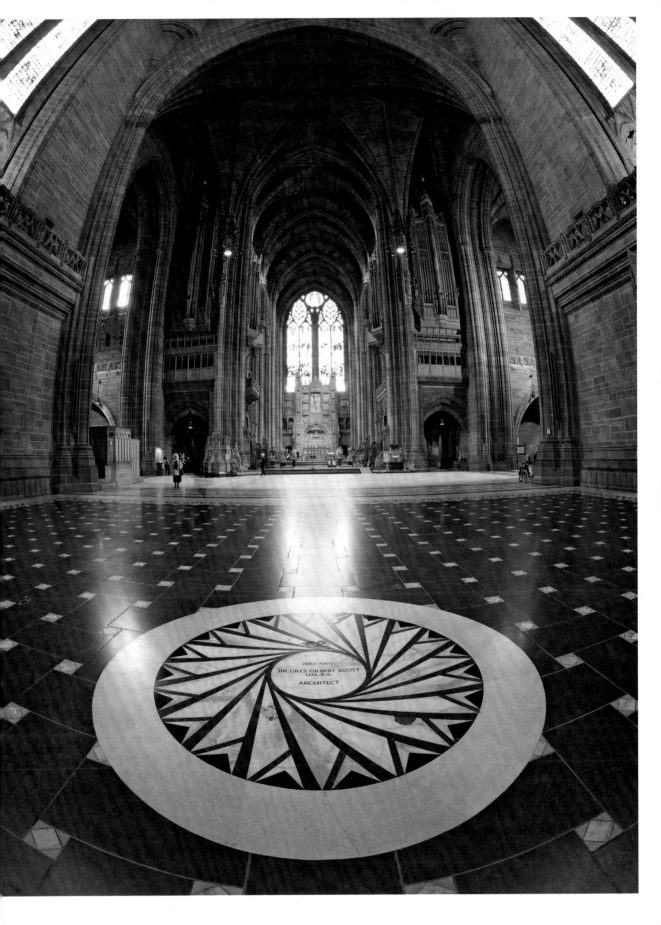

The cheese sandwich

EXIF Data

📷 Olympus OM-D EM-1

🎞 M.Zuiko 17mm *f*/1.8

◁ 17mm (34mm equivalent)

◐ *f*/1.8

● 1/320 second

▣ -0.3 EV

ISO ISO 200

◉ Natural

Who doesn't love a toasted cheese sandwich? This isn't any old sandwich; it's a sublime specimen from Kappacasein in London's Borough Market. I've been enjoying these for well over a decade on trips to the city, where Kappacasein owner Bill Oglethorpe packs Montgomery cheddar, onions, leeks, and garlic between two slices of Poilâne sourdough bread. I can also recommend his traditional Swiss Raclette.

Food has become one of the most popular subjects of casual photography, but even if you're just posting your lunch on Instagram, there's no excuse not to try and make it look as attractive as a portrait or landscape. Indeed, good-looking food photography is always a guaranteed hit on social media and is a great way to grow your following.

Some food photographers are very precise, styling and lighting food with as much care as a high-end fashion shoot. I think you already know that's not my style. Instead, I opt for a much more raw and natural approach, but I still have a number of rules in the back of my mind.

Number one is the lighting: It's not controversial to say food looks most appealing in natural light. Studio pros spend massive amounts of effort trying to emulate that look with artificial lights. Fortunately, we don't need to worry about that. Just aim for café or restaurant tables near windows or skylights or, better still, shoot outside. Like portraits though, food doesn't look great with harsh shadows, so if it's very sunny, find a shaded spot.

Second, focus on the pose: If the food is presented on a plate, this is normally where you'd shoot it. If it's in a carton, get it out or try to avoid as much of the packaging as possible in your composition. If it's a sandwich or burger, consider holding it up for a point-of-view angle as if the viewer is about to take a bite.

Finally, think about the surroundings. In this example, I concentrated on the food but looked around to find a background that complemented rather than distracted. Shooting with a shallow depth of field also better isolates the subject.

TIP It should be apparent by now that I'm a huge fan of good food. Not fancy food in posh restaurants, but well-executed street food delivering a gourmet experience at affordable prices. London is packed with street food markets — some good, some not so good. My favorites include Kerb and Borough Market. If you're in my home town of Brighton, aim for Streetdiner on Friday at lunch time. They offer essential sustenance for tourists and locals alike.

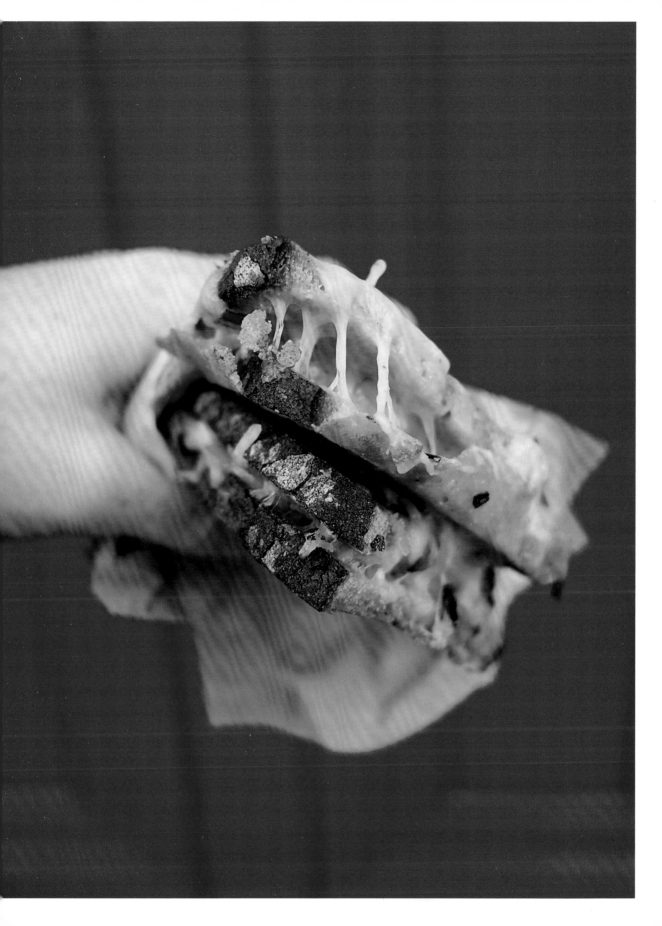

The blue door

EXIF Data

📷 Panasonic Lumix GX1

🎞 Lumix 7–14mm *f* / 4

◁) 14mm (28mm equivalent)

✺ *f*/7.1

⬤ 1/160 second

▨ 0 EV

ISO ISO 160

◎ Standard

In 2012, I spent an enjoyable 12 days driving around Morocco from Marrakech to Fes via the Atlas Mountains and the edge of the Sahara desert. When planning a trip like this, there are always photographic goals in mind, which for me were mostly focused on the city markets and sand dunes, but often your favorite images come from unexpected situations and locations.

Take this image, for example, taken in Chefchaouen, a city about four hours' drive north of Fes through beautiful agricultural countryside. It's one of my favorites from the entire trip, but we only ended up here because we managed to depart the dunes and traverse the country more quickly than expected. One bonus day on the schedule allowed us to pay a brief but enjoyable visit to this unique location.

The city was founded in 1471 as a small fortress by Moorish exiles from Spain. It's most famous for its blue-rinsed buildings, which dominate the old Medina area. As you approach the town from a few miles away, the sight of a town dominated by blue buildings is striking.

Walking through the old town is spectacular. Not only do you have the thin, windy backstreets reminiscent of Fes and Marrakech but, additionally, almost all the doors and walls are painted blue. It really is one of the most picturesque places I've ever visited, and a photographer's dream! Better still, even though it is touristy, the various sellers seemed much less forward than in other cities, allowing you to walk around without much interruption.

While walking around the town, I kept being drawn to this particular door so I ended up shooting it several times. The one featured here from the morning without direct sunlight on it turned out the best. I used the Panasonic GX1 and Lumix 7–14mm lens at 14mm (28mm equivalent), composing the image in two halves, with the doorway and elaborate tiling on one side and the stairs on the other.

TIP Digital cameras have become very good at evaluating the lighting in a scene, not just for exposure, but also for white balance; I almost always rely on the camera's metering and Auto white balance. However, in the same way you sometimes need to override an exposure, occasionally Auto white balance gets it slightly wrong. If one color dominates a scene, the camera may try and compensate for it. For subjects like these, I often set the white balance manually to avoid losing the impact. Here, I based the scene on natural lighting and opted for the Shade white-balance setting. If you do change your white balance away from Auto, remember to set it back again when you're in more predictable circumstances.

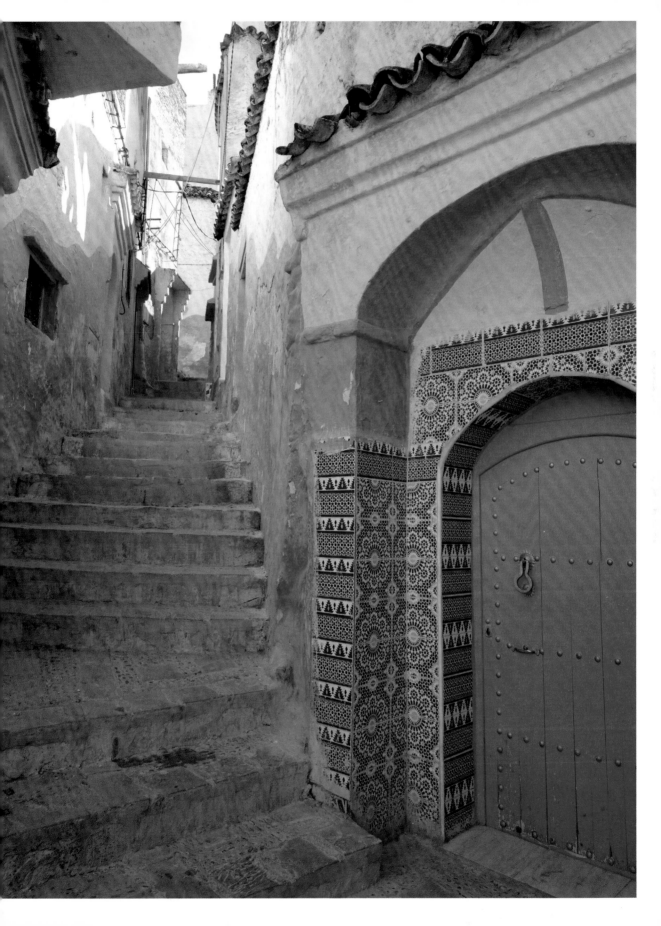

The bonfire march

EXIF Data

📷 Sony α7S Mark II

🎞 Sony FE 55mm f/1.8

◁ 55mm

⚙ f/1.8

● 1/3200 second

▣ 0 EV

ISO 12800

◉ Standard

Here's a shot from the annual Lewes Bonfire Parade where, for one night a year, this normally small and sleepy UK town is transformed into the bonfire capital of the world. With flaming torches and firecrackers being tossed around narrow streets with abandon, it's not an event for the fainthearted, and it's equally very tough to photograph. Shooting anything that moves in very dim light always presents a challenge for autofocus, while the contrast between dark shadows and intensely bright torches can confuse even the best metering systems. Beyond the technical challenges, I'm also looking for a strong sense of identity and location when shooting events like these, as I want my images to reflect that it's no ordinary display.

Addressing the low light issue first, I always shoot my street-side views of Lewes Bonfire Parade with a bright, standard lens. A 50mm f/1.8 is ideal, gathering plenty of light to give the AF system a fighting chance at locking onto a subject while also delivering coverage that's ideal for shooting from the edge of the street whether mounted on a full-frame camera or a cropped-frame body.

With unpredictable motion from the people in the march, not to mention jostling from viewers on either side, I needed to use a fast shutter speed. In dim conditions, this means a very high ISO. I normally choose a suitable shutter speed in Shutter Priority then leave the camera to work out the sensitivity with Auto ISO, realizing it will invariably be at least 6400 even with the lens aperture wide open.

You'd assume continuous AF would be best for a march, but its suitability really depends on the confidence of your camera under dim conditions. A high-end camera may be able to track a subject like this in low light, but a lower-end model will search back and forth fruitlessly, losing the moment. The solution is to either manually focus at a preset distance and shoot bursts as subjects walk through it or wait for a momentary pause, and use Single AF. A brief pause also allowed me to better frame the composition, including the sign of this particular society in the background: Borough, one of the most famous at the parade, particularly with their distinctive striped shirts.

TIP Like sports photography, the key to maximizing your success at an event like this is to take a lot of photos and take regular opportunities to check your images for focus and exposure. If you're consistently suffering from badly exposed or blurred images, adjust your technique before continuing, but if you have a mix of winners in there, I'd consider sticking with your settings and just shooting as many more as possible. Ultimately though, if you're not enjoying any success and you begin getting frustrated, just put your camera away and enjoy the spectacle with your eyes.

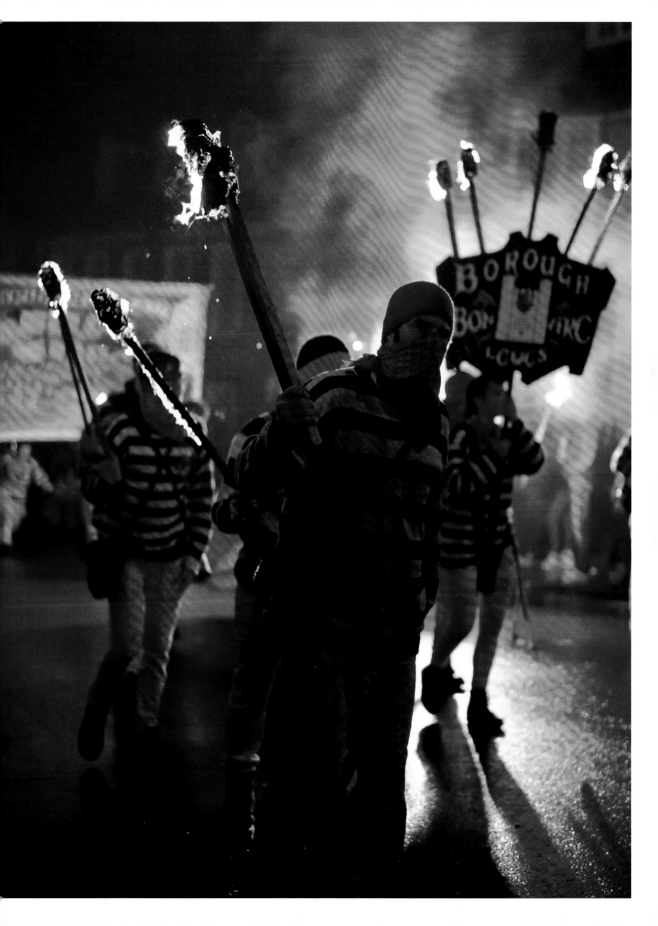

The breakfast waffle

EXIF Data

📷 Olympus OM-D EM-1

🔲 Panasonic/Leica 25mm
 f/1.4

◁ 25mm (50mm equivalent)

⬡ f/1.6

⬤ 1/25 second

🔲 0 EV

ISO ISO 200

◉ Natural

Here's the breakfast waffle at Brighton's Seven Stars Pub. When shooting food, it's easy to concentrate on the plate alone, giving little idea of the surroundings or context. Sometimes that's what you want, but I find that backing off a little and showing where you are can greatly enhance the overall composition and impact.

For a photo like this to be successful I think you have to choose your background carefully. While you want it to be attractive, it shouldn't detract from the primary subject. I loved the blue wall at the back of the pub and thought it would compliment the reds of the berries on the dish, but I had to frame the shot carefully to avoid areas of the wall with different décor. Immediately above the top of the frame, it changes entirely, so I composed to avoid it.

Of course, the angle also has to work for the food itself. When aiming for a background like this, it's easy to find yourself shooting at a very low angle, almost to the side of the plate, which rarely works for showcasing the food. So I simply adjusted my shooting height carefully to show enough of the plate without compromising the background. I also turned the table a little so the corner was visible, as the point draws you into the frame. As for the tray, I turned it to be parallel with the edge of the table and deliberately cropped one corner off, again to lead your eyes and allow the dish to be maximized without being domineering.

I shot with my Olympus OM-D EM-1 fitted with the Panasonic/Leica 25mm f/1.4 for a standard 50mm equivalent field of view. I shot in Aperture Priority at f/1.6 for a shallow depth-of-field effect to blur the background.

TIP If you're including the restaurant in the background of a food shot, keep an eye on it while you compose the foreground in case anything changes that might spoil it. Sometimes, you want to see people, sometimes you don't. Sometimes a perfectly placed chair or table finds itself moved. I've had jugs, glasses, cutlery, and more moved from beneath my nose even as my camera was pointed at them. You can't be too controlling in a public environment, but you can be aware.

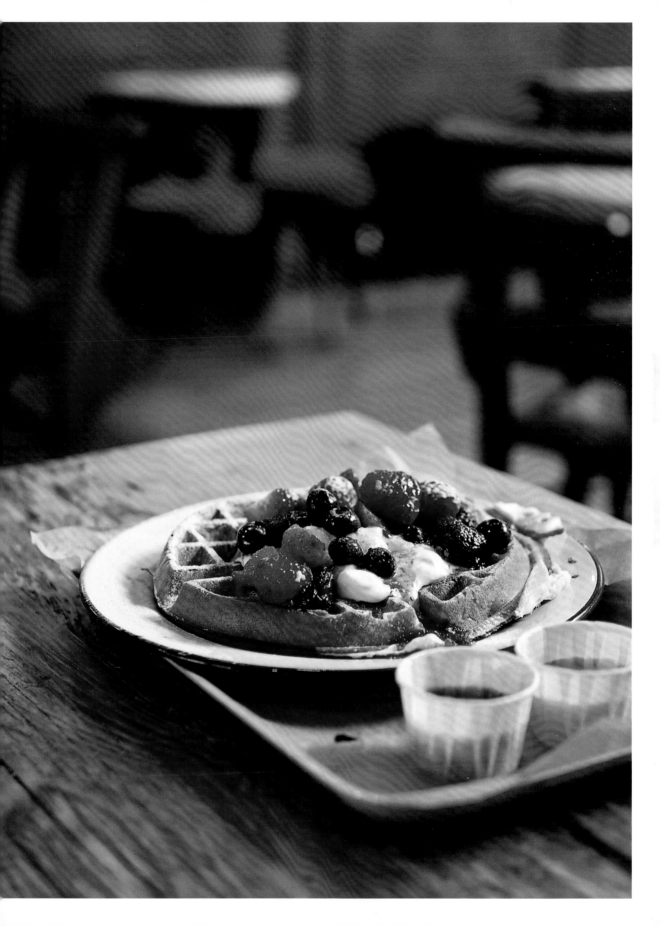

The burlesque model

EXIF Data

📷 Sony α7S Mark II

🎞 Sony FE 24–70mm *f*/4

◁ 24mm

◌ *f*/4

● 1/320 second

▣ 0 EV

ISO ISO 12800

◑ Tungsten white balance

At a Sony event, I had the chance to photograph burlesque performer Amber Ray C. Up to this point in the evening, I had been taking fairly conventional, face-on portraits, but when she changed into this outfit, I knew my images would benefit from a different angle. I noticed another photographer shooting from a higher perspective, looking down and that gave me the inspiration to go even higher where, from almost above, her arc of feathers resembled an exotic flower.

There were, however, a number of challenges. For one thing, I didn't have a ladder or a platform. Plus, I had to deal with extremely low light and lack of any particularly bright lenses. Finally, the black velvet background that provided isolation at traditional angles was of considerably less use when shooting from above.

I solved the first issue by flipping out the articulated screen on the camera and composing with it instead of the viewfinder. This is one of the major benefits of shooting in Live View mode, which is the only option on mirrorless cameras. In order to freeze any motion, I needed a fairly fast shutter, which in the low light with no flash and the lens already at its maximum aperture meant a high sensitivity setting was necessary. I shot this image at ISO 12800, which would normally mean a fairly noisy result, but luckily I had access to a Sony α7S Mark II, which employs a large full-frame sensor and 12-megapixel resolution to deliver clean results at high ISOs.

As for the background, I wanted it to be completely black to highlight the subject, so I adjusted my position, angle, and distance to maximize the velvet drape behind Amber until there were no gaps around the edges. Some cameras also allow you to adjust the internal tone curve so that tones in the shadows are effectively merged into a uniform black. Either way, keeping a close eye on the background is an important skill if you're attempting to achieve a final result in camera without subsequent retouching.

TIP If you want to maintain certain shutter speeds in low light and can't use a flash or open the lens aperture any wider, you have little choice but to increase the ISO sensitivity. This amplifies the signal to give the effect of greater sensitivity to light, but it will amplify the electronic noise, too, which is why you see more of those digital speckles at higher ISOs. Even so, increased noise is always preferable to camera shake or underexposure.

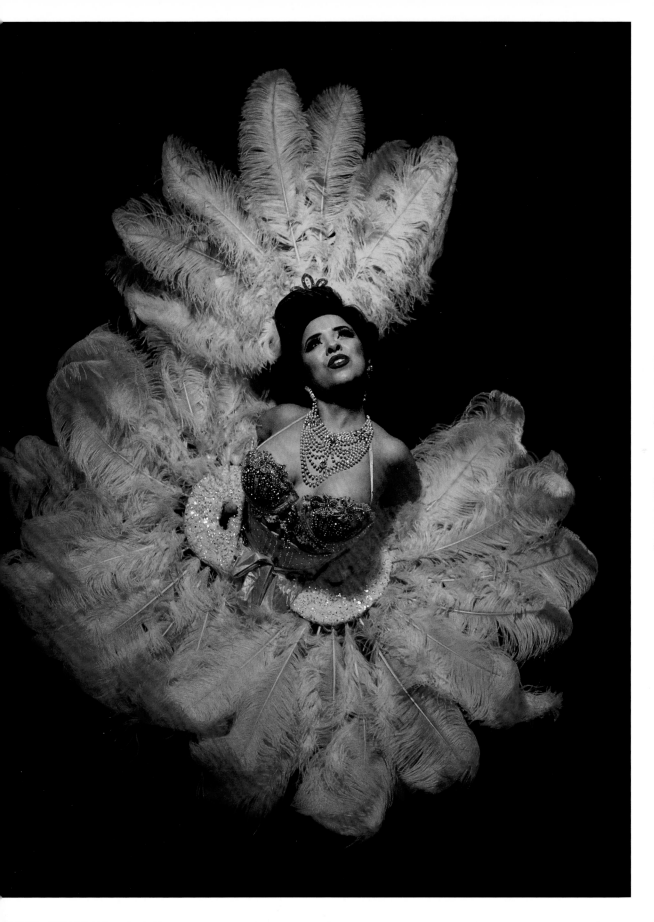

The inevitable sunflower

EXIF Data

📷 Olympus OM-D EM-5

🎞 Lumix 7–14mm

◁ 14mm (28mm equivalent)

⚙ f/4

● 1/2500 second

▣ +0.3 EV

ISO ISO 200

◉ Natural

Driving through Northern Spain in the height of Summer, you can't help but be struck by the beauty of the countless fields of sunflowers. Rows upon rows of huge yellow and orange faces worshipping the sun, surrounded by dark green foliage and deep azure sky without a cloud in sight. Really, what's not to like?

Capturing a nice photo of a field of sunflowers is on the bucket list of most landscape photographers, including myself, but it's harder than it looks. This photo is my favorite of about 50 I took during a brief stop one day, and I'll readily admit most of the others were rather dull. The trick, for me anyway, is to have a hero flower dominating the frame, surrounded by many others. I want to see the detail in the primary model, but it's crucial that it's not a flower in isolation, rather one nestled among a field of many others.

It's only when you start framing things up that you realize many of the flowers may not be as perfect as they seemed when you were driving past, and when you do find a really good one, it could be surrounded by a load of mediocre-looking ones. So, the first step is to find a star model that's surrounded by some good-looking counterparts, but even then that may not be quite enough. In order to see the flowers around my "hero," I favor a slightly elevated position, looking down a little. The problem is, the hero flower may be resolutely pointing straight forward, and when viewed a little from above, may look like it's actually pointing down or away from you as if shy or disinterested. For the ultimate pose, I wanted a great-looking flower that was not only surrounded by other good-looking flowers, but also pointing up a little. And you thought posing kids was difficult!

Once I found my candidate, I opted for a standard wide-angle lens to capture the shot. I used an Olympus OM-D EM-5 with a Lumix 7–14mm at 14mm for a 28mm-equivalent field of view, with the aperture wide open and focused very close to the hero flower. The wide lens, modest aperture, and small format meant the depth of field was never going to be very shallow, but at this close range there's still a little blurring to separate the subject from the flowers behind it.

TIP My preference of a huge hero flower surrounded by smaller flowers is best achieved with a wide lens, but it doesn't have to be an ultra-wide. I took this photo with a 28mm-equivalent field of view, which in wide-angle terms is fairly mild. If you go for something wider still, you could certainly further accentuate the size of the hero against the background, but you'll need to get even closer to it, running the risk of casting a shadow and of losing precise focus as the flower sways gently in the breeze.

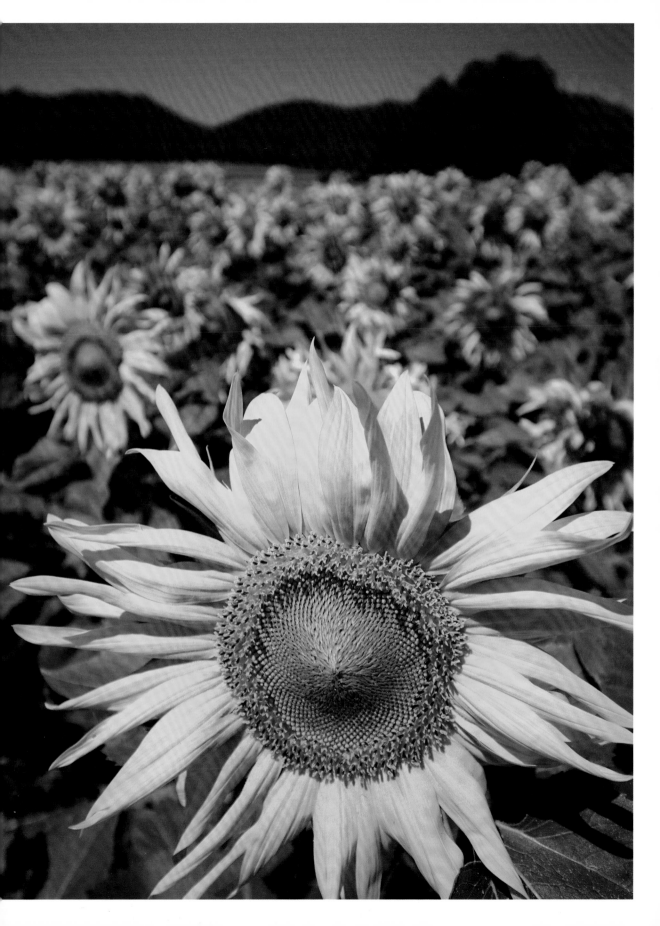

The winning shot

EXIF Data

📷 Sony α6300

🎞 Sony FE 70–200mm *f*/4

◁ 70mm (105mm equivalent)

⬡ *f*/4

⬤ 1/4000 second

▣ 0 EV

ISO 800

◑ Standard

During a trip to Miami, I was invited to a sunrise volleyball shoot on the beach. I'm no fan of early mornings, but you can't turn down that kind of offer! With the sun rising over the sea I had two options: shoot into it to include the water or turn around and shoot the subjects bathed in yolky orange light. While the latter can certainly yield some attractive results, for me there's only one direction to shoot when you're on the beach: I want to see the sea.

As photographers, we're often warned not to shoot into the sun. Shoot with care though and you can enjoy some great results. I've included several such examples in this book, some employing wide lenses with closed apertures to render a midday sun into a starburst. Others have been shot with longer telephoto lenses at sunrise or sunset when atmospheric haze soaks up a lot of the brightness. Even at these times of day, however, avoid looking directly at the disc itself and minimize your camera sensor's exposure to it.

I positioned the sun just to the right of the frame here so it didn't pose any danger, but the sky is still much brighter than the player in the foreground. So which do you expose for? If you expose for the player, the sky and sea become overexposed and washed out. If you expose for the sky, the player becomes silhouetted. One way to capture both is to expose for the sky but position a flash near the foreground subject to illuminate it. It's a fun technique, but I prefer to work entirely with natural light, so opted for the silhouetted foreground.

I set the camera to Manual exposure mode, set the shutter to 1/4000 second to ensure the action would be frozen and opened the aperture to the lens's maximum of *f*/4 to deliver a shallow depth of field. I then adjusted the ISO until the sky looked to be exposed correctly; you can use the histogram to judge accurately or just do it by eye. With the exposure fixed regardless of where I pointed the camera, I framed up the net, set the drive to high speed, and the focus to continuous. Then I waited for some action close to the net, firing off bursts as the players reached for the ball.

I shot this with the Sony α6300, which has such good autofocus I just let it figure out where the subject was; on less capable models, I'd have locked the area or even manually focused on a targeted position. I chose this frame as I like the position of the ball, the player mid-jump, and the small cloud of sand below her foot just catching the sun.

TIP I varied my height to alter the position of the horizon on the frame and settled with an almost half-way split where the player would cross in front of both sea and sky. I was careful to ensure the horizon was straight, using the electronic grid as a guide.

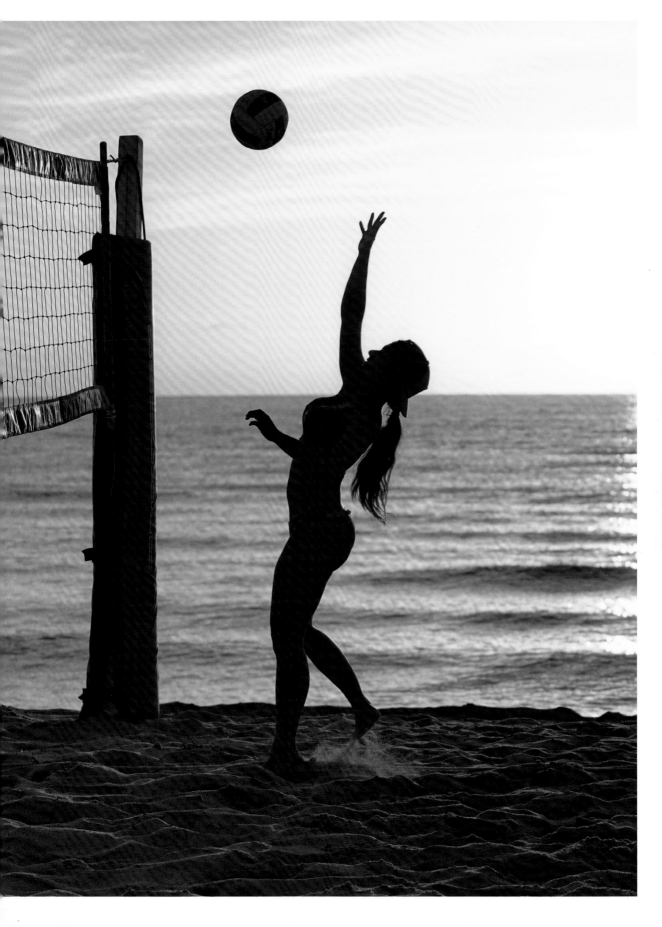

The Irish peak

EXIF Data

📷	Fujifilm X-T1
🎞	Fujinon XF 10–24mm $f/4$
◁	14mm (21mm equivalent)
◐	$f/7.1$
●	25 seconds
🔲	0 EV
ISO	ISO 400
◉	Velvia

This is Mount Errigal, a 2464-foot peak in Donegal, Ireland. I captured it using a 25-second exposure with my Fujifilm X-T1 and 10–24mm lens at 14mm for a 21mm equivalent field of view. I visited Ireland as part of the 2014 European photo walk organized by Athena Carey, John Dunne, and Andy Bitterer. It was another superb weekend of photography with friends and I encourage you try and come along to the next one; they're typically held every autumn.

This particular location was selected for the reflection on the water and the timing to coincide with the sun, hopefully, bathing it in orange light before dipping below the horizon behind us. Unfortunately, the spectacular sunset never happened, but I still loved the reflections on the water and pretty much shot constantly from 5:30–7:15pm. I always find it interesting to go through a series of shots taken over a long session from the same location, watching the conditions gradually change. Here, I particularly noticed the degree of reflection varying as the water's surface was disturbed then settled down again.

I've also become very fond of long exposure as a technique for shooting landscapes. It famously blurs the surface of water into a smooth surface and turns clouds into streaks, but it also delivers surprisingly good results when the conditions aren't particularly great for normal handheld shots. A solid gray cloudbank can be transformed into a mysterious or ominous display given a chance to move a little during an exposure. In order to shoot exposures that last a minute or longer during daylight hours, you'll need some kind of neutral density filter to soak up the light. I use a Lee Big Stopper ND filter that reduces incoming light by a whopping ten stops so, in conjunction with a medium-to-small aperture and low ISO value, it's easy to deploy long exposures.

The sun peeked out below a cloudbank for about 45 seconds, giving the cloud atop the mountain a subtle but nice orange glow. I managed to fire off a half-minute exposure, but as I triggered a subsequent one, the light had gone once more, for good this time. As the only shot in this sequence with any color, however little, it proved to me that when it comes to sunsets, you have to stay until the show really is over.

TIP When shooting long exposures you have to be very careful not to wobble the camera. Tripods help, but you still need to be aware of any movement in your surroundings. This image was photographed from a marsh covered with thick, springy heather that moved every time anyone took even a small step. In more urban environments, passing traffic or other people can cause a wobble, so be aware and always magnify the image afterward to check for errors in case you need to reshoot.

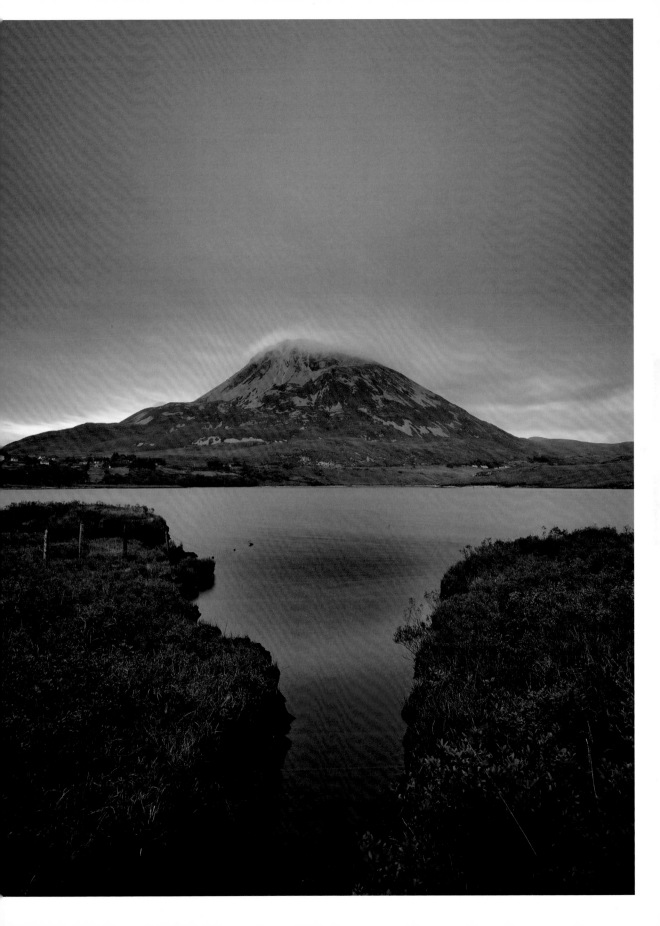

The last night in Manhattan

EXIF Data

📷 Sony α7S Mark II

🎞 Sony FE 55mm *f*/1.8

◁ 55mm

⚙ *f*/8

● 4 seconds

⊠ 0 EV

ISO 100

◉ Vivid

New York has many wonderful views, but by far my favorite is that from the observation deck of the Rockefeller Center, appropriately named The Top of The Rock. Here, you'll enjoy wonderful outdoor views of Manhattan, from Central Park to the iconic Empire State Building, and there's no better time to shoot than the "Blue Hour" following sunset. Heading up here has become a tradition for the last night of my visits to New York, but coming away with successful photos requires a little planning.

The first thing to figure out is your timing (see the Tip below). From there, the second issue is a technical one: The Top of The Rock staff are happy for you to photograph to your heart's content up there, but they do not allow full-sized tripods, as they'd simply get in the way of the crowds. If you're shooting during daytime, this isn't an issue, but at night it can be a problem, especially if you don't have a camera with great stabilization or want to avoid high sensitivities for the best quality.

The trick in such situations is to find somewhere to balance your camera. In this case, there were ledges around the top floor with uninterrupted views. I've used Gorillapods, tabletop tripods, or even simply my beanie hat as a stand, and if you don't have a cable release or remote control app, simply use the self-timer to trigger the exposure without incurring any wobbles.

I shot this image with the Sony α7S Mark II and FE 55mm *f*/1.8 lens, closed to *f*/8 for the best quality. At ISO 100, this required an exposure of four seconds and I made it with the camera balanced on my hat. The view also lends itself well to multi-frame panoramas (remember to use the same exposure in Manual for each frame and select a set white balance) or a time-lapse image showing the day turn to night and the lights flickering to life (using Auto to adjust the exposure for the varying light conditions over time).

TIP The Top of The Rock sells tickets with a strict time window of entry, so the first step is choosing one that will get you up to the observation deck in time for sunset. This is normally one of the most popular times, so I'd recommend buying your ticket online at least one day before. Allow about 45 minutes to get through security, watch the presentation, and queue for the lift. So, if sunset during your visit is at, say, 6:00pm, you really want a ticket that lets you in at around 5:15pm.

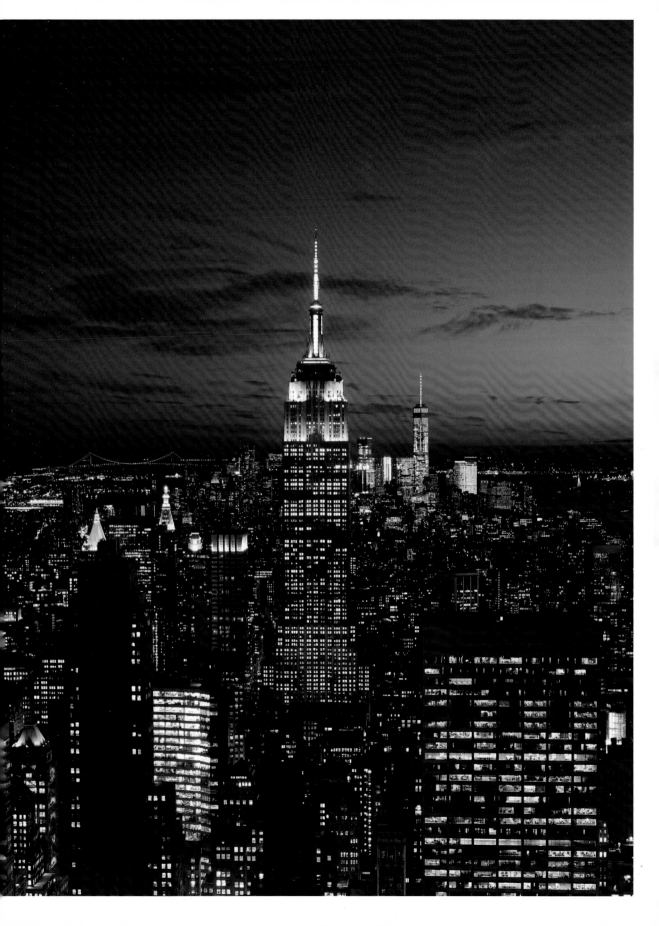

The Chelsea chill

EXIF Data

📷 Fujifilm X-T1

🎞 Fujinon XF 10–24mm *f*/4

◁ 24mm (36mm equivalent)

⬡ *f*/6.4

● 1/200 second

▣ +0.3 EV

ISO ISO 800

◉ Monochrome

Throughout this book, you'll find me referring to a casual bucket list of subjects I've wanted to capture on my travels. One of those is a snowy scene in New York, but until recently the weather had never cooperated by providing a convenient snow shower during any of my visits. During my last trip, however, I awoke to a short but strong blizzard so I headed out to try and find a suitable scene.

Actually, I'll be perfectly honest and share that my trip out that day already had two objectives: My ultimate destination was the B&H camera superstore to buy a spare battery, and I planned to stop off en route to try Intelligentsia coffee in the High Line Hotel on 10th Avenue. This route took me through the up-market Chelsea neighborhood, which looked wonderful in its fresh coating of snow. Sure, it would have looked even better with additional snow on the ground, but the lining on the branches of trees and iron railings came close to the look I was after.

I took the image featured here on West 22nd Street, just beyond the junction with 10th Avenue, and with Clement Clarke Moor Park on the right-hand side, just behind me. I set my camera to its high-contrast Monochrome mode to deliver a punchy black-and-white image, which while clichéd, always looks nice for an urban snowy scene. I framed up the street with the lamp on the left and waited for people to walk toward me. I don't claim to be a street photographer, but I feel a shot like this benefits from someone to give it context. Ideally, they'd look like James Dean, huddling against the cold with a long coat and a cigarette, but even in New York this isn't guaranteed. I waited as long as I could, but with my battery depleting quickly and a flight impending, I took a few bursts and moved on.

TIP Cold is the enemy of batteries; it saps their power more quickly than normal temperatures do. As such, it's always advisable to keep a spare battery at hand when shooting in cold conditions. If the worst happens and you run out of power without a spare on hand, try removing the battery and warming it in your hands or inside your coat for a few minutes. This sometimes releases enough power for a few extra shots. Ironically, this happened to me on this very day as I was heading to B&H to buy another spare, but by warming the battery, I managed to eek out a little extra power to capture this image.

The old town

EXIF Data

📷 Fujifilm X-Pro2

🎞 Fujinon XF 10–24mm *f*/4

◁ 24mm (36mm equivalent)

◐ *f*/10

● 20 seconds

⊠ 0 EV

ISO ISO 200

Ⓕ Provia and crop

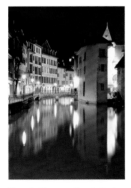

Here's the version I shot at night from the same position a couple of days earlier. I normally prefer night shots, but the lighting looked too artificial here.

When visiting cities in Europe, I'm always drawn to the old areas of the town with their ancient buildings, winding streets and, if you're lucky, a handy canal or river for a nice reflection. This is Annecy at the foot of the Alps in southeast France, a city famous for its lake and surrounding mountains, but which also has a pretty old-town area to rival the best.

There are some lovely views from the numerous bridges in town, normally including a mountain glimpse to put their elevated location in context. This is my favorite (non-lake) view in Annecy, and I always stop by for a snap whenever I'm in town. It paid off this time, too.

I always wanted to shoot this scene at night as a long exposure and got my first chance to do so prior to a weekend in the snow one Easter, but the result just didn't do it for me. The combination of gaudy lighting and a surprisingly shallow canal made the view look artificial, almost like a Las Vegas Casino.

Disappointed, I took the chance to return at the end of the weekend, arriving a little earlier for sunset, and while there was no color in the sky at that time, there was a brief glimpse of direct light for literally one minute. Luckily, I already had my camera setup on a tiny tabletop tripod poking under the railings of the bridge with my Lee Big Stopper Neutral-density filter fitted.

I'd been shooting for about ten minutes when the clouds briefly opened behind me, allowing a few shafts of sunlight to peek through the winding streets and provide the buildings in front of me with welcome illumination. I managed to fire off a pair of 20-second exposures before the clouds closed once more. Many passersby missed the moment. I was lucky to be setup and ready, but again it was simply a case of revisiting a location to maximize my chances of favorable conditions.

TIP I think there are some photographers who rarely revisit a location once they're happy with an image, but I often return to my favorites and shoot them again and again, mostly in case I'm luckier with the light or have better quality gear with me, but also because I simply enjoy the process. It's like greeting an old friend. Familiarity with a location or subject also allows you to get to work quickly and be ready for brief, but favorable conditions, such as I met with here. I always try to visit a mix of old and new locations when traveling.

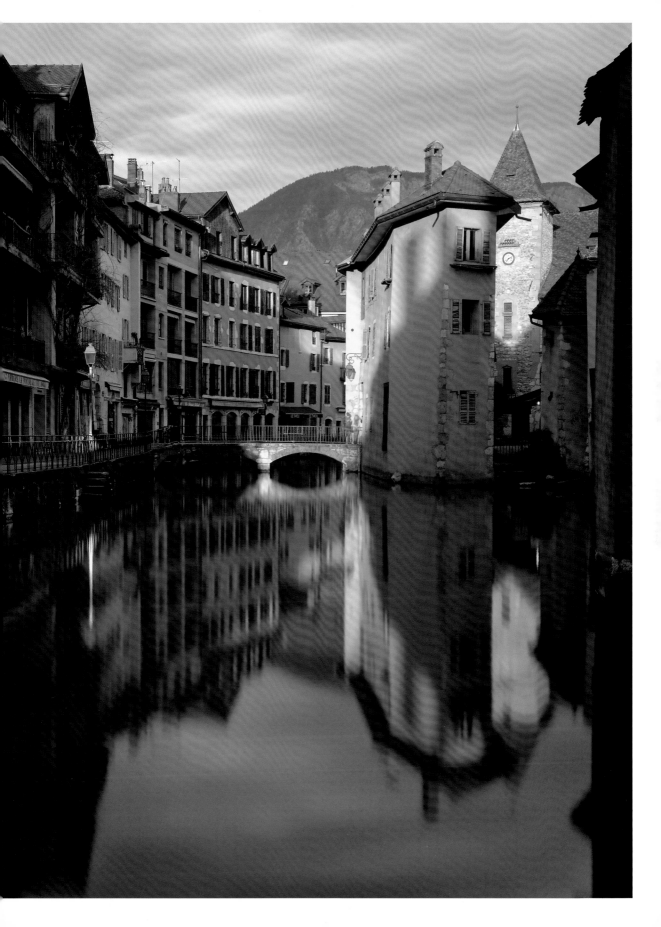

The organ pipes

EXIF Data

📷 Olympus OM-D EM-5

🎞 Samyang 7.5mm Fisheye

◁ 180° diagonal field of view

⟳ ƒ/4

● 1/8 second

▨ 0 EV

ISO ISO 400

◑ Natural

I love the work of Catalan Modernist architect Antoni Gaudí, which makes Barcelona one of my favorite cities in the world. During a highly enjoyable week in the city, I made a pilgrimage to his big three: the Park Güell, La Pedrera (Casa Milà), and of course La Sagrada Familia, the cathedral — no, basilica — which has been a work in progress since 1882 and has at least a couple of decades to go. These are the organ pipes.

Wow. What can you say about this place with its unique style that combines classic Gothic architecture with striking Modernism? It's not to everyone's taste, but I adore it and always ensure I make a visit every time I'm in Barcelona. While I inevitably end up taking similar compositions each time, I always try and improve on my technique and this is my third attempt at the organ pipes.

I reckon the best approach for La Sagrada Familia is to either go tight into the details with a telephoto or try and capture the drama with your widest lens. The latter was my favorite approach for the organ pipes, getting close and pointing straight up their length. I used a Samyang 7.5mm ƒ/3.5 fisheye on my Olympus OM-D EM-5 body.

Fisheye lenses capture a huge field of view by distorting the scene heavily; the effect can often be off-putting, but here I felt it worked with what were already highly curved, organic shapes. I also took an ultra-wide version with the 7–14mm, which looked similar other than a smaller field of view.

The biggest challenge for me here was symmetry. I used the camera's on-screen gridlines to position the central line straight along the middle pipe and through the lights above, but was frustrated to find it didn't then intersect the stained glass window at the top. I spent ages adjusting and readjusting before realizing nothing is straight or perfectly symmetrical here, so you have to make a choice and stick with it.

TIP Many European cathedrals ban the use of tripods, making it a challenge to capture a clean image in low light. Here, I used the combination of a forgivingly wide lens with the built-in stabilization of the Olympus body to handhold a modest exposure at a fairly low sensitivity of ISO 400. At other times, I've balanced the camera on my backpack or even on the floor and used a Wi-Fi connection with my phone to compose and capture the image — the ultimate articulated screen. At other times though, you simply have to increase the ISO until you reach the shutter speed you need to successfully handhold a sharp image.

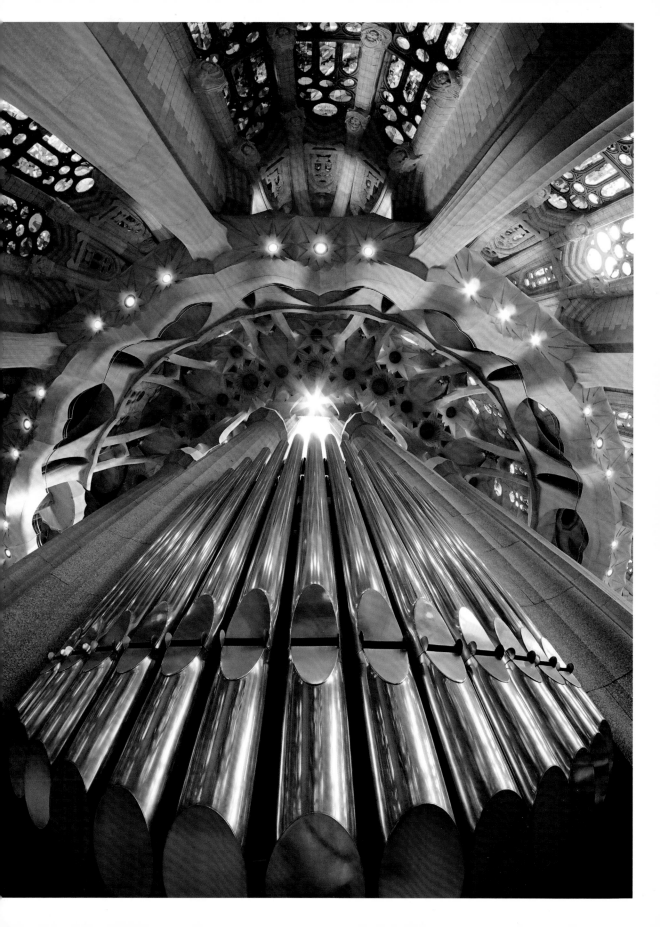

The palm tree

EXIF Data

📷 Fujifilm X-Pro2

🎞 Fujinon XF 10–24mm *f*/4

◁ 10mm (15mm equivalent)

⬡ *f*/4

⬤ 1/7 second

▣ 0 EV

ISO 1600

Velvia

Miami's Ocean Drive was somewhere I'd always wanted to visit — all those wonderful art deco hotels restored to their former glory and looking fabulous against the vibrant light. As I discovered though, it was harder to capture the architectural photos I'd pictured in my mind. Sure, there were glimpses of the buildings, but a great deal was obscured either by awnings over the outdoor seating or a line of parked vehicles. It was proving hard to get a flavor of the place.

By getting close to the Breakwater Hotel with an ultra-wide lens, I managed to bag one of the famous buildings (see The Miami vice on page 146), but another, the Colony Hotel, was proving more elusive. From the opposite side of the street, the entire lower portion was obscured by modern cars and the omnipresent awnings. Getting close didn't help either, as there weren't any of the gaps I'd enjoyed at the Breakwater Hotel.

Frustrated, I tried a view from the side, but again found it obscured. As I angled my camera around in vain, I finally did notice a rather good-looking palm tree that nicely contrasted against the dark sky and seemed to enter the frame in a jaunty manner. I tilted the camera straight upward for a more abstract approach and noticed the Colony Hotel and the building alongside entered the opposite end of the frame. Now I was getting somewhere. I shuffled sideways until I was between the two buildings and tilted back until they were square on with the frame. A little fine-tuning later and I'd positioned the palm tree on the opposite side. I've only captured a peek of the Colony Hotel in the lower right corner, but I like the juxtaposition of organic and angular here. Not what I was initially after, but I like it nonetheless.

TIP When you've chosen to visit a particular location to see something specific, it's hard not to become focused on capturing that subject as best you can. Just like focusing solely on the sun as it sets, you might be missing a great show in the sky behind you. The moral here is to always keep an open mind to notice other possible subjects, angles, or approaches when the primary goal fails for whatever reason (see The moody cove on page 154 for another example). Even if you do capture the shot you want, still look out for other views. Some of my favorite shots have been unexpected opportunities instead of — or in addition to — the sight I originally set out to capture.

The parliament building

EXIF Data

📷 Sony α7R Mark II

🎞 Sony FE 70–200mm *f*/4G OSS

◁ 150mm

⚙ *f*/16

⬤ 13 seconds

▣ – 0.7 EV

ISO 50

◉ Standard

Here's the wonderful-looking Parliament building in Budapest, Hungary, built in the late 1800s in the Gothic style. I took this shortly after sunset with the Sony α7R Mark II and FE 70–200mm *f*/4G OSS at 150mm. It's a 13-second exposure at ISO 50 and *f*/16.

I took the shot from one of the many bridges crossing the Danube with a long exposure in mind to help blur the water. Unfortunately, my ND filters didn't fit this lens, so my only choice for a long exposure was to close the aperture down small and choose the smallest ISO value. I could have gone for *f*/22, but I've found the difference in softness through diffraction is significant, so *f*/16 was as small as I wanted to go. This resulted in a 13-second exposure, which isn't as long as I'd have liked, but was long enough to smooth out some of the water's surface.

The bigger problem, though, was stability. When you shoot from bridges, you must be aware of the impact of traffic, motorized and pedestrian alike. Each can wobble the platform and blur your image whether you're using a tripod or not. The trick then is to find a position on the bridge that isn't as susceptible to wobbling. In some cases, there aren't any until you get to the far ends, but in many designs, there are two or more towers midway through that are rooted to the ground. I positioned myself at one of them and found I could deploy exposures as long as 30 seconds without issue. As is often the case, I didn't use a tripod; I simply balanced the camera on the thick stone ledge and used the self-timer to trigger the exposure.

I should add, many of Sony's cameras support downloadable apps to extend their capabilities. One such app is called Touchless Shutter, which uses the viewfinder detector to trigger an exposure without the need for a cable release or smartphone connection. It also works well for long exposures, as a wave can start and end an exposure in Bulb mode.

TIP Before leaving any location, I always briefly review my photos for technical errors. I'll use the screen or viewfinder to magnify the image and check for focusing accuracy or any camera shake. An image may look great when viewed in its entirety on screen, but looking closer can reveal issues. It's also worth inspecting the histogram view to check the range of tones, especially at night when it's easy to be fooled by a relatively bright screen. If the histogram graph shows the tonal range bunched up on the left side, try a longer exposure to extend the range. Ultimately, if you find errors when you're still at the location, you've got a chance to reshoot a better version.

EXIF Data

📷 Fujifilm X-Pro2

🎞 Fujinon XF 100–400mm
f/4.5–5.6

◁ 190mm (255mm equivalent)

◎ f/11

● 1/125 second

▣ 0 EV

ISO ISO 200

◉ Provia

The racing car

When it comes to shooting sports, the natural impulse is to freeze the action. This is certainly the best approach for situations when you can see the expression of the athlete or capture their body in an unusual or dramatic pose, but freezing the action can deliver an emotionless result in other situations, particularly with motorsports. Unless the vehicle has momentarily leapt off the ground or is dramatically banking as it corners, it may look strangely static in a photo, especially with a car that essentially looks the same on the ground whether parked or driving at 200mph.

Rather than freezing the action, you really want to get across the feeling of speed. One of the most popular techniques to achieve this is with a sharp subject against a blurred background — not blurred through a shallow depth of field, but through sheer motion. The trick is to pan the camera as the vehicle goes past and take the photo while you're panning. If the shutter speed is slow enough, you'll blur the background with the panning action while, crucially, keeping the subject sufficiently still in the frame for it to be sharp. Meanwhile, the slower shutter will also allow the wheels to blur, again lending the impression of speed and motion to your final result.

The perfect shutter speed depends on a number of factors, including subject distance and focal length, not to mention how accurately you can maintain the subject's position in the frame during the exposure. Slower shutters will deliver greater blurring, but also a greater risk of the subject moving and blurring, too. The trick is to refine your panning technique and experiment with different shutter speeds.

I use Shutter Priority with Auto ISO and start relatively fast at around 1/500 to ensure I have some shots that will definitely be sharp, then gradually slow it down. In this particular case, the slowest I could manage was 1/125 with a focal length equivalent to 255mm. If you're closer with a shorter lens, you should be able to manage much slower speeds.

TIP Professional sports photographers always try to capture poses with at least "one and a half eyes" visible and I feel this equally applies to cars where I want to see at least some of the second headlamp. This means timing your bursts to capture the vehicle while it's still at least slightly face on, as I feel the impact reduces when viewed from the side, and even more from the rear. As for the panning technique, just practice and practice, taking as many shots as possible to maximize your chances. Some pros also suggest panning with your waist rather than your arms for a smoother result.

The return visit

I believe in second chances, and this represents two: my second trip to Bruges (in recent times) and my second night in a row at this very location. Last time I was here, it was steadily drizzling and I was the only one foolish enough to be trying to take a photo. The result that night was pleasant enough but was plagued by orange light pollution bouncing off the rain clouds (see The medieval city on page 144). Since Bruges is only one hour's drive from Calais though, I knew I'd almost certainly get a second chance to shoot it under hopefully better conditions, and here it is.

I'd like to say this is a secret spot I stumbled across on a backstreet, but I'd be lying. You're looking at one of the most popular views in one of the most popular tourist towns in Belgium. I may have been alone when I visited last time in the rain, but on this clear night I was surrounded by a constant stream of tourists all grabbing the same photo.

I actually returned to this spot on two consecutive nights during this trip, giving me the chance to deploy different techniques. On the first night, I used a selection of filters: an ND to extend the exposure and a hard-graduated filter to darken the upper half in relation to the reflection. Since no boats disturb the canals at night in Bruges, the surface didn't need an epic exposure length to become fully smooth. Plus, the graduated filter ended up darkening the buildings too much.

On the second night I went filter-free, and even with almost identical conditions, ended up with a better-looking result. The water was sufficiently smooth with a 20-second exposure and the composition benefitted from the buildings being brighter than their reflection. I also closed the aperture to $f/16$ to generate a spike on the bright floodlight on the left side. I selected the Velvia preset to saturate the colors. As always with the "Blue Hour," keep taking photos until it gets dark and you'll find one that has the perfect balance between the illumination in the sky and on the buildings. It's well worth waiting until the show's over.

EXIF Data

- Fujifilm X-Pro2
- Fujinon XF 10–24mm $f/4$
- 14mm (21mm equivalent)
- $f/16$
- 20 seconds
- 0 EV
- ISO 200
- Velvia

Here's the X-Pro2, sadly without an L-bracket, on location. Even shot with a phone, the scene looks lovely at this time of day.

TIP In the lower corners of the image, you'll see boats moored for the night along wooden platforms used for boarding. These platforms don't float and are sufficiently steady for you to shoot a long exposure from, although to access them at night you'll need to hop over a closed gate. At the end of the platform on the right side, there's a clear view of the Bell Tower, which works well in a portrait/tall orientation. Technically though, you shouldn't be there at night, so proceed at your own risk.

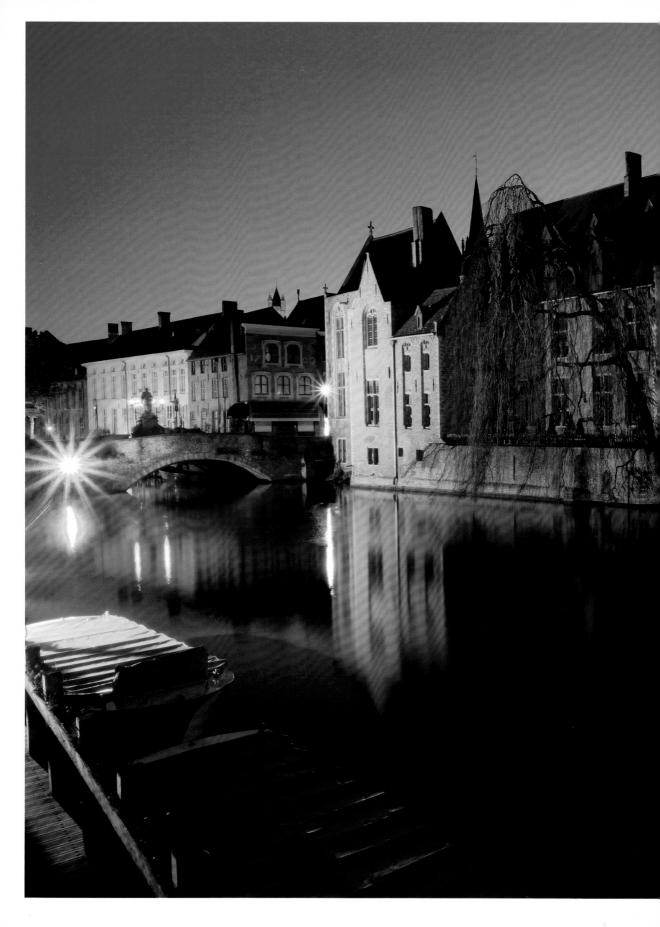

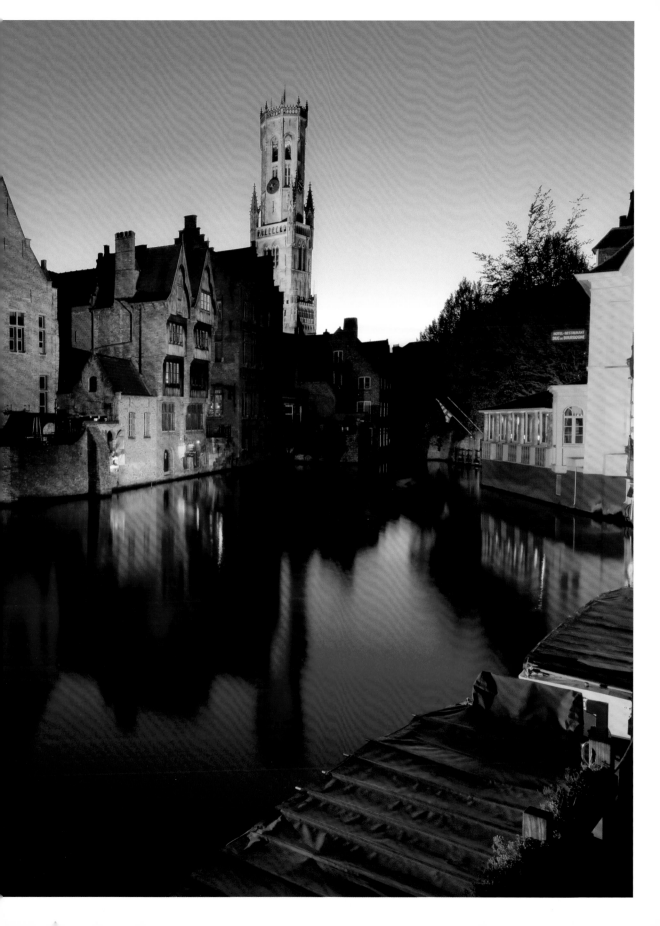

The city's veins

EXIF Data

📷 Olympus OM-D EM-5

🎞 Panasonic/Leica 25mm
f/1.4

◁ 25mm (50mm equivalent)

◈ f/4

● 1.6 seconds

🔲 0 EV

ISO ISO 200

◉ Natural

I don't think I'm alone in believing the best elevated view of Chicago is from the observation deck of the Hancock Tower, so that's what you're looking at here. I realize my composition doesn't include the Sears Tower, another Chicago icon just off-frame to the right, but I found the roads converged more neatly when I was framed more to the left with a 50mm equivalent focal length.

On the advice of local photo guide and all-around nice guy Chris Smith, I headed up to the deck shortly after 5:00pm to coincide with the sunset in late October. There are few things I enjoy more than devoting a couple of hours to just sitting and watching the scene change at this time of day. Some photographers chase the final moments as the sun sets, casting an egg-yolk orange light on the scene, but (to stay with the egg analogy) I enjoy the whole omelet, especially immediately following sunset when there are still some warm colors on the horizon mixed with the blue above, before darkness (and often light pollution) becomes dominant.

That's when I took this photo. When I look through my shots taken that evening, or indeed from any other sunset sequence, I inevitably find them gradually reaching a peak before dipping back down again, and for me this was the optimal time. There's no challenge to the timing; just keep taking photos for the entire period and you'll find a winner nestled in there.

The real challenge was shooting through windows as, infuriatingly, there's no exterior access on the Hancock deck, not even a teeny hole to poke your lens out of. This means you need to be painfully aware of reflections from internal lights, of which there are plenty in the Hancock viewing area.

Another challenge as daylight dwindles is capturing long exposures. Luckily, the Hancock staff seem absolutely fine with tripods, at least my small one anyway, so I set it up and extended one leg a little longer so the lens was leaning against the window. I lost a few shots to people knocking the window, but again when you're shooting for two hours solid you'll have plenty of potential keepers.

TIP As mentioned in The East River write-up on page 102, my best advice for shooting through windows is to eliminate any gap between your lens and the window's surface. An easy way to do this is to press the lens right up against the glass, at which point a lens hood helps with the contact. Unless you're lucky enough to find an ideal composition square onto the glass though, you'll inevitably need to angle the camera a little, which in turn opens up gaps for light to get in. To combat this, shield the gaps with your hands, a hat, a scarf—anything! Just make sure there aren't any gaps or you will find reflections in your photo.

The commercial curve

EXIF Data

📷 Olympus OM-D EM-5

🎞 M.Zuiko 75mm *f*/1.8

◁ 75mm (150mm equivalent)

◎ *f*/4

● 1/2000 second

▣ 0

ISO 200

◎ Natural

Shooting abstract shapes is one of my favorite photographic endeavors, cropping in tightly on a subject until the sky, horizon, or any other reference points are eliminated and I'm left with simple patterns. I don't mind if they're natural or manmade, I just love the initial brain tease when you're figuring out what it is you're looking at, not to mention the scale.

Of course, if you're a fan of American architecture, the game is already up. You're looking at a section of the famous Aqua Tower in Chicago. During a trip to the Windy City in 2013, I met up with a bunch of local photographers and we gradually edged our ad hoc photo walk in the direction of the Aqua Tower; I asked if they could take me to the building with the wavy balconies. They obliged and we arrived late on a wintery afternoon as the sun was already descending behind the towering city.

A large portion of the tower was still brightly illuminated by the sunset, but other areas had already fallen behind the shadows of neighboring buildings. The stark difference between them would have made for a messy-looking shot, but I wasn't too concerned initially as I knew I'd be going for a tighter view, concentrating on the curves. As I started trying out different compositions, however, I noticed the shadows creeping across the building faster than I thought. My choices were becoming limited, so I had to act fast.

I mounted my longest lens onto my Olympus OM-D EM-5—the M.Zuiko 75mm *f*/1.8, which delivers a 150mm equivalent field of view for a medium telephoto shot. I was happy to use this lens, as it's one of the sharpest in the Micro Four Thirds catalog, ensuring crisp details from corner to corner, which is exactly what I want in an architectural shot. I took this image at *f*/4, where I've found the lens to perform at its best, although it isn't half bad even set wide open. Moments later, the shadow crossed this portion of the building and it was game over.

TIP I quickly scanned the surface of the building, searching for interesting patterns. If there's no horizon, you can get away with rotating the camera too, and I'd encourage you to do that, as some lines only come to life when crossing the frame at an angle. After a few twists and turns I found the shapes I was looking for and snapped the shot.

The compulsory sunrise

EXIF Data

📷 Sony α6300

🎞 Sony FE 70–200mm *f*/4 G OSS

◁ 200mm (300mm equivalent)

◑ *f*/5.6

● 1/1000 second

▨ 0 EV

ISO ISO 100

◉ Natural

If there's one thing I remember about taking up photography as a kid in the 1970s, it was the almost constant mantra of "Don't shoot into the sun!" Doing so was considered a mortal sin, I assume as much due to the optical challenge of a bright light shining directly into your lens as much as any potential safety hazard.

To be fair, both are valid concerns. Shooting into any bright light will cause an inevitable reduction in contrast along with an increase in flares and internal reflections, while pointing any unprotected instrument directly at the sun runs the risk of damage to it and your eyes, but that's not to say you shouldn't shoot directly into the sun. You just have to do so carefully.

One of the safest times to shoot directly into the sun is just before sunset or just after sunrise when the disc is very low in the sky. The light is passing through more of the atmosphere, which in turn soaks up a great deal of its brightness, even more so if the surroundings are foggy or polluted. Don't underestimate the sun though; it can still be very bright, and I'd suggest minimizing the time you point your camera and eyes at it, particularly if you're shooting with an optical viewfinder.

I'm not a morning person, so this is a rare sunrise shot from me, taken over the Atlantic Ocean from Miami Beach. Shooting a sunrise or sunset over water always provides the bonus of reflections, but for me it's still all about the sky, so I choose my focal length based on how much of it looks good. If the display is huge I'll go wide, but in many cases there's only a brief strip of interest immediately above the horizon, in which case I go in tight with a telephoto lens and enjoy the extra size of the solar disc.

The sun and moon share the same apparent size in the sky, and due to their brightness, are actually a lot smaller than they look. This image was taken at an equivalent of 300mm and you'd still fit eight of them across the short side of the image.

TIP The extreme brightness of the sun can fool metering systems into under- or overexposing the image, so when shooting sunrises or sunsets, I frequently adjust the compensation dial until the colors in the clouds look good, typically an underexposure of –1 EV, or even more in some situations. If the clouds need a boost in color, increase the saturation or choose a vivid picture mode. Here I was lucky, as the clouds dominated enough of the scene for the camera to meter them correctly and there was enough color for no further enhancement — another straight-out-of-the-camera shot without intervention!

The deep forest

EXIF Data

📷 Sony α7R Mark II

🎞 Sony FE 28mm $f/2$

◁ 28mm

⚙ $f/8$

⬤ 1/4 second

⚡ 0 EV

ISO ISO 800

☁ Cloudy White Balance

I do like a good evergreen forest photo. All those tall, straight trunks and that muted green lighting from the canopy above... there's something very soothing about it. I took this during a very pleasant hike to Bledne Skaly Rock Formations in Poland, a park I can highly recommend if you're in the region (also see The rock formation on page 186).

For me, a shot of a forest like this is about the position and density of the trees as well as the actual color. In terms of the trees, I always look for a good trunk to use as my primary "hero" subject and I think about where it works best in the frame. Here, I've gone for a fairly predictable position according to the Rule of Thirds. I then edged sideways back and forth to ensure it didn't block or conflict with the nearest trees behind it. I would have liked to see the entire bottom of the trunk, but my versions that included it weren't as sharp.

Next, I wanted the trunks to be perfectly straight vertical lines so I carefully angled the camera to be squared up with them, using the on-screen gridlines as a guide to ensure they were all as parallel to the edges of the frame as possible. While there is a main hero subject, I wanted as much as possible near and far to be in focus as well, so I chose an $f/$number in Aperture Priority to achieve this. I went for $f/8$, which for a 28mm equivalent lens was just about sufficient if I focused slightly behind the nearest tree. I could have done with $f/11$ to be safe, but I wouldn't have been able to handhold the shot.

Finally, and most importantly, comes the color. To accentuate the greens, I always shoot forests with my white balance set to Cloudy and the style set to a vivid mode to boost the saturation. I find the combination delivers a pleasant effect, especially on overcast days.

TIP Light levels in forests can be surprisingly low, forcing you to use higher sensitivities and slower shutters than you might expect. Here, thanks to the fairly small $f/8$ aperture, the camera metered a slow shutter of ¼ second at ISO 800. With a medium-resolution camera, a wide lens, and good stabilization, you should be able to handhold such a shot, but to be sure, look out for somewhere you can brace yourself or balance the camera. Here, in the absence of a tripod or ledge, I had the camera pressed against the trunk of another tree. Careful technique was essential, as I was shooting with the unforgivingly high resolution of the Sony α7R Mark II.

The desert ripple

EXIF Data

📷 Panasonic Lumix GX1

🎞 Panasonic/Leica 45mm f/2.8

◁ 45mm (90mm equivalent)

⚙ f/4

⬤ 1/500 second

⚡ −0.33 EV

ISO ISO 160

◉ Standard

During a very enjoyable trip to Morocco, I hoped to capture several photos of sand dunes. I'd rented a car in Marrakech and spent several days exploring the varied towns and the countryside on my way to Merzouga on the edge of the Sahara desert where I'd pick up an overnight camel trek I'd previously booked with Auberge du Sud.

I used every opportunity, day and night, to capture the photos I was after, but quickly realized that a pristine stretch of dune is hard to come by; most within range of any accommodations and tours were inevitably marred by footprints from people and camels, and tracks from quad bikes and 4WDs. You might also hike up a dune hoping to enjoy a peaceful scene over the ridge only to find a hundred tourists waiting for the sun to rise or set. It would seem the only way to avoid — or at least minimize — this is to arrange a private tour or head-off in your own 4WD.

With my plans fixed for this particular trip though, I simply had to work with what I had and forget about the big, expansive landscape views. Luckily, I discovered the abstract shots I was after could be achieved with longer lenses on smaller stretches. You'll see one of them on page 188 (The sand dune), but here I unexpectedly deployed an even tighter approach.

After the crowds and their footprints, the second thing I noticed was that the surface of the sand dunes was marked with fascinating patterns created by the wind. Gears slowly turned in my sunburned head until I figured out how I could solve observation one by exploiting observation two. Yep, a macro close-up shot.

For this image, I got about 20cm from the surface of the sand with a Panasonic GX1 and a Leica 45mm macro lens, opened the aperture to f/4 (as the maximum f/2.8 delivered a depth of field that was a little too shallow for this composition), and focused on the bottom of the frame. The tight horizontal framing avoided any tourists while the shallow depth of field ensured that any footprints and other imperfections in the background were rendered effectively invisible. Meanwhile, I captured the mysterious wavy lines wandering into the distance. As is often the case, I visited this location hoping to capture a particular shot, but ended up being most pleased with something completely different.

TIP The two sand dune photos I've included in this book were both taken with a short telephoto lens, equivalent to 90mm. This surprised me, as I assumed I'd be shooting large, expansive views with an ultra-wide, but the tourists, vehicles, tracks, and footprints put that idea to rest. Instead, I managed to avoid the unwanted extras by shooting much tighter views with a longer lens. The moral is to always be flexible with your approach and be willing to try different techniques and gear.

The Simpson's hut

EXIF Data

📷 Fujifilm X-Pro2

🎞 Fujinon XF 10–24mm ƒ/4

◁ 10mm (15mm equivalent)

⬡ ƒ/9

● 1/220 second

▣ 0 EV

ISO 200 ISO

◉ Velvia

When the lifeguard huts of Miami Beach were wiped out by Hurricane Andrew in 1992, the city saw it as an opportunity to replace them with something new. Today, the 35 strikingly designed lifeguard stands spread between 87th Street and South Pointe have become new icons of Miami Beach, joining the art deco hotels of Ocean Drive.

I'm the first to admit I'm not a beach person, but these huts placed at regular intervals really are like catnip to a photographer, particularly on a sunny day when the colors really pop. This one, on 24th Street, is by far my favorite and a relatively new addition to the rest. It was actually unveiled toward the end of February 2016, only a few weeks before I visited the city.

The stand was designed by architect William Lane, who was also responsible for a number of the others. He saw an opportunity to make them more playful, although they do, of course, still have to function as stands for lifeguards. From the side, its spiked star-like design reminded me of the cartoon character Lisa Simpson.

When I first saw this hut, it was the color as much as the shape that caught my eye. The colors stand out at any time of day, but particularly so under the orange light of the setting sun. I had to act fast as the evening shadows slowly crept up the structure. For dramatic effect, I shot this with an ultra-wide lens from close range and positioned the natural horizon roughly across the middle of the frame to minimize geometric distortion. While the colors were already vibrant, I decided to go large and select the camera's Vivid profile, for even greater saturation. It's unapologetically full on!

Here is a different view of a nearby hut, taken from the rear and looking out to sea. I love the perspective of an ultra-wide when including the sky.

TIP The lifeguard stands responded well to a variety of approaches, one of my favorites being from directly behind with an expanse of beach, sea, and sky in the background (left). Ultra-wide angles provided the right drama, whether close up to focus on the structure or a little farther back to include more of the surrounding scenery. If you are shooting close, be careful not to capture your own shadow against the building and think about whether you want people in the shot or not for scale and context.

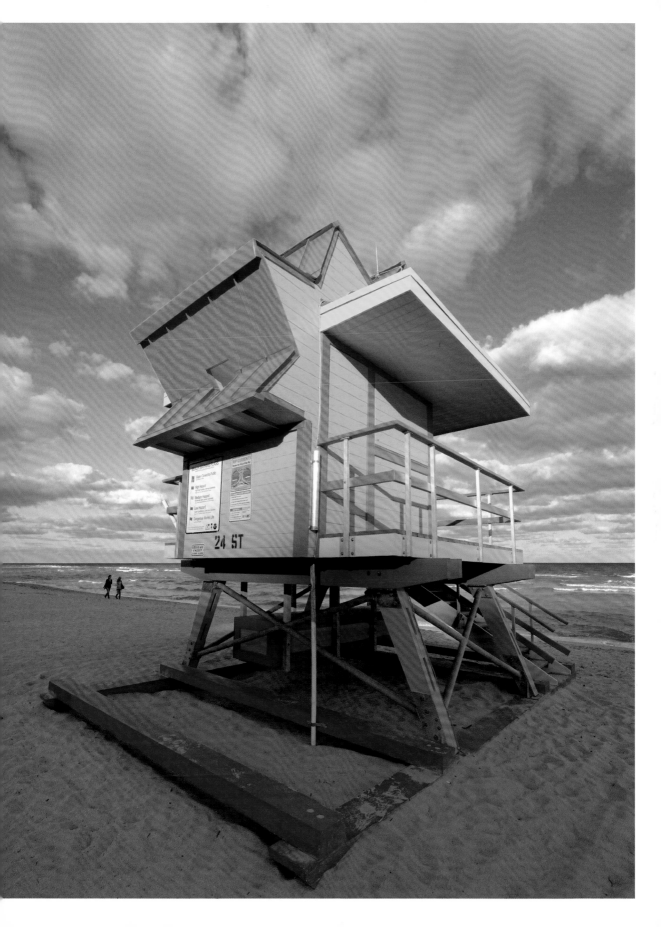

The slot canyon

EXIF Data

📷 Panasonic Lumix GX1

🎞 Lumix G 7–14mm *f*/4

◁ 14mm (28mm equivalent)

⚙ *f*/10

⬤ 0.8 seconds

▣ +1 EV

ISO ISO 160

◉ Daylight white balance

Antelope Canyon, near the town of Page, Arizona, is a famous slot canyon carved by flashfloods that have exposed beautifully colored rock walls with grooved surfaces. The canyon itself is a narrow passageway about two stories deep and around a couple of meters wide. In places, you have to squeeze yourself through, but unlike caving there's rarely a feeling of claustrophobia. If you can climb down some narrow stairs, you'll have no problem paying a visit.

There are actually two Antelope Canyons: Upper and Lower, located on opposite sides of a main road. Upper Antelope Canyon is widely regarded to have better sunbeams, and as such is the more crowded of the two. To be honest, though, I find the beams a little contrived or even cheesy. I personally prefer to avoid the sky, ground, and sunbeams altogether and instead focus on the beautiful, abstract swirly patterns, and colors of the rock formations. I don't even want it to be immediately obvious which way up the image should be.

Photographically, the canyons benefit from ultra wide-angle shots. They can be dusty too, so you don't want to be swapping lenses down there. Shoot with small apertures for a nice, large depth of field. Thankfully, the subject matter won't be greatly affected by diffraction, so feel free to use *f*/11 or *f*/16 without fear. Small apertures and low-light levels will, however, result in long exposures, typically of at least a few seconds if you're using the lowest ISOs for the best quality. You may get away with a handheld wide shot of around a second if you have great image stabilization, but I'd still recommend a tripod if possible.

This shows a different view in the same canyon using the similar idea of avoiding the sky and ground for an abstract effect. I don't go chasing light beams!

I shot this with a Panasonic Lumix GX1 fitted with the Lumix 7–14mm, which delivers a 14–28mm equivalent range. I had it zoomed to 14mm for a 28mm equivalent view here, closed the aperture to *f*/10, and exposed for 0.8 seconds at ISO 160, which is the base sensitivity of the GX1. I also set the white balance to Daylight to prevent the camera from compensating for the dominant colors.

TIP For safety reasons, both canyons are now only accessible by tours in groups of around 20 people, leaving every 15 minutes or so. When I visited, there was also a self-guiding photographer's permit, although it's up to the ticket office whether or not they deem you and your equipment as sufficiently "professional." On a previous visit with a medium-format film camera, I had no problem; this time with a smaller mirrorless camera, I was rejected! I of course complained, and while I still wasn't granted a permit, I was offered a private tour for the same price as a group option, which effectively worked out the same.

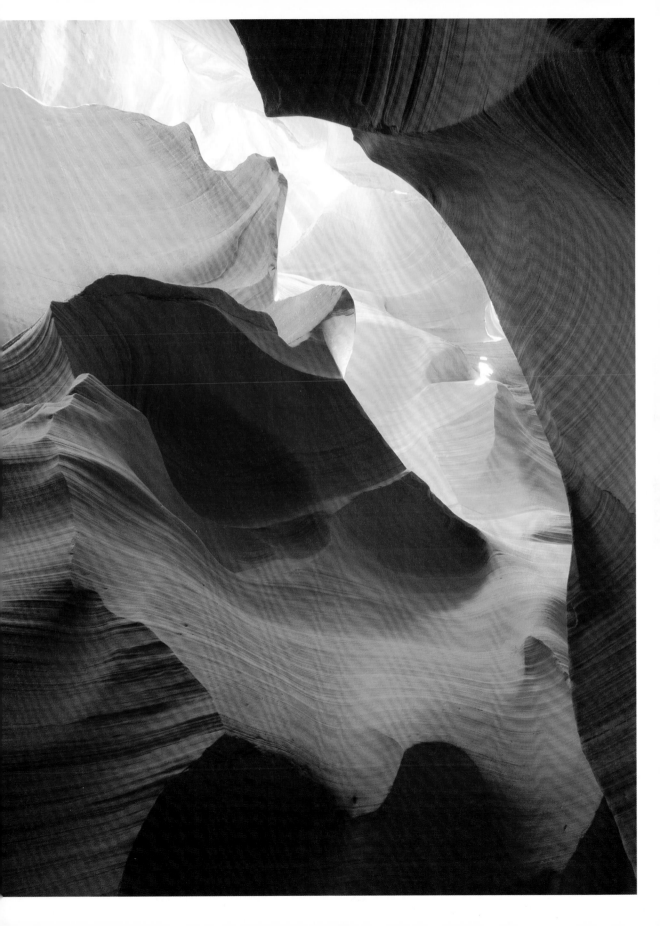

The cocktail

EXIF Data

📷 Olympus OM-D EM-1

🎞 Panasonic/Leica 25mm
 f/1.4

◁ 25mm (50mm equivalent)

○ f/1.4

● 1/80 second

▣ 0 EV

ISO ISO 200

◐ Natural

I may be a confirmed beer drinker, but who doesn't like a cocktail from time to time? They're always so appealing to look at with their bright colors and exotic glasses. When it comes to photographing cocktails, I think showing the drink in the context of the surroundings is very important, as it's all part of the experience. Whether at the beach, by the pool, or at a nice bar, I want to see it.

This particular drink, a gin-tini, was served at the Seven Stars in Brighton, an attractively decorated pub with a gorgeous copper bar top. Shooting drinks at the bar is a popular technique as it gives the impression that they could be for you, along with the promise of an enjoyable time ahead. I feel it's more inclusive than shooting at a table where you may feel you're intruding on someone else's party.

I chose a curved section of the bar to create a line that naturally leads your eye to the subject and also divides the frame in an appealing manner. Meanwhile, for a nice background, I shot toward some lights in the distance that I knew could be turned into attractive out-of-focus blobs by opening up the lens aperture. Doing so also better isolated the subject and let it stand out.

These are fairly standard compositional techniques, but the copper bar also presented an opportunity for a reflection. The trick with reflections is to adjust your position back and forth and, importantly, up and down until you get the desired effect. It was particularly tricky here as I wanted to capture the full glass in the reflection for symmetry, but I couldn't angle the camera too far down as I'd lose the desired background composition. In the end I shot from quite a low angle, almost square-on to the glass and used a viewfinder gridline to ensure the stem and its reflection were vertical.

I used my Olympus OM-D EM-1 fitted with the Panasonic/Leica 25mm f/1.4 for a natural 50mm field of view. This lens is great for blurring backgrounds when you select a small f/number, and here I went wide open at f/1.4. I used Aperture Priority to select the desired f/number, but left the camera to work out the rest as it does a good job with metering.

TIP Blurring the background is a popular photographic technique to help the main subject stand out. This technique employs a shallow depth of field and the potential for it becomes greater on lenses with large apertures (indicated by small f/numbers) and at longer focal lengths or closer distances. If you're shooting with non-telephoto lenses, you really need a lens with an f/number of 2.8 or smaller to achieve much blurring.

The coffee cup

EXIF Data

📷 Fujifilm X-T1

🎞 Fujinon XF 35mm *f*/2

◁ 35mm (53mm equivalent)

⟳ *f*/2

● 1/110 second

▣ 0 EV

ISO ISO 400

◉ Provia

A wide angle gives a different perspective to your coffee shot, allowing you to capture the surroundings of the café. Be sure to keep an eye on potential distractions in the background though.

I love coffee, and my home town of Brighton is blessed with more cafés per head than anywhere else in the UK. Many of them serve excellent coffee, but my favorite is Bond Street, named after the street on which it's located. Its coffee, sourced from Horsham Roasters, is not just delicious, but a lovingly crafted thing of beauty. Predictably, I'm writing this while sitting in their window, where with a complete lack of coincidence, I took this photo.

The rise of Instagram has seen food and drink photography become one of the most popular genres of current times and it's fair to say a large proportion of these images are of coffee. So, only half-jokingly, I think it's useful for any photographer to have a few techniques in mind when presented with a fine cup.

As I've mentioned elsewhere in this book, I normally like to show food and drink in the surroundings of the café or restaurant that serves it, but this can present a challenge with coffee. If you shoot at too low an angle to include the surroundings, you'll end up with a boring side-on view of the cup. If you want to see the top of the drink to show off any "latte art" from expert baristas, you'll need to be shooting at a fairly high angle, looking down, but doing so will make it hard to show much of the surroundings; indeed, you'll inevitably be pointing toward the floor.

In this scenario, I try to make a feature of the table, positioning the cup near a corner so the point can be used to cut across the frame or draw the viewer toward the main subject. If the corner is at the bottom of the frame it can lend some drama to the composition, and if it's at the top of the frame you should be able to include some of the café behind it. Since I post lots of coffee photos, I've played with the concept here by placing it on a thick wooden-backed menu I used as the point on the frame. I also like the contrast of natural textures in the material and the wooden table. I used a large aperture (small *f*/number) for a shallow depth-of-field effect.

TIP I believe food and drink always look best when illuminated by natural light, so I look for tables by windows and avoid those lit by colored bulbs. I also avoid any processing effects, as we're very attuned to judging food by its color, so anything too saturated or too faded looks artificial and unappetizing. While I love natural light, I generally avoid direct sunlight on food and drink as the harsh shadows rarely work well. That said, a long shadow at sunset or sunrise can look good on a cup or a condiment jar.

The colored doors

EXIF Data

📷 Fujifilm X-T1

🎞 Fujinon XF 10–24mm *f*/4

◁ 14mm (21mm equivalent)

⬡ *f*/8

● 1/60 second

⊠ 0 EV

ISO ISO 400

◉ Velvia

This is a simple tale of color and geometry at close range. You'll find these brightly colored doors on Hope Street in Liverpool, which coincidentally connects the two main cathedrals pictured in The northern crown (see page 164) and The cathedral floor (see page 38). Every time I'm in Liverpool, I take photos of the two cathedrals and walk down this street between them, and every time I'm drawn to these colored doors. There's something irresistible about them.

This photo is obviously primarily about color, and to make it pop, I chose to shoot using one of the camera's vivid profiles, which boost saturation. On the Fujifilm X-T1 I used here, it's the Velvia film simulation. Even with the dominant color theme, however, this image is about more than color.

As you'll know from elsewhere in this book, I always try and avoid skewed lines slightly rotated subjects. I try my hardest to keep everything nice and square, but in this instance it proved quite a challenge. For a perfectly square image I needed to shoot the doors face-on with the camera held at roughly the height of the letterboxes, half way up the frame. To shoot from this height without anything getting in my way, I needed to take the picture at fairly close range. Any further back and I'd be in the gutter, lower down, and dealing with tightly parked cars. Beyond there, I'd have a constant stream of traffic to deal with. So, I got close enough to avoid the vehicles and pedestrians, which in turn meant shooting pretty wide to actually squeeze the subject in. I ended up using around 21mm equivalent.

When you shoot wide from close range, it's easy to suffer from converging lines. I wanted the vertical lines to be parallel with the edges of the frame, so I adjusted the camera carefully using the on-screen grid as a guide. Even very minor adjustments can have a big impact in this scenario. I also composed the shot to include some redundant pavement at the bottom, which could be cropped when presented on Instagram in a squarer format.

TIP You'll notice there's no direct sunlight in this shot. I've taken it on several occasions in a variety of conditions and prefer the flat lighting of an overcast day without any distracting shadows or bright streaks. This may seem in contrast to many landscape shots, which benefit from the shadows generated by a sunny day, but there are plenty of situations and subjects when flat, diffused lighting is actually preferable. Most famously, it's the preferred lighting for outdoor portraits, again to avoid harsh shadows (not to mention keeping your subject from squinting at the bright light).

EXIF Data

📷 Sony α7R Mark II

🎞 Sony FE 28mm *f*/2

◁ 28mm

◎ *f*/8

● 1/60 second

🔲 0 EV

🔳 ISO 400

🎞 Standard

Szimpla Kert was so packed with photo opportunities that I did nothing more than turn around from the spiral staircase for this view. It was a target-rich environment indeed!

The ruined pub

The "ruin pubs" of Budapest in Hungary are said to have started in the early 2000s as places to go for an affordable drink in the capital, but they have since become major tourist destinations. The idea was simple: Take abandoned or ruined buildings and turn them into a bar. Fill a hotchpotch of rooms with an eclectic array of furniture and decoration, then sit back and enjoy the view.

If it were in London or New York, it could easily become hopelessly trendy, but the reality of ruined pubs in Budapest is that they're for everyone — young and old, tourists and locals alike — and thanks to their often spacious interiors with many interconnected rooms, it's easy to find somewhere to get away from the bustle if that's your thing. Plus, if you're not into drinking or the growing popularity of "ruin pub crawls," many run farmers markets during the day where you can try local produce and snacks.

Ruin pubs are a photographer's dream, with an endless array of interesting interiors to shoot. I spent several hours just wandering around the most famous of them, Szimpla Kert, snapping photos around every corner. I was particularly drawn to this spiral staircase and found a nice angle looking down from an elevated position, using the camera's flip-out screen to compose with it held overhead. I fitted a standard wide-angle 28mm-equivalent lens, then shuffled back and forth, using the on-screen gridlines to keep the composition square and centered, then waited for people to climb up.

I like this simple shot as the person walks into the frame. Her face is hidden, so you could imagine it was someone in your group or even yourself. This is what I look for in a travel photo — something slightly unusual with a human element I can connect to.

TIP I love shooting in Live View with articulated screens. Most obviously, they let you compose comfortably at high or low angles, and in this instance, they made it easy to frame the shot with the camera held high overhead. Shooting with a camera held away from your face is also a discreet way of capturing street photography, as most people don't tend to notice you taking photos unless you're looking through a viewfinder. Even if they do, I always find them more at ease; it's less confrontational when a camera isn't hiding your face. You can make eye contact, smile, and make a connection.

The two cities

This is Porto, Portugal at night, taken with the Sony α6000 and FE 70—200mm ƒ/4G OSS lens at 70mm for a 105mm equivalent field of view. It's a 20-second exposure at ƒ/11 and 100 ISO. I took the photo from the end of the Luis Bridge, which spans the Douro River, joining the cities of Porto and Vila Nova de Gaia. The shot is taken from the Gaia end, looking back toward Porto. The fortified wine, Port, is named after the Porto area and is typically stored and aged in barrels on the Vila Nova de Gaia side after being transported down the river from the vineyards of the Duoro Valley.

When crossing the bridge earlier that day, I was struck by how much the view half way across reminded me of one of my favorite photos from the Rialto Bridge in Venice — the way the water snaked past beautiful old buildings (see The money shot on page 150). It's interesting how we're drawn to the same shapes and compositions in different locations.

I snapped away at the view in daylight but knew I needed to return in the evening for a night shot. However, once upon the bridge at night, I was buffeted by constant strong winds (it is, after all, 44 meters tall), and it made any long exposures impossible. So, I made my way to the end where the angle may not have been quite as good, but at least I was on solid ground. That said, I still had issues with exposures over 30 seconds, so I stuck below that figure and tried to shield my tripod from the wind with my body.

I took this composition at every aperture to see which rendered the nicest-looking diffraction spikes on bright lights. At ƒ/4 and ƒ/5.6, most of the lights were blobs, but at ƒ/8 small spikes emerged and by ƒ/11 they were looking quite good. Beyond here, my exposures became too long and susceptible to the wind, but I noticed the negative impact of diffraction had kicked in and was impacting the quality. So, ƒ/11 was the sweet spot and that's what I've presented here.

TIP As noted elsewhere in this book, closing the lens aperture down (using larger ƒ/numbers) not only increases the depth of field, but can also render point sources of light as spiked shapes. The number and style of spikes is defined by the shape of the iris, which closes the lens aperture. There are twice the number of spikes as there are aperture blades, so the 18 spikes here indicate nine blades in the Sony FE 70—200mm ƒ/4G lens.

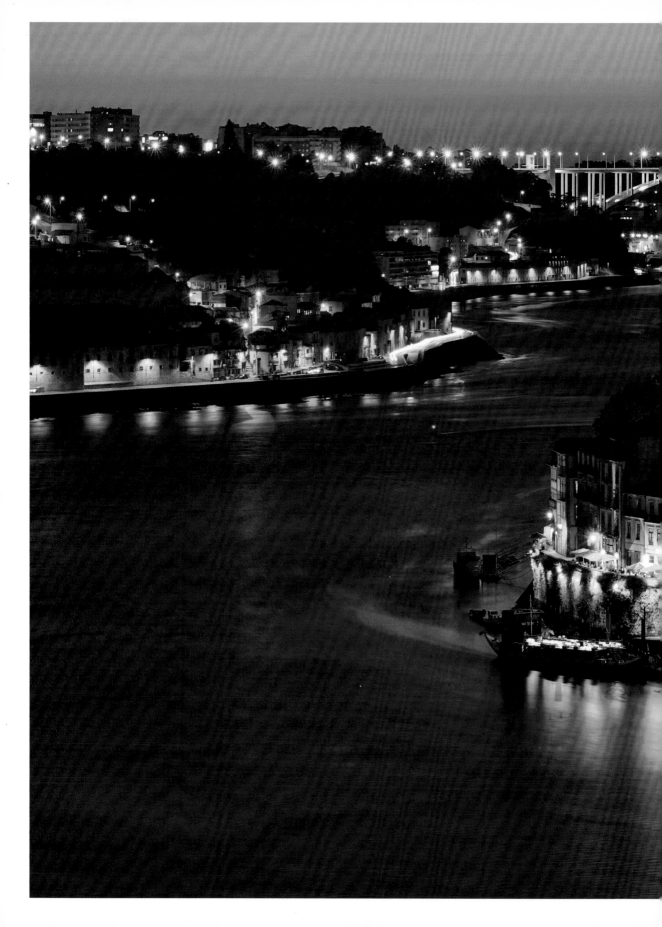

The Dutch tulip

EXIF Data

📷 Olympus OM-D EM-1

🎞 Panasonic Lumix 42.5mm
 f/1.7

◁ 42.5mm (85mm equivalent)

◎ *f*/1.7

● 1/50 second

▣ −0.3 EV

ISO ISO 200

◉ Vivid

I know of few photographers who haven't been seduced by the appeal of macro photography at one time or another. Getting really close to a subject unveils a whole new world to explore, with landscapes and textures that are often alien to more general photography.

When does a close-up become a macro photo? Definitions vary and the term "macro" is often abused when it comes to some cameras and lenses. Arguably, a macro photo is achieved when the camera can reproduce the subject at actual size on the sensor. So, if the subject is 10mm across, then a true macro would reproduce it at 10mm on the sensor. How big it then appears in the image depends on how big the sensor is, but the generally accepted definition is a 1:1 reproduction.

If you really want to reproduce at 1:1, you'll need a specialized macro lens that can focus sufficiently close and deliver the required magnification. That said, you may find the effect you're after is actually much more mild than a true macro.

Consider this tulip, photographed in the amazing Keukenhof Garden just outside Amsterdam in The Netherlands (incidentally, the world's second largest flower garden, only behind the Dubai Miracle Garden). The petals measured about 6cm, which means at 1:1 reproduction I'd only squeeze about half of the entire flower on a full-frame camera and even less on the smaller APSC or Micro Four-Thirds formats. The reproduction you see in this photo is closer to 1:4 on full frame.

The reason I mention this is because this degree of magnification/reproduction is within the realm of many lenses that aren't technically considered true macro models, but for many people, myself included, they may be close enough. I took this with the Lumix 42.5mm *f*/1.7 on my Olympus OM-D EM-1 with the aperture opened wide to the full *f*/1.7 for a shallow depth of field. This lens can focus as close as 31cm, which allowed me to capture the image you see here without cropping or using any specialized equipment.

TIP If you want to isolate the subject against a blurred background, you need a shallow depth of field. To do this, shoot in Aperture-Priority mode and choose the largest aperture for your lens, indicated by the smallest *f*/number. You can accentuate the effect by using longer focal lengths and/or closer focusing distances. The telephoto focal length and close focusing used in this shot, coupled with the *f*/1.7 aperture, easily blurred the background despite it being fairly close to the main subject.

The East River

EXIF Data

📷 Fujifilm X-T1

🎞 Fujinon XF 10–24mm f/4

◁ 20mm (30mm equivalent)

◐ f/5.6

● 1/140 second

▣ 0 EV

ISO ISO 400

◉ Classic Chrome

Here's the view of New York's East River, crossed by the Manhattan and Brooklyn Bridges, from the World Trade Center observation deck. Unlike the original World Trade Center, which offered an outside viewing option, the observation area on the new tower is completely enclosed, which means shooting through glass.

Taking photos through windows can be a challenge, but follow some simple rules and it's possible to achieve good-looking images (also see The City's Veins on page 74). The most important step is to eliminate visible reflections from lights or other bright objects on your side of the glass. To do this, you'll need to get your camera as close as possible to the window, ideally with the lens barrel pressing against it.

Understandably, you may be concerned by the welfare of your lens when doing so, but in almost all cases, the actual glass elements of the lens are positioned comfortably behind the rim of the barrel itself, allowing you to press it up against the window without fear of contact or damage. Obviously, if your lens is one of the exceptions where the front element protrudes beyond the barrel, like an ultra-wide or fisheye, then you'll have to be more careful. An ideal solution is to employ a lens hood, which effectively extends the barrel way beyond the glass, allowing you to press the camera against the window with confidence.

For a perfect fit, you'll want the lens to be perpendicular to the window's surface, which may not yield the best composition. As you angle the camera to improve it, you'll create a gap between the lens and window, allowing reflections to appear. The solution is to try and block the gaps; I often use my hand or beanie hat. Another tip is to wear a dark top to minimize your own potential reflection.

I shot this with a Fujifilm X-T1 and XF 10–24mm using the Classic Chrome profile for muted colors. Often, thick windows will subdue a lot of color or apply a cast, so you may wish to experiment with different profiles or white balance settings to compensate. Alternatively, just ignore color and shoot in black and white. And while it's tempting to always go for a wide view as I've done here, sometimes a telephoto close-up of a building can look great.

TIP When shooting through a window, look out for any marks or smears on the surface and either wipe them clean or adjust your camera's position to avoid them. Shoot at larger apertures for a shallower depth of field, which will help you avoid capturing any of the window itself or having unavoidable marks coming into focus. Here, I shot with an f/4 lens closed to f/5.6 for the best quality, avoiding smaller apertures to prevent imperfections on the window from becoming sharp.

The elevated railway

EXIF Data

📷 Fujifilm X-T1

🎞 Fujinon XF 10–24mm *f*/4

◁ 10mm (15mm equivalent)

⚙ *f*/6.4

⬤ 1/800 second

▣ 0 EV

ISO 200

◉ Provia

The image above shows what happens when you don't shoot square-on to the subject. By tilting up or down even just a little, vertical lines will angle in or out.

During the last day of a trip to New York, I was treated to four seasons of weather in a matter of hours. Luckily, what started as a blizzard ended with clear skies for my flight home!

During my last few hours, I visited the excellent Whitney Museum in the Meatpacking District, which while packed with lovely art on the inside, also has a number of exterior balconies offering superb views of Manhattan and the south end of the Highline Park. I've featured the Highline elsewhere in this book with The neon corridor on page 160 — a tunneled section just beyond the square building on the left side of the frame (actually the Standard Hotel). You can see the former elevated railway line running from the lower right corner of the frame here and passing under the hotel.

Even though it was chilly following the brief snow shower, I couldn't wait to get outside the galleries and capture some crisp views of the city under a thin coating of snow before it melted. I love photographing cities from an elevated position, as it allows you to shoot square-onto some buildings and avoid converging lines. That's what I did here, angling my camera up and down until vertical lines on both sides of the frame were straight. There's still some minor distortion due to using a very wide lens (in this case equivalent to 15mm), but I've taken care to get the view as square as possible.

You will, however, notice that by shooting square to the hotel, there's rather a lot of blue sky above it in the frame. I could angle down, but doing so would ruin the geometry and result in converging lines, as seen in the image left. The solution is to either try and shoot from a different height or embrace what you've got in a different format. I shot this with a square shape in mind, knowing I'd be cropping a large strip from either the top or bottom, so it was off with the spare sky.

TIP While the tall/portrait images in this book are presented in the 4:3 aspect ratio, I frequently shoot with other shapes in mind. In particular, while Instagram now natively allows rectangular images, I still enjoy posting in the original 1:1 square shape. Knowing you're going to crop to a square shape allows you to deploy techniques, angles, or compositions that would otherwise compromise a portion of a wider or taller image. I frequently shoot square to a subject to avoid converging lines and end up with too much sky or ground as a result. But cropping to a square allows you to dispense with the empty section of the frame.

The elevating canal

EXIF Data

📷 Fujifilm X-T1

🎞 Fujinon XF 16mm *f*/1.4

◁ 16mm (24mm equivalent)

🔅 *f*/6.4

⏺ 1/340 second

🔲 0 EV

ⁱˢᵒ ISO 400

◉ Provia

In the 1930s, the Forth & Clyde and Union Canals in Scotland were linked by 11 locks, which took almost a day to navigate. Dismantled in 1933, the two canals remained disconnected until the late 90s when, in 1994, the concept of a boatlift was suggested. Work started in 1998 and was completed in 2002 when the Queen opened the Falkirk Wheel.

The pair of 600-ton gondolas hold half a million liters of water, but by being perfectly balanced, it requires only 1.5kWh of energy to turn. There may still be two locks to navigate, but by eliminating nine of them, the connection between the two canal systems is considerably faster than before.

The Falkirk Wheel, located roughly between Edinburgh and Glasgow, is also a fascinating place to visit with plenty of photo opportunities. I made a quick detour to catch it en route to a photo walk in Glasgow and enjoyed blue skies. As I brewed up an Aeropress with freshly ground coffee (much to the amusement of my fellow photographers), I couldn't help but notice the striking reflection in the still surface of the lake. The lift looks twice as big as it really is with the axis on the water's surface, but the rotation, of course, takes place around the tube, half way up the structure.

There were plenty of good angles on the lift from around the lake with the strong reflection visible, but with a fairly featureless sky I was left with an expanse of blue at the top and reflected at the bottom of the frame. Had their been some nice clouds, it could have looked amazing, but in their absence I needed something else. Luckily, some reeds and grasses came to the rescue, so I moved around the lake's edge until I found a bunch where their shape dipped in the middle to accommodate the structure's reflection.

TIP I've mentioned how the Falkirk Wheel presents a number of nice views around the lake. It's worth a wander up the small hill opposite this photo, which considerately brings you in line with the axis of the wheel. This elevated position provides nice perspective on the structure and the countryside beyond while also increasing your chances of finding a nice-looking sky.

The entrance beckons

EXIF Data

📷 Sony α7R Mark II

🎞 Sony FE 28mm _f_/2

◁ 28mm

⚙ _f_/7.1

⬤ 1/50 second

▣ -0.7 EV

🆔 ISO 800

◉ Monochrome

If you love interesting rock formations and find yourself in central Europe, I'd strongly recommend paying a visit to Adršpach-Teplice Rocks in the Czech Republic near the border with Poland. As you hike through the lovely trails, you'll find some amazing views to photograph, but one of my favorites was this gate, which just looked so mysterious and beckoning.

I chose to shoot this in black and white, not just to increase the moodiness but because it allows you to really see the textures of the rocks. As with all the black-and-white photos in this book, I used the monochrome mode of the camera itself (in this case, a Sony α7R Mark II). To increase the impact a little more, I deliberately underexposed by dialing in -0.7 EV of compensation. I really like the in-camera monochrome modes as they typically do a great job with black-and-white conversions, especially those with optional filter simulations; choosing a red filter effect darkens blue skies, for instance.

Compositionally, I used a standard wide-angle lens equivalent to 28mm and angled it up very slightly from a lower position to increase the drama. The only other challenge was waiting for a break in the almost constant stream of people walking through and posing underneath.

In terms of exposure, I closed the aperture down to _f_/6.4 to ensure everything would be crisp, including the edges of the frame, as the lens in question isn't the sharpest in the box. I then increased the ISO sensitivity to allow me to handhold without camera shake, selecting ISO 800 and a 1/50 shutter speed. That may sound like overkill for a 28mm lens, especially on a body with built-in stabilization, but I find that high-resolution bodies like the Sony α7R Mark II break the one-over-focal-length tradition and demand faster shutters than normal to completely eliminate the effects of camera shake appearing in the final image.

TIP In the main description, I mentioned how I needed faster shutter speeds than normal to handhold sharp results with the α7R Mark II thanks to its very high resolution. This is yet another example of using what you know as a guideline rather than a strict rule, and relearning how to get the best from new equipment. Similarly, when it comes to lens apertures, the old _f_/8 rule for the best quality can actually be detrimental on smaller-format sensors. Always test and retest and adjust your technique accordingly for the equipment in hand.

The Epcot show

EXIF Data

📷 Panasonic Lumix GX1

🎞 Lumix G 7–14mm *f*/4

◁ 12mm (24mm equivalent)

◎ *f*/11

● 4 seconds

⊠ 0 EV

ISO ISO 160

◐ Standard

Fireworks photography is very much like baking; there are very specific rules to follow for the best results. Here's my basic recipe to get you started. First, find a good spot with an unobstructed view of the sky where the action will take place, and preferably where you can avoid knocks and bumps from passersby.

Second, set up your tripod and camera, and frame your shot if you know approximately where the fireworks are going to explode, incorporating any foreground subjects if desired. Third, manually focus your lens on a distant subject and don't touch the focusing from this point; owners of mirrorless cameras beware that when your camera powers down or goes to sleep, it might reset the focus back to infinity, so keep it "awake" during the show with half-presses of the shutter-release button.

Fourth, put your camera into Manual exposure mode and set the sensitivity to the minimum ISO value, the aperture to *f*/8, and the shutter speed to four seconds; these are starting points to be refined during the show. And fifth, when the action kicks off, trigger the shutter with a cable release or two-second self-timer when you hear the rockets being launched; hopefully, they'll explode in your frame while the shutter is open. Then refine and repeat.

Sounds simple right? In some respects, it really is. Obviously, as the show progresses, you may wish to recompose your shot, and you will almost certainly need to make some exposure adjustments, too. This is easy, though; just adjust the aperture for the brightness of the trails and the shutter for their length.

I took this shot during the nightly fireworks display at Epcot Center in Disney World, where for me, a successful composition is all about getting the right position around the edge of the lake. Avoid the surprising number of trees, as they'll get in your way, but don't worry so much about stray light from nearby lampposts; they'll turn them off during the show.

TIP Many cameras apply long exposure noise reduction for shutter speeds of one second or longer. This takes a duplicate exposure afterward, but with no light, in order to generate a reference frame with noise only — this is then subtracted from the first main exposure for a cleaner result. It works, but also delays your chance to take another image. If the photos from your camera look fine without long exposure noise reduction, I'd suggest disabling it for fireworks to enjoy a more responsive experience. That said, I had it enabled here for the cleanest results with this particular camera.

The ethereal creature

EXIF Data

📷 Olympus OM-D EM-1

🎞 M.Zuiko 8mm *f*/1.8 Fisheye

◁ 8mm (16mm equivalent)

✺ *f*/1.8

⬤ 1/25 second

▣ 0 EV

ISO ISO 800

◉ Vivid

For me this giant creature was the star of the Lumiere London festival of light in 2015: a huge balloon/kite hybrid, floating in an ethereal manner above the street of Piccadilly while bemused commuters marched on underneath. When shooting lights at night, it's easy to assume some kind of tripod will be necessary. Refreshingly, the organizers of the event ensured the streets of London and their countless security guards were considerably more tripod-friendly than normal.

For this shoot though, I left my tripod at home. As usual, I was attempting to see far too many things in a short period of time, which meant a breakneck pace around the city and little or no chance to extend any legs for a leisurely shoot. Since I'd be handholding all my photos, I opted to shoot with my Olympus OM-D EM-1, which has excellent built-in stabilization. I also decided to shoot with very wide lenses for a dramatic effect; they are also more forgiving on wobbles.

Back to the creature, it was one of several floating over Piccadilly that evening, expertly flown by performers on the street. They were actually a lot larger and lower than they looked, which meant anyone shooting with standard lenses had to be positioned some way off, shooting up or down the street. I initially tried this approach, but didn't like the distractions of the street below. As I fitted wider lenses and angled upward, I liked how the street itself gradually disappeared and the buildings on either side provided an effective frame.

The effect was further accentuated with a fisheye lens pointed straight up, distorting the buildings on either side into curved frames, while allowing me to capture the entire creature despite it only being a few feet above me. I shot with the screen angled out and took several bursts to maximize my chances of an attractive S shape with the tail surrounded by dark sky, adjusting my position to minimize visible lampposts or overhead cabling. The vertical angle and constant repositioning meant a tripod would have been more of a hindrance than a help here.

TIP Fisheye lenses deliver a unique effect that heavily distorts the image to squeeze a 180° field of view within the frame. Anything toward the edges or corners becomes heavily curved, such as the buildings in this shot, but objects in the middle can look quite natural. With the right subject and careful framing, fisheyes can deliver useful ultra-wide coverage that's typically more affordable than high-quality wide lenses or zooms. I don't use my fisheyes often, but for events like this one, they're the perfect choice.

The fairytale castle

EXIF Data

📷 Olympus OM-D EM-1

🎞 M.Zuiko 7–14mm ƒ/2.8

◁ 7mm (14mm equivalent)

◐ ƒ/4

● 1/640 second

▣ 0 EV

ⓘ ISO 200

◉ HDR 1

This image shows an alternative view of the castle at the corner of the moat, using the ledge as a V-shaped frame. Sometimes it's good to have some foreground interest.

Europe is full of fairytale castles, many of which have been described as inspiration for the famous Disney castles. Here's Castle Bojnice in Slovakia, another contender for that accolade. It's a great-looking specimen, complete with the requisite pointy towers, fancy turrets and, of course, a moat surrounding it.

One look at the castle and I knew I wanted a reflection of it in the moat, but there were several problems. For one thing, the castle was huge and close to the best viewing areas, demanding an ultra-wide lens to fit both it and a reflection into the frame. Second, the sky was much brighter than the reflection, making it impossible to expose for both properly without either a graduated filter or multi-frame HDR shenanigans. And third, it was the middle of the day with flat, uninteresting lighting.

Tackling the third issue first, it would be great to be at every location in time for sunrise or sunset, but most of my travels are done with my family and we inevitably arrive at the sights in the middle of the day for a short period. Unless we're staying overnight, we're normally back on the road long before the shadows lengthen and the sky starts getting interesting. It can be frustrating at times, but you just have to be creative about the conditions you have.

The castle was large and I couldn't step back without losing the reflection, so the only option was to go ultra wide. I shot this with my Olympus OM-D EM-1 and the M.Zuiko 7–14mm ƒ/2.8 at 7mm for a 14mm equivalent field of view. As you can see, even then, it only just squeezed it all in. As always when shooting wide, I was particularly mindful of the angle to ensure the sides were straight.

As for the difference in brightness, I resolved it using the EM-1's built-in HDR mode. I'm not into post-processing, but this result was captured and generated in camera, and while the result is inevitably a little flat, it still allowed me to capture both the castle and its reflection.

TIP High Dynamic Range, or HDR for short, is a technique where several different exposures of the same scene are combined into one. The shorter exposures retain detail in bright areas like the sky, while the longer ones reveal tones previously lost in shadows. Depending on the techniques used to combine them, the result can vary from fairly natural to completely bonkers. I'm not normally a fan, but here I had no choice if I wanted to successfully capture both the castle and its reflection under the conditions of the day. Rather than process the result myself though, I exploited the EM1's built-in HDR mode, which captured and combined three frames in camera using the milder HDR 1 style.

The lucky puddle

EXIF Data

📷 Olympus OM-D EM-5

🎞 M.Zuiko 17mm ƒ/1.8

◁ 17mm (34mm equivalent)

⬡ ƒ/4

⬤ 1/250 second

▣ 0 EV

ISO 400

◉ Natural

When visiting a city, I always try to connect with local photographers who I've met on social networks. It's great to connect in person and to enjoy access to views and locations you may not normally come across! During a visit to Chicago, I arranged to spend a day shooting with Chris Smith, author of a fabulous photo guide to the city and organizer of the "Out Of Chicago" photo walks and conferences.

Chris took me to a number of great locations, but my favorite was this one, looking back toward the city from a quiet construction area near the lake. As fans of long-exposure photography, both of us naturally gravitated toward a large puddle and its lovely reflection of the Hancock Tower and the downtown area. My first instinct would be to deploy a long exposure here with neutral density filters to extend the exposure time and smooth the water's surface, but as we were dealing with a large puddle and not a lake, the water was already very still. Plus, the clear sky had no clouds to blur. What little color remained post-sunset was rapidly disappearing, so I needed to act fast.

Rather than setting up a tripod or getting my feet wet, I leaned over the edge of the puddle and fired off some handheld shots. It was a precarious-looking pose with the camera held out to the side at arm's length and the screen angled around for composition. I was more than a little wobbly and Chris looked on, bemused, but the excellent built-in stabilization of the Olympus OM-D body ironed out the shakes and the flip-out screen allowed me to frame the shot exactly as desired from arm's length. The moral here is to exploit the capabilities of a modern camera to let you adapt to situations and shoot quickly as needed. I grabbed this image in less time than it would have taken to mount my camera on a tripod.

TIP I've said it before and I'll say it again: Puddles are nature's gift to photographers, deploying temporary mirrors randomly across a landscape following a shower. I love their ephemeral nature; they rarely last for long and their reflections bring new views to a scene. So when it rains, don't feel bad. Instead, look forward to exploring the array of new views the post-rain landscape will provide. (Also see The lawmaker's reflection on p134.)

The fire station

EXIF Data

📷 Fujifilm X-T1

🎞 Fujinon XF 10–24mm $f/4$

◁ 10mm (15mm equivalent)

◎ $f/5.6$

● 1/105 second

▣ +0.3 EV

ISO ISO 200

◉ Provia

As you browse through the images in this book, it's fair to say I'm a big fan of wide-angle photography. I love the drama of shooting wide—the sweeping curves, the leading lines, the potential for deliberate distortion. I like the chance to have everything in focus from near to far and the chance to get really close to a subject and have it dominate the frame. It's dynamic and exciting, but there are pitfalls to watch out for.

Most obviously, the perspective of wide-angle lenses means things in the distance appear much smaller and farther away, while those closer elements occupy a much larger portion of the frame. As such, it's critical to find something interesting nearby or you'll end up with a large amount of nothing in the foreground.

While wandering around New York, I was initially drawn to the bright red colors of the 18th Squad Fire Station entrance and truck, thinking how a square composition could work well on Instagram. As I moved away though, I noticed the yellow crest on the road outside, which not only confirmed the location, but also provided useful foreground interest in an ultra-wide composition.

I shot this with my Fujifilm X-T1 and XF 10–24mm at 10mm for a 15mm equivalent field of view, closing the aperture to $f/5.6$ to ensure a sufficient depth of field. The colors were already sufficiently vivid for the standard Provia preset. I then adjusted my position back and forth to include the crest on the road, taking care not to angle the camera up or down to ensure the lines on the wall remained straight.

I should also add that I stood in the middle of a road here, luckily not a busy one, but I was aware of potential traffic at all times. In these situations I prefer to shoot with the screen so my eye is positioned away from the camera, allowing me to be more aware of my surroundings if I need to get out the way.

TIP Most of the images in this book are presented in the tall/portrait orientation, as I personally prefer this shape for most of my compositions, but I always try and capture a horizontal/landscape version too, in case I end up preferring it, or a future project demands this shape. In this instance, it allowed me to include the FD NY initials on either side of the crest, further reinforcing the location. The famous magazine saying goes, "Are you shooting for the spread or the cover?" I say, why not go for both!

The foggy church

EXIF Data

📷 Olympus OM-D EM-1

🎞 M.Zuiko 7–14mm *f*/2.8

◁ 7mm (14mm equivalent)

⬡ *f*/4.5

● 1/1000 second

🔲 +1 EV

ISO ISO 200

◎ Monotone

A serious peasouper had descended as we drove through the small town of Igel shortly after crossing into Germany from Luxembourg. Fog, with its reduced visibility and diffused lighting, may seem like a problem for photography, but it's actually a gift. It can lend a peaceful, mysterious, or even eerie look to a scene, neatly eradicating anything in the distance so that only the nearest subjects are visible.

When faced with fog, I immediately think in black and white since nature has essentially rendered the scene into grayscale already. I look for tones — or lack thereof — bearing in mind that nearby subjects are the only ones that will appear truly dark. To help with the composition, I always switch my camera into a monochrome mode so I can see what I'm going to get. As always, I shoot in RAW+JPEG so that I also have a color version as a backup just in case.

We'd visited Igel to see a famous Roman column, but it was the church atop the hill behind that caught my eye. I'm fond of the architectural style and liked the way the fog had reduced the tonal range of the scene and soaked up any color. I switched my Olympus OM-D EM-1 into its monotone mode and started snapping with the M. Zuiko Digital 7–14mm wide zoom. With large expanses of plain white sky, you can either darken the exposure to make it a moodier gray or brighten it to keep it whiter. I went for the latter, applying +1 EV of exposure compensation.

The other problem with an overcast or foggy sky is you'll end up with a large featureless area at the top of the frame. In these situations, I look out for an overhanging tree to fill the space. Luckily, there were several attractive candidates at the rear of the yard. Since the branches were hanging low though, I had to position the camera barely above the ground in order to prevent them from obstructing the top of the spire. Indeed, I'd have preferred a tad more space between them. That said, I liked the curved shape of the canopy, so I zoomed the lens to its widest 7mm focal length for a 14mm equivalent field of view.

TIP Shooting at low angles is much easier with an articulated screen, and fortunately my OM-D EM-1 has one that can tilt vertically. While this allows me to compose from ground height by simply angling the screen upward, it sadly doesn't have the full articulation required when shooting in the portrait/vertical orientation, so I shot blind here. This is where cameras with fully articulated screens (like that of the OM-D EM-5 II or Lumix G series) score big, as they provide the greatest flexibility.

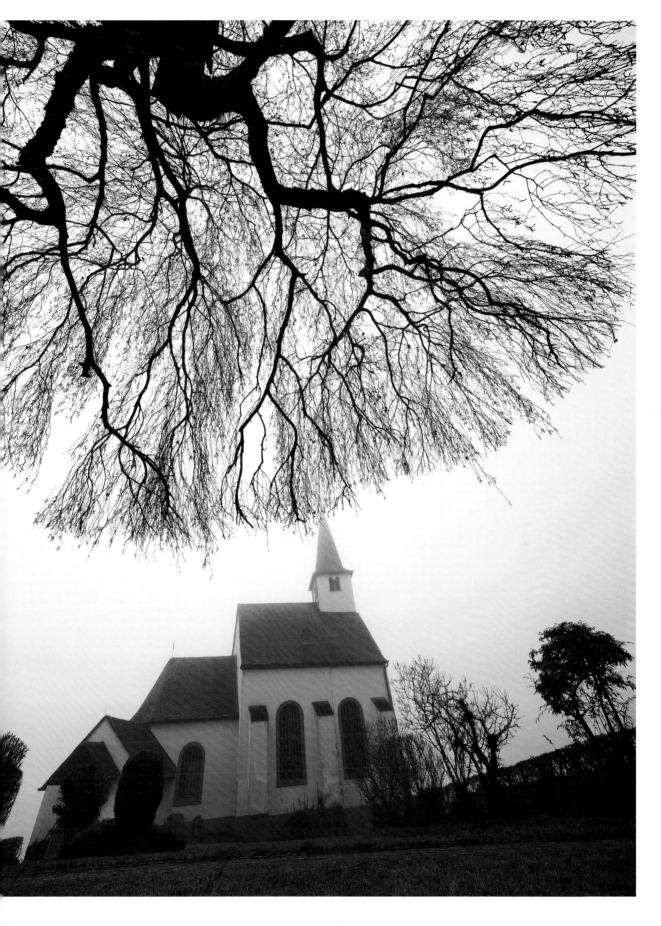

The Giant's Causeway

EXIF Data

📷 Fujifilm X-T1

🎞 Fujinon XF 10–24mm f/4

◁ 15mm (22mm equivalent)

⚙ f/9

● 25 seconds

▣ 0 EV

ISO ISO 200

◉ Provia

Here's my Fujifilm X-T1 on location and mounted via an L-bracket. This lets me shoot in the vertical format without tilting a ball head by 90 degrees.

These are the unmistakable interlocking basalt columns of The Giant's Causeway in Antrim, Northern Ireland. I managed to squeeze in a visit at dawn on my way back to Belfast airport following a photo-walk weekend in Donegal (see The Irish peak on page 54). It was well worth it, with the world-famous location delivering the spectacular views I'd hoped for.

Prior to arriving, I wasn't sure what to expect in terms of other visitors. I feared the rocks would be crawling with tourists, but at 9:00am on a Monday morning, I was pleased to find only a small handful of folks. Coincidentally, there were several long-exposure photographers, and they were actually packing up to leave. These photographers had arrived prior to sunrise when the light was even dimmer, allowing them to deploy exposures of several minutes. For their efforts, it was already game over by the time I arrived.

While I was facing exposures of less than a minute at this point, even with my darkest neutral density filters, my exposures would still be relatively long. Lucky for me, I found myself setting up as the other serious photographers were leaving and before the general tourists arrived. I literally had the entire site to myself for the better part of an hour before the first coach parties turned up.

I took this with my Fujifilm X-T1 and XF 10-24mm zoom set to 15mm for a 22mm equivalent field of view. I composed the shot to include details of the columns in the foreground and adjusted my sideways position so a natural sweep guided the eye to the small peak in the distance. With a base sensitivity of ISO 200 and the aperture closed down to f/9, the camera metered an exposure of around 1/30 second. Slotting my ten-stop Lee Big Stopper ND filter soaked up enough light to extend this to around 25 seconds, allowing the lapping tide to blur into a mysterious steam-like effect. I also added a hard graduated filter to darken the sky.

TIP While I was lucky to avoid crowds of tourists at The Giant's Causeway, I've been in other situations where it's impossible not to include them. Sometimes it's actually fun to feature the human impact on a scene, but if you'd like to minimize their appearance in camera, simply fit a strong neutral density filter for a long exposure. Anything that moves will become blurred and less visible. Someone walking past may even become almost invisible in some situations. At worst, the ghostlike trails of people moving around can provide an ethereal alternative to a shot packed with static humans.

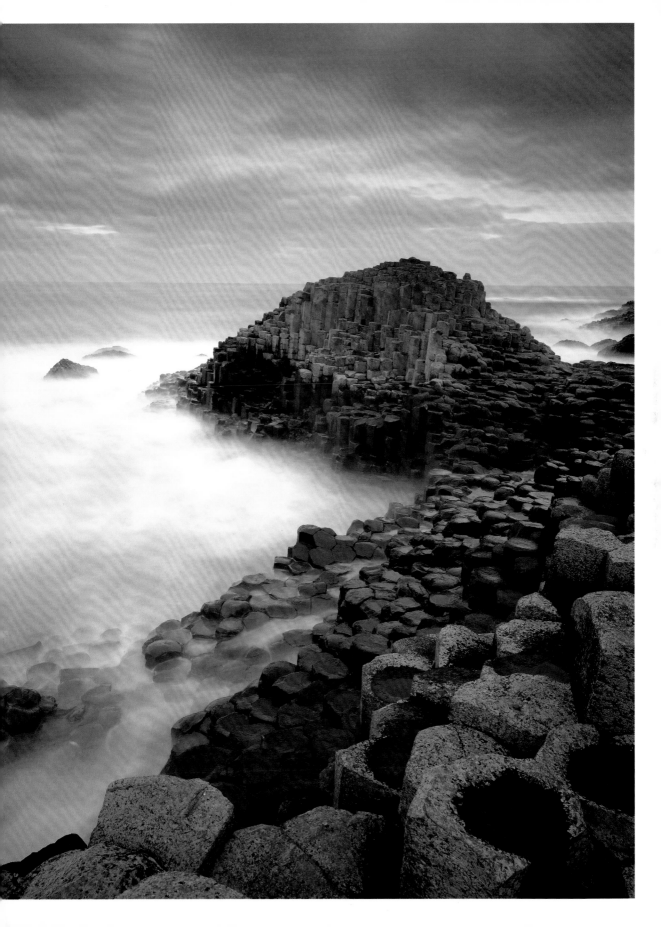

The headlight trails

EXIF Data

📷 Fujifilm X-T1

🎞 Fujinon XF 10–24mm $f/4$

◁ 24mm (36mm equivalent)

◎ $f/14$

● 30 seconds

▣ 0 EV

ISO ISO 100

Ⓥ Velvia

Light painting comes in many forms, but the principal remains the same: opening the camera's shutter for several seconds or more while a source of light moves across the frame, leaving a trail behind it. You can use it to write words or paint patterns in the sky using a torch (see The light painting on page 33), and you can also use it to capture fireworks exploding (see The Epcot show and The shock and awe on pages 110 and 190 respectively).

Another popular light painting subject is the trails of vehicle headlights as they drive along a road at night. It's very easy to achieve, too. You simply put your camera into Manual mode, adjust the exposure time for the length of the trails, and adjust the aperture and ISO sensitivity for the brightness of the trails. Some experimentation will almost certainly be required, but by your second or third attempt you should get a good result.

The first step is to find a good viewing location. I always prefer to shoot headlights from above, looking down on a road, as you'll see multiple streams of light crossing large portions of the frame. If you shoot sideways from street level, you'll end up with a narrow band of trails, which looks a bit odd. I took this from a bridge at High Line Park in New York.

Next, you'll want to experiment with exposures. Set your camera to Manual and try starting with a shutter speed of 15 seconds with an aperture of $f/8$ and a sensitivity of ISO 100. If you don't have a cable release, use the self-timer to trigger the exposure without touching the camera. You'll also probably want to keep the camera steady during the exposure with a tripod or a handy fence. I balanced my camera on my beanie hat on a ledge for the image featured here. An attractive alternative effect embraces the wobbles of a handheld long exposure taken from a moving car.

TIP For longer or shorter trails, use longer or shorter shutter speeds respectively. For brighter trails, open the aperture by using smaller $f/$ numbers or increase the ISO sensitivity. For darker trails, close the aperture or reduce the ISO. Remember, small apertures/large $f/$ numbers also have the benefit of turning point sources of light into starbursts due to diffraction. I also like to include vehicles turning or changing lanes for some curves among the straight lines.

The high key

EXIF Data

📷 Fujifilm X-Pro2

🎞 Fujinon XF 35mm *f*/2

◁ 35mm (53mm equivalent)

⬡ *f*/5.6

⬤ 1/350 second

▣ +3 EV

ⓘ ISO 200

◔ Classic Chrome

Here's the tip of Brighton Pier. I liked the way the funfair and particularly the helter-skelter slide jutted into the sea, but at midday the light was overcast, flat, and predominantly white. In situations like these, I'd normally try and find something to occupy the featureless sky, such as an overhanging branch or a handy rooftop, but in the absence of either I decided to embrace the pale and use a high-key effect.

High key is a photographic technique that pushes tones to the bright end of the spectrum. Already pale features, such as overcast skies, become completely blown out, isolating your subject against ethereal expanses of white. It's another technique for transforming an otherwise ordinary or boring backdrop into something much more mysterious and interesting. What makes it even more appealing is the ease with which you can use it. High key is, at its heart, little more than a deliberate overexposure.

I shot this with the Fujifilm X-Pro2 and XF 35mm *f*/2 for a standard field of view, deliberately positioning the pier in the lower corner so it would be surrounded, even dominated, by the white sky. I then gradually increased the exposure compensation until the sky and, critically, the border between sky and sea became pure white, first using +1 EV, then+2 EV, and finally +3 EV. While black and white often works well for high-key shots, I wanted some muted fairground colors so I chose the Classic Chrome film simulation, which does just that on the Fuji cameras.

While the result looked fine on the camera's screen, I noticed some patches of faint blue in the sky when I got home. Luckily the X-Pro2 offers in-camera processing of RAW files, so in playback I simply boosted the brightness a little farther and saved it as a new JPEG — all achieved in camera.

TIP To overexpose your image you need to gather more light than you would for a balanced exposure. If you're shooting in Manual, simply choose a slower shutter speed, a larger aperture (smaller *f*/number), or a higher ISO. If you're shooting in Aperture or Shutter Priority, Program, or Auto, use your exposure compensation control, indicted by a +/-EV. Selecting positive compensation will overexpose the image, making it brighter; +1EV represents double, +2EV double exposure again. Smaller increments are also possible, typically in thirds.

The Manhattan sunset

EXIF Data

📷 Fujifilm X-T1

🎞 Fujinon XF 10–24mm *f*/4

◁ 16mm (24mm equivalent)

⬡ *f*/7.1

● 180 seconds

⊡ 0 EV

ISO ISO 200

◉ Velvia

Here's my Fujifilm X-T1 on location a little earlier in the evening. Notice the textures and details on the water's surface that are smoothed out in my long exposure.

For me, there's only one place to be in New York at sunset and that's in Brooklyn Bridge Park looking back at Manhattan. There are lots of nice views from the park, but if you walk along until you reach a ramp entering the water just before Pier 2 Roller Rink, you'll find a bunch of wooden posts rising out of the water. These are ideal for creating leading lines toward the buildings in the distance and also perfect for long-exposure photography, as the water splashes around them.

During my latest trip to New York, I inevitably found myself in exactly the same location I shot on my previous trip; I'm nothing if not a creature of habit! My excuse for returning was different equipment and more experience with long-exposure photography compared to the previous visit. A word of warning though: While it's tempting to go beyond the chain across the jetty for the best angle, doing so can get you into trouble with the police or security. For good reason, too, as water levels can increase quickly while you're distracted and you can find yourself with wet feet or gear, especially with the wake from passing boats. Whatever you do, keep your camera bag on your back to avoid unexpected waves from sloshing in; I speak from soggy experience. Bring a flashlight or headlamp too, as by the time you leave it will be dark.

When shooting wide, you really need something close in the foreground, so I opted for a low angle, perched on the nearby rocks so that the closest posts were a decent size on the frame. After that, it was a case of shifting left or right until the posts lined up as desired, directing your gaze toward the buildings. I used my Fujifilm X-T1 and XF 10–24mm at 16mm for a 24mm equivalent field of view. I'd started with my Lee Big Stopper, but as the sky darkened I switched to a less dense three-stop ND filter. After some trial and error, I used Triggertrap to set a three-minute exposure at ISO 200 and *f*/7.1.

TIP Another thing to be aware of is the brightness of the sky versus the lights on the buildings. Annoyingly, the best-looking sky color normally occurs before the building lights go on here, and by the time the buildings are lit, all color from the sky has departed, leaving you with orange light pollution. While some would see this as an ideal opportunity for a composite image, I always like to achieve everything in camera, so timing is crucial. Just keep shooting from sunset as the sky gradually darkens and you'll find an image with the best balance of sky and lights. This was mine.

EXIF Data

📷 Olympus OM-D EM-10 Mark II

🎞 M.Zuiko 17mm *f*/1.8

◁ 17mm (34mm equivalent)

⬡ *f*/4

⬤ 120 seconds

▣ 0 EV

ISO ISO 100

◉ Vivid

Here is the OM-D EM-10 Mark II on location on Brighton beach. You can clearly see on screen the dual impact of the ND filter's colorcast and the Vivid color mode, deepening the blues.

The old pier

Every photographer has a muse and right now, this is mine: Brighton's iconic West Pier, opened in 1866, closed in 1975, and the victim of several fires in 2003. Today, only the skeletal structure of the outer pavilion remains, isolated in the sea just beyond the beach, with sections gradually collapsing during stormy weather. Meanwhile, several pillars that previously supported the walkway remain on the beach, jutting into the sky.

Some consider it an eyesore, but I adore the West Pier with its recognizable silhouette against the skyline, enhancing photos from near or far. It's perfectly placed for sunsets, but for me it really comes to life afterward during the "Blue Hour" when long exposures satisfyingly smooth the waves and blur passing clouds.

When the tide is very low, it's possible to walk out beyond the pillars and photograph the pier in isolation, but most of the time several posts will be submerged in front. So, often a composition involves working out how to place the pier relative to them. Here, I've gone for a central shot, framing the pier with the outermost pillars on either side, although annoyingly, their relative positions prevent a perfectly symmetrical arrangement. Sometimes it's easier to just position the pier to one side.

I shot this with the Olympus OM-D EM-10 Mark II fitted with my 17mm *f*/1.8 lens for a mild wide view equivalent to 34mm. I closed it to *f*/4 for the best quality across the frame. To smooth out the water, I wanted an exposure of around two minutes, but even with the sensitivity reduced to ISO 100, the camera metered 15 seconds. To extend this to 120 seconds, I fitted my three-stop ND filter from Lee. To darken the sky relative to the sea, I also slotted in a hard-graduated filter. In the absence of a filter, I could have simply closed the aperture by three more stops to *f*/11, but doing so on some Micro Four-Thirds bodies can compromise the sharpness due to diffraction.

TIP When shooting a long exposure image, it's critical to have a stable platform for your camera. Just having a tripod may not be sufficient in some environments. Here, I was positioned on a pebble beach with the waves lapping at my feet—mine and those of the tripod. Each time the waves came in and out, the pebbles would move a little, which could dislodge my tripod's position. The key is to really push those feet down deep and hang a weight (like your camera bag) from under the head or column. If your tripod feet do get wet, be sure to clean them afterward, as the salt water can corrode.

The lawmaker's reflection

EXIF Data

📷	Panasonic Lumix GH4
🎞	Panasonic/Leica 25mm f/1.4
🔊	25mm (50mm equivalent)
◐	f/1.4
●	1/6400 second
▣	0 EV
ISO	ISO 100
◉	Standard

It rained very hard when I was in New York one day in April — really hard, the kind of rain that eventually penetrates every item of clothing — and yet I wasn't unhappy, as I knew once it stopped there'd be loads of little mirrors scattered across Manhattan, providing unique glimpses of the high-rise city by simply looking down.

Just north of Houston Street, I found a series of puddles that looked promising and proceeded to perform the photographer's maneuver that always gets attention. You see, in order to get a nice reflection, you normally need to get down very low, literally skimming the surface of the water with your lens barrel. In your mind you're a dynamic and exciting artist, wrangling the best from the conditions, but to everyone else you're a crazy person lying on the floor getting wet and dirty for no apparent reason. The upside is, most folks will steer well clear of you.

In situations like these, I love mirrorless cameras with fully articulated screens. I can shoot in Live View using the screen and flip it out to a convenient angle where it's facing up even though the camera's facing forward. If I were shooting with an optical viewfinder or a fixed screen, I would have been lying in the dirt.

I used the Panasonic Lumix GH4 with the Lumix 25mm f/1.4 lens, which on a Micro Four-Thirds body delivers a 50mm equivalent focal length. I opened the aperture to f/1.4 in Aperture Priority for a shallow depth of field, focused on the background, and waited for something interesting to walk or drive past. I captured a few shoppers and a couple of classic yellow cabs, but the image that most caught my eye was a police car. Crucially for a travel photo, the car is labeled NYPD so you're in no doubt where the photo was taken. Since I was focused on the background at f/1.4, the car is a little soft and the curb is obviously quite out of focus, but these add up to giving the image the toy-like tilt effect I wanted.

TIP Puddles are a gift to photographers. Not only do they put a well-needed positive spin on the preceding miserable conditions, but they also deliver reflections in areas where you wouldn't normally see any. Try varying your distance, angle, and height to the puddle for the best results, but be fast, as they can disappear as quickly as they arrived. (Also see The lucky puddle on page 116.)

The London beach

EXIF Data

📷 Fujifilm X-T1

🎞 Fujinon XF 35mm *f*/2

◁ 35mm (53mm equivalent)

⬡ *f*/14

● 26 seconds

▣ 0 EV

ISO ISO 200

◉ Provia

London is famous for many things, but a beach isn't one of them. And yet, during low tides, the River Thames withdraws to reveal a southern bank of sand, pebbles, and... er... other stuff. There are few who'd lay a towel down here for a relaxing stretch or encourage the kids to build a castle with a bucket and spade, but when the river allows it, this meager beach provides an interesting alternative viewpoint for some of the city's famous sights. It's easy to access from the South Bank, too, with several staircases leading down from outside the Oxo Tower and Tate Modern.

I've included the beach here to add some foreground interest to a longish exposure looking north toward the financial district, City of London, with a glimpse of the Tower of London on the right. I took this only a few meters to the west side of Tower Bridge and it's become one of my regular spots to shoot in town, primarily to test the optical quality of lenses, although I like the view, too.

I didn't actually shoot this image from the surface of the beach, though. I'd be a little wary at night, especially with a load of camera gear. I captured this photo from the path along the South Bank where tourists line up for selfies with Tower Bridge behind them. There's a thick, low wall along the length of this section with a ledge that's perfect for balancing a camera, on or off a tripod.

In this instance, I was traveling light and had no tripod with me. As I've done many times before, I balanced the camera on the ledge using my beanie hat for fine tuning. It's not ideal when shooting in the tall/portrait orientation, but with a bit of folding you can support the lens barrel and prevent the camera from leaning down.

I used the Fujifilm X-T1 fitted with the XF 35mm *f*/2 lens here for a standard field of view, and in the absence of any ND filters or cable releases with me, closed the aperture to *f*/14 to get close to the maximum standard shutter speed. At the base sensitivity of ISO 200, the X-T1 metered 26 seconds, which is enough to blur the water a little, while the small aperture rendered bright points of light into diffraction spikes. I used a self-timer to trigger the shot.

TIP Balancing a camera on your hat on a ledge can work but it isn't the most ideal way of making an image. When I'm not carrying my full tripod, I do always try and pack a tabletop stand of some sort. For a long time I used a Gorillapod, but I recently switched to a Feisol TT15—a small but sturdy carbon-fiber stand with legs that can angle almost horizontally for very low perspectives. You can screw a ball head on if you like, but I mostly mount the camera directly to the legs or use a quick-release mount and L-bracket if I'm shooting in portrait orientation.

The festive street

EXIF Data

📷 Olympus OM-D EM-1

📷 M. Zuiko 8mm *f*/1.8 fisheye

◁ 8mm (16mm equivalent)

⚙ *f*/2

● 1/10 second

▣ 0 EV

ISO ISO 400

◉ Vivid

Here's Ganton Street, just off Carnaby Street in London, all dressed up for the Lumiere London event, which lit up the capital in early 2016. It's one of three images in this book from what turned out to be a very productive evening (see also The rainbow birdcage on page 180 and The ethereal creature on page 112). I'm certainly looking out for future Lumiere events.

When shooting architectural spectacles, I always like to go with wide-angle lenses. Not only do they simply pack a great deal into the frame, but their exaggerated perspective and geometric distortion further enhances the drama. No lens does this more than a fisheye, which uses deliberate distortion to squeeze a 180° field of view into the frame.

The effect can be extreme, especially if you angle the camera up or down, with previously straight buildings and lines transformed into banana-like curves. As such, fisheyes are not best suited to everyday photography, but if the subject is already curved or surreal in some regard or your intent is to transform an everyday subject into a surreal one, then a fisheye can be just the thing. Revealingly, after hardly using my fisheye for a whole year, I ended up using it more than any other lens that evening at Lumiere London.

Not only did it give the already surreal event a further twist, but also the wide coverage was very forgiving on camera shake, allowing me to handhold all of my nighttime, low-light shots. Here, you can see that the fisheye enabled me to include the lights hanging directly overhead (indeed a little behind me), along with people on the street directly in front. Meanwhile, the distortion has curved the edges of the buildings to form a frame for the lights against the dark night sky.

The lights were gradually glowing in different shades and colors, so once I found a composition I liked, I took several shots in a row to capture the changing lights. I liked this one with the pink and purple cast best and used the Vivid preset to boost the colors further.

TIP When you buy a fisheye lens, it's initially tempting to use it for most of your shots. It's exciting, dramatic, and different, just like using a polarizing filter or some special effect. Like all of these, though, you may eventually grow tired of the effect and find the resulting photos to be simply too much. As such, whenever I find myself smitten with a new effect or technique, I always make sure I also take a standard version of the shot just in case I end up preferring the more conservative treatment later.

The lunar eclipse

EXIF Data

📷 Olympus OM-D EM-1

🎞 Televue Genesis telescope

◁ 540mm (1080mm equivalent)

◇ f/5.4 (fixed)

● 1/10 second

🔲 0 EV

ISO 3200

◐ Daylight white balance

A total lunar eclipse is one of nature's most spectacular displays. My favorite part occurs a minute or two before or after totality when you can expose for this dark shadowy area, revealing the dull red color, while grossly overexposing the sliver that's still illuminated by the sun.

That's what I did for this image during the total lunar eclipse of September 28, 2015. I used an Olympus OM-D EM-1 mounted on my Televue Genesis SDF telescope, using it as a 540mm f/5.4 telephoto lens. The 2x field reduction of the EM-1's sensor effectively doubled the focal length to 1080mm and the image you see here is not cropped. Whatever lens you use, it's best to pre-focus on the moon then switch to Manual focus to prevent any accidental searching. I'd also suggest setting the white balance to Daylight.

As for exposure, the moon will go through a huge range of brightness values during a total eclipse. In the early phases, I recommend shutter speeds of around 1/60 to 1/250 at ISO 100 and f/5.6. Bear in mind that the moon is much brighter than it looks, so ignore your camera's suggested settings or you'll end up with a horribly overexposed, featureless white circle.

As more of the moon is covered in shadow, it will become much darker. In the moments before or following totality, increase the sensitivity to between ISO 800 and 3200 and use exposures of around half a second at f/5.6. If the image is too bright, try a faster shutter speed and a lower ISO, or vice versa. Suffice to say, at this point you should definitely be using a tripod with either a cable release or the self-timer to avoid wobbling the camera as you take the shot.

During totality, you may need exposures of one or even two seconds even at ISO 3200. If you're using a longer lens, the effect of the earth's rotation will begin to come into play. At 500mm, the moon will visibly move a little during a one-second exposure, causing some motion blur. Unless you have a tracking mount, your only option to avoid this is to keep exposures to less than a second or two and simply bump up the ISO until you get the desired brightness.

TIP If you're shooting a lunar eclipse from start to finish, it's a great idea to take photos at regular intervals, say every five minutes, working backward and forward from the time of maximum totality. And of course, squeeze in extra shots on either side of totality. You can then make a nice composite image of several phases of the eclipse. Remember to adjust the exposure to reflect the phase of the eclipse. Oh, and how do you know when and where the next eclipse will take place? Easy! Head to MrEclipse.com, the website of NASA's eclipse expert, Fred Espinak.

The Magic Kingdom

EXIF Data

📷	Panasonic Lumix GX1
	M.Zuiko 45mm ƒ/1.8
◁	45mm (90mm equivalent)
◐	ƒ/8
●	4 seconds
⊡	0 EV
ISO	ISO 160
◑	Daylight white balance

The fireworks show at the Magic Kingdom is arguably the best-known pyrotechnic display in the world and I wanted to capture that scene. Getting it right in real life is surprisingly difficult and hinges on your exact location, so on this page I'll detail the position and leave the exposure tips to my other fireworks tutorials in this book (see pages 110 and 190).

Say what you like about Disney, but this kind of recreation with attention to detail is exactly what the company does best. Every night, the fireworks are triggered with clockwork precision to recreate the famous introduction and you too can enjoy the spectacle, so long as you're in exactly the right place. The fireworks will only appear symmetrical if you're precisely in front of the middle of the castle. Stand to either side of center and they'll appear to explode to one side. Stand too close and the castle will obscure the fireworks; stand too far and they'll explode too far above the castle.

Finding the center line is simple: So long as you're in the middle of Main Street USA, you'll enjoy a non-skewed display. As for the distance, the bridge just beyond Casey's Corner at the end of Main Street USA is pretty spot on. It allows you to look down a little at the castle, and every little bit helps when you're shooting over the heads of a crowd. The ideal focal length for the composition will be around 50–70mm, which is covered by most kit zooms. I shot this with a Lumix GX1 and 45mm ƒ/1.8 for a 90mm equivalent view.

After that, the remaining challenge is the tall person, the bunch of balloons, or the kid on their parent's shoulders standing right in front of you. There's nothing you can do about these, so if it goes wrong, just forget the photo and enjoy the show. It's pure luck of the draw. Remember, it is for kids. A tall tripod may help, so simply repeat the effort as many times as possible during your stay.

I nailed the position and even avoided the tall folks. Then, at the last minute, dense fog rolled in and rendered the entire display almost invisible—a washout in the conventional sense, but the fireworks did illuminate the mist with some eerie and unusual colors, so that's what I have for you here. Best of luck out there!

TIP The streets will be lined with people prior to the firework display, but it's relatively easy to shuffle into the middle of the road after the last parade. Once you've found your ideal spot, extend your tripod and stick to it. The cast members may ask everyone to move forward, but you should stay where you are, and once they see your tripod, they won't give you any trouble. I've also deployed a baby stroller next to my tripod to discourage anyone from standing immediately in front of me!

The medieval city

EXIF Data

📷 Panasonic Lumix G6

🎞 Lumix 14–42mm ƒ/3.5–5.6

◁ 14mm (28mm equivalent)

⬡ ƒ/5.6

⬤ 6 seconds

▣ 0 EV

ISO ISO 160

◉ Standard

Canals are a gift to photographers. On peaceful evenings after the boats have docked and the birds are home to roost, they settle to deliver often perfect, mirror-like surfaces. Best of all, they can provide beautiful compositions following, or even during, poor weather.

Take this shot in Bruges, Belgium, for example. I'd gone out for the evening, hoping for some "Blue Hour" photography, but instead was confronted by steady rain. With several favorite bars within reach, I decided to forget the photography and concentrate on drinking instead (cheers, De Garre!). When I emerged a couple hours later in a somewhat stunned but happier state, I found this scene.

Since it was already late at night, there was no longer any natural color left to the sky, only the relentless orange of sodium light pollution. There was also still a steady drizzle, but I was met with a spectacular reflection that was almost as well defined and bright as the original above it. While the conditions were far from perfect, I knew I had to at least try and take a photo.

I set up my tripod on the walls of the canal and mounted a Panasonic Lumix G6, which I was testing at the time. Over the following half hour or so, I swapped between multiple lenses, long and wide, but ended up preferring the field of view delivered by the basic 14–42mm kit lens, in this case delivering a 28mm equivalent. Knowing this lens performs at its best when set to ƒ/5.6, I put the G6 into Aperture Priority, set this value and let the camera work out the rest.

The Lumix G6 metered an exposure of six seconds at its base sensitivity of ISO 160, which was long enough to smooth out any ripples on the water's surface without committing to a much longer exposure (and the risk of more raindrops) with an ND filter. After shooting this scene for about half an hour, my gear and I had gathered a fair dousing of rain so I decided to call it a night. This image does, however, illustrate that it's well worth shooting even during poor weather. (I was able to reshoot this location on a subsequent visit with much better weather — see page 71.)

TIP While some compositions lend themselves to a particular range of focal lengths, I like to try a broader selection when I have time, as sometimes you may stumble across a preferable approach. Indeed, this shot worked with a variety of lenses: longer focal lengths, crops where the tower on the left side almost touched the top and bottom of the frame, ultra-wide lenses. I compared all my shots and experimented with cropping, but kept coming back to this one, which is particularly satisfying as it was taken with a simple and affordable kit lens.

The Miami vice

EXIF Data

📷 Fujifilm X-T1

🎞 Fujinon XF 10–24mm ƒ/4

◁ 10mm (15mm equivalent)

⚙ ƒ/7.1

● 1.2 seconds

▣ +0.33 EV

ISO ISO 200

◎ Velvia

Here's the gorgeous façade of the Hotel Breakwater in Miami's South Beach. Designed in 1936 by Yugoslavian architect Anton Skislewicz, it has become an icon among the strip of art deco hotels on Ocean Drive. After a period of neglect, many of these hotels have been refurbished and returned to their former glory, making a stroll along Ocean Drive an essential part of a trip to Miami once again.

Like so many visitors to Miami, I had earmarked a walk along Ocean Drive but wasn't sure what to expect in person. Upon arriving at the end of the road, I was dismayed to find many of the buildings obscured by awnings over the outdoor seating; if you're walking along the hotel side of the street, you'll be aware of little other than the solid stream of drinking and eating opportunities with little evidence of the art deco architecture hiding behind the awnings above you.

Things are a little better across the road, but the lower halves of the hotels are still obscured by vehicles, bar seating, and those cursed awnings. It's easy to become frustrated by situations like these, but if you can't avoid an obstruction, the best approach is to work with it, or even embrace it.

I wanted the entire height of the hotel in my shot, but I didn't want the cars or bar seating in front of it. To avoid them, I crossed the road and framed up a shot right outside the main entrance, looking up. In situations like these, I always ask the door staff first, not just out of politeness, but also because they can help shepherd people out the way or even pose for you. I'm pleased to say all the staff people I spoke to on Ocean Drive were very friendly and helpful.

From this close range, I needed my widest lens and to shoot almost from ground height, coincidentally at an angle that was almost face-onto the awning, minimizing its visibility. I shot the same composition handheld during dusk, but returned with my tripod here at night for a longer 1.2-second exposure at the base sensitivity. I also applied the camera's Vivid profile for more saturated colors.

TIP If you want to avoid people appearing in your picture but can't shoot at quieter times, try mounting your camera on a tripod and using an exposure of several seconds. Anyone who walks past during the exposure will become a faint, blurred trail, rendering them almost invisible, or certainly much less intrusive. You can see this on the right side of the photo where someone paused to read the menu then moved on. Even with the pause, their movement has rendered them into a ghostlike figure that doesn't detract from the main image.

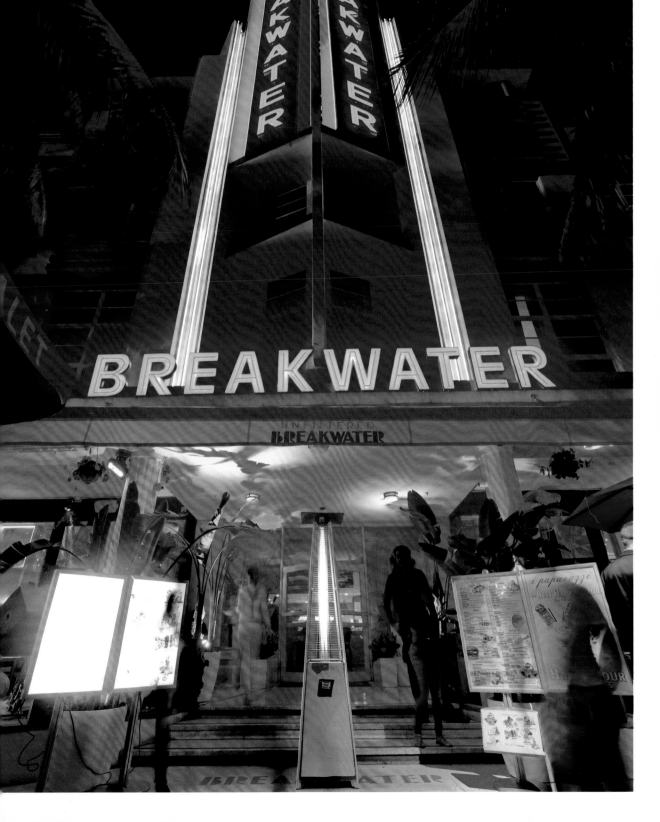

The Minecraft winery

EXIF Data

📷 Olympus OM-D EM-1

🎞 Lumix 7–14mm f/4

◁ 7mm (14mm equivalent)

◔ f/5.6

● 1/250 second

☑ 0 EV

ISO 200

Ⓥ Vivid

Here's the impressive entrance of Bodegas Ysios, a winery in the Rioja region of northern Spain designed by Santiago Calatrava. I first saw it on an excellent TV show about the art of Spain, by British art historian Andrew Graham-Dixon. Like most who see this entrance, I was immediately struck by its dramatic appearance. The stepped outline looks like something designed in Minecraft and is reminiscent of the 8-bit computer games of my childhood; it makes a wonderful juxtaposition against the organic rolling hills behind it. When a drive to Portugal passed through northern Spain, I earmarked it for a visit.

Bodegas Ysios is officially only open to pre-booked tours, so if you're interested in tasting the wine, you'll need to give them a call beforehand, especially if you'd like a tour in English. That said, it is possible to park outside the vineyard and wander up to the building to photograph its cathedral-like exterior without complaint, or at least it was when I visited anyway.

The building looks wonderful both near and far. I took several shots from a distance with a short telephoto lens, which captured the full undulations of the building with the mountains behind it. Here though, I've gone for the close-up of the entrance with an ultra-wide lens pointing straight up. It may not show the building in context, but by removing the hills and any surroundings, it's become an abstract subject, concentrating on the architectural details.

I used my Lumix G 7–14mm lens on my Olympus OM-D EM-1 at 7mm, delivering a 14mm equivalent field of view. The ultra-wide coverage accentuates the design for dramatic effect, but is also susceptible to skewing.

TIP When shooting architecture with wide lenses, you'll need to be very aware of symmetry and geometry as even the smallest tilt will become an annoying skew. First, ensure your camera's optical axis is dead center to the subject, then use the on-screen or viewfinder-based gridlines to correct any rotations or skews. You'll have to keep your eye on all four edges of the frame, using certain portions of the subject as a guide. Some photographers are happy to correct geometry afterward on their computers, but I think it's good practice to achieve it in-camera at the point of capture.

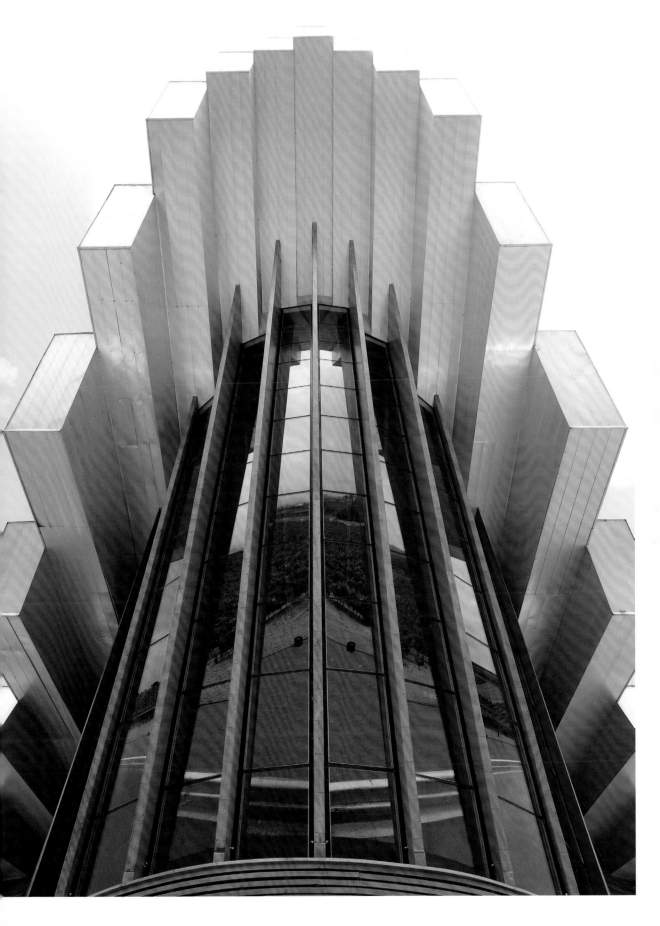

The money shot

EXIF Data

📷 Panasonic Lumix G6

🎞 M.Zuiko 45mm *f*/1.8

◁ 45mm (90mm equivalent)

⬡ *f*/5.6

● 3.2 seconds

▣ 0 EV

ISO ISO 160

◉ Shade white balance

Sometimes you have to go for the money shot. This is the view of the Grand Canal, taken from the Rialto Bridge in Venice. You're looking at one of the most famous views from one of the most famous bridges crossing one of the most famous thoroughfares in one of the most famous cities. In fact it doesn't get much more touristy than this, but it doesn't diminish my fondness for the image.

I was in Venice for two nights and spent a large portion of both on the Rialto Bridge. I arrived late on the first night when the sky was dark, but fired off a number of shots I was quite happy with. I was shooting with the Panasonic Lumix G6 and started off with wide-angle lenses to capture the whole scene.

With a plain sky occupying a large portion of the frame, however, I switched to the tighter view of an Olympus 45mm *f*/1.8 for a short telephoto view equivalent to 90mm. With my camera turned to the portrait aspect and recomposed to concentrate on one side, I was able to capture finer details on the magnificent buildings and the curve of the canal without the shot suffering from a vast expanse of dark sky and equally dark water.

I knew the sky would look better with some color in it, so I returned the following night a couple of hours earlier and took the same composition again and again over three hours using different exposures. It was wonderful to stand there and soak up the scene as the light subtly changed and countless tourists passed by. I took many long exposures, but to my surprise ended up preferring a much more normal exposure for the image here: 3.2 seconds at *f*/5.6 and ISO 160.

I know it doesn't have the smooth surface of a really long exposure, nor the trailed boat lamps or any starburst effects, but it best captures the scene I remember seeing in person. For me, that's what photography is about — capturing the essence of a place with an honest portrayal that immediately takes you back to the moment you were there in person. Every time I look at this photo, I'm reminded of those three hours I spent soaking up the atmosphere of this wonderful city. Venezia, ti amo!

TIP Shooting long exposures in a busy location is always a challenge, as people can't help but bump your tripod. The solution is to balance your tripod on a ledge where it's out of the way, either folding down the legs or using a smaller tabletop model. For this shot, I balanced my tripod on the sloping ledge of the bridge and loosely held my strap to prevent it and my camera from taking a plunge into the canal below. Minimizing your impact on crowds also reduces the chance of officials asking you to move on.

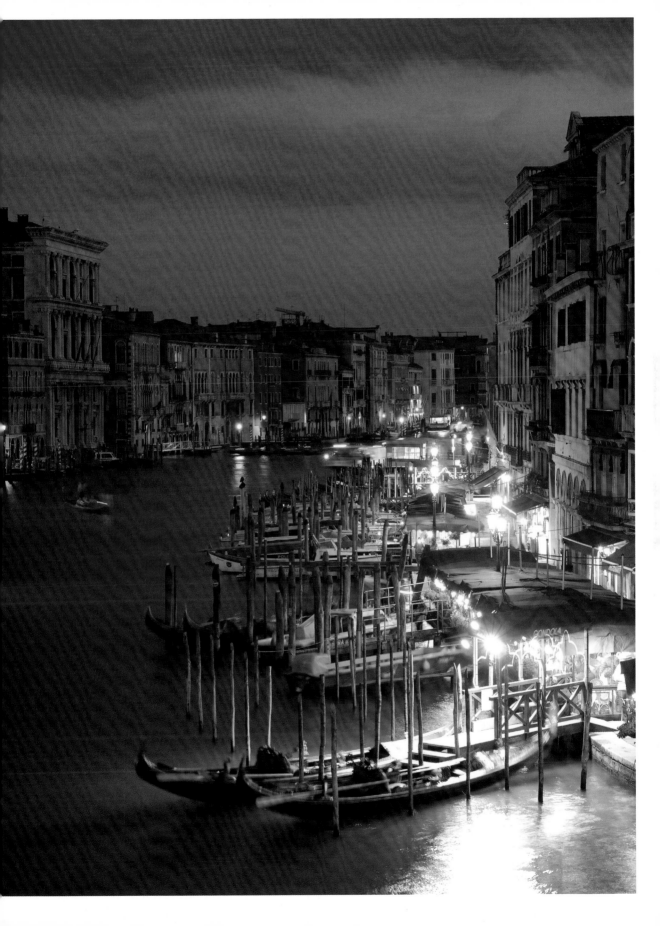

The mono reflection

EXIF Data

📷 Fujifilm X-T1

🎞 Fujinon XF 10–24mm ƒ/4

◁ 13mm (20mm equivalent)

◎ ƒ/10

● 240 seconds

▣ 0 EV

ISO ISO 200

◉ Monochrome

Most photographers have a bucket list of subjects, locations, or styles they'd like to shoot, and I'm no different. Even when you specifically aim for a particular photo, though, it can turn out very differently than you first imagined. If the primary target doesn't work out, you should still try and come away with something useful. Believe it or not, this was what I ended up with after attempting to shoot a classic sunset view in New York's Central Park.

I'm not sure why, but I've never taken a shot in Central Park that I'm happy with; I'm just like that with some subjects or locations. During a business trip to New York, I'd earmarked some time to photograph the park around sunset and researched the most photogenic bridges, but when I got there, I just couldn't find an approach that worked for me. Maybe it was the time of year, maybe it was the light, maybe my mojo just wasn't firing, but all the shots were disappointing. Worse, as time marched on, the surroundings became quite dark and potentially dangerous (if nothing else, from the alarming number of rats that emerged). Any natural color from the sky had also disappeared, leaving me with the orange glow of big city light pollution.

Normally at this point, it would be easy to give up and go find a bar to drown my sorrows, but with all my gear on me I was adamant to shoot some long exposures. So rather than photograph a bridge, I walked around and shot *from* a bridge where the small lake gave a nice reflection of the skyscrapers beyond. I fitted a mild neutral density filter and used Triggertrap to time a four-minute exposure — arguably overkill since the lake was still and there were no clouds in the sky. The upper half was too bright, so I deployed a hard graduated filter to darken that portion. Still, I was plagued by the orange sky, so I simply switched the camera to a monochrome mode to kill the undesirable color. Now I could give up and get that drink!

TIP I shot this with the Fujifilm X-T1 and XF 10–24mm ƒ/4 lens at 13mm for a 20mm equivalent field of view. I'd have gone a little wider, but the mounting for my relatively small ND filters becomes visible with this lens at its wider focal lengths. I could opt for a larger filter system, but I prefer the compact nature of my existing kit. In this instance, with dark conditions and an almost static lake, I could have alternatively used a basic 30-second exposure without any filters and zoomed wider, but I was keen to pack up and move on, so I stuck with this exposure.

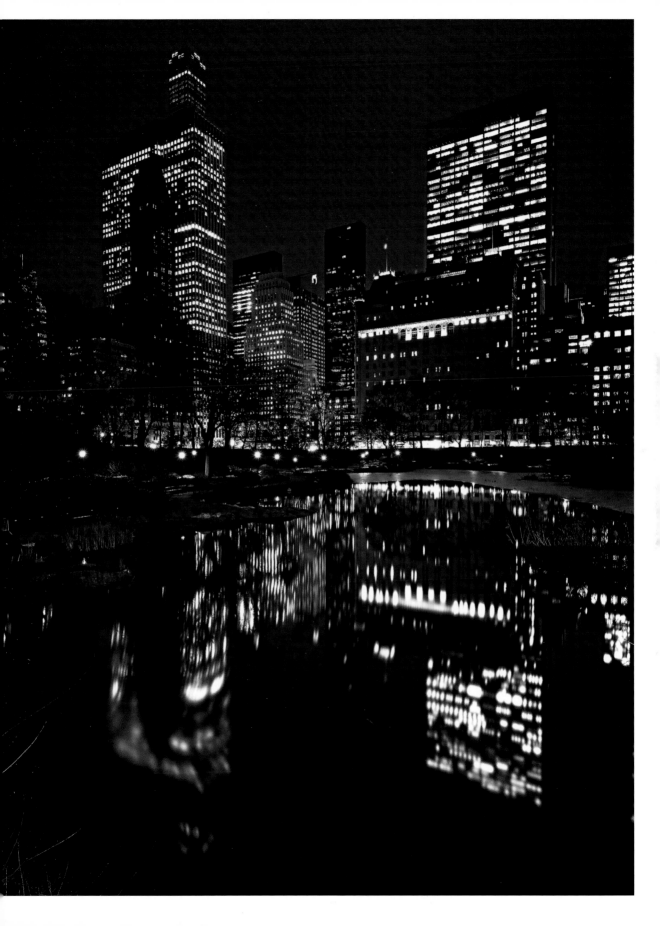

The moody cove

EXIF Data

📷 Olympus OM-D EM-5

🎞 M.Zuiko 17mm *f*/1.8

◁ 17mm (34mm equivalent)

⟳ *f*/16

● 20 seconds

▣ 0 EV

ISO ISO 200

◉ Natural

Nestled in the coast of Dorset in southwest England near the pretty village of Lulworth is Durdle Door, a spectacular natural rock arch that draws visitors from the world over. It's just behind me in this photo. Sorry about that.

I love Durdle Door, but I've never managed to capture a satisfactory photo of it. Even if your mojo isn't firing on all cylinders when you visit a popular location, don't let it put you off exploring as you may end up finding something else that gets your creative juices flowing. In this instance, I hopped over the saddle to the opposite Man O' War beach and was immediately inspired by what I found. Long, thin rocks pointed into the distance like spindly fingers with the seawater lapping between them, while a moody sky loomed overhead. This was more like it, so I set up just on the edge of the tide.

I wanted to shoot it as a long exposure, which by mid-morning, demanded a neutral density filter to soak up most of the light. I fitted my Lee Big Stopper, which reduces the incoming light by ten stops, and I also added a hard graduated filter to darken one half of the image. I adjusted it to darken the sky and better reveal details in the clouds. I realize you can do all of this in post-processing afterward, but I love the immediacy of seeing the result in the field as you physically push a filter up and down or rotate it a little until you get what you want.

When dealing with exposures that could last several minutes, I find it best to meter the scene without the filter then calculate the longer version according to the number of stops on the ND filter. When it's bright daylight and the exposure isn't going to be longer than 30 seconds even with the filter, I find I can normally just trust the metering of the camera with the filters in place. That's what I did here, with the EM-5 recommending 20 seconds at *f*/16 and the camera's base sensitivity of ISO 200.

The blue-green colorcast is actually a side effect of early versions of the Big Stopper filter. You can compensate for it by setting the white balance to a high temperature like 10,000K, but I like the effect here, as it's made an otherwise pleasant sunny day at the seaside look like an imposing dusk or dawn with storm and uncertainty ahead.

TIP A composition like this cries out wide angle to me, but it's important to try a variety of focal lengths. If you go too wide, any objects in the distance will become tiny while those nearby will be huge. This can work really well for some compositions, but less well for others. In the end here, I opted for a modest wide angle of 34mm equivalent, using the M.Zuiko 17mm *f*/1.8 lens mounted on my Olympus OM-D EM-5 body.

The moonset

EXIF Data

📷	Panasonic Lumix GX1
🎞	Lumix G 7–14mm *f*/4
◁	14mm (28mm equivalent)
⬡	*f*/4.5
⬤	30 seconds
🔲	0 EV
ISO	ISO 400
◉	Standard

I've photographed so many sunsets over the ocean that I wanted to try something different here: the moonset. Actually, it wasn't that calculated. I was here to shoot a sunset and the "Blue Hour" that followed, and by pure good luck on timing, found the moon satisfyingly drifting into my field of view. (For all you astronomy fans out there—and I count myself as one—I realize the sun and moon share the same ecliptic path, but I'd lost track of the phase.)

I took this in Santa Cruz, California while visiting my friend Barry Blanchard (check out his social streams for wonderful floral, coastal, and aerial imagery). The rocky outcrops around the coast are ideal for long exposures, but as the sky darkened and I considered packing up, I was drawn to the reflection of the setting moon over the Pacific.

I used the horizon to naturally slice the image in half vertically, then positioned the moon on the horizontal center—hardly controversial, but I liked the symmetry. I framed the composition with the Lumix 7–14mm mounted on a Panasonic GX1, which delivered a 14-28mm equivalent field of view. I zoomed to the longer end here and closed the aperture just a small amount to improve the sharpness at the edges, although the beauty of this kind of subject is that the low detail is forgiving on your optics.

At ISO 400, the GX1 metered an exposure of 30 seconds, enough to slightly smooth the ocean's surface, and for the stars in the background to become visible. Note that the exposure length has resulted in a slight drifting of the stars due to the rotation of the earth, most visible closer to the horizon. To avoid this and maintain them as points, you'll need to try and stick to exposures shorter than ten seconds at this focal length, especially close to the horizon, which means using either a brighter lens aperture or a faster sensitivity. In this case, I could have increased to ISO 1600 for an eight-second exposure, although I would have had a noisier image as a result.

I feel this image is very peaceful and include it here as a dedication to my late stepfather, Bill, who passed away that evening.

TIP If you want to include the sun or moon in a particular position, you don't need to rely on chance or good timing. Many smartphone apps exploit the predictable motion of celestial objects, and built-in GPS receivers show you exactly where and when you'll need to be for the perfect arrangement. My favorite is The Photographer's Ephemeris for iOS and Android, which lets you know exactly where the sun and moon will be for a particular date, time, and location. It's invaluable for sunset information when traveling.

The nearest neighbor

EXIF Data

📷 Olympus OM-D EM-5

📼 Televue Genesis SDF
telescope with 2x Barlow

◁ 540mm (2160mm
equivalent)

◉ f/5.6 native / f/10.8 with
Barlow converter

● 1/100 second

🗲 0 EV

ISO ISO 400

◉ Monotone

The moon is a popular subject for photographers, but can prove a challenge for two main reasons. First, it's a lot brighter than it looks, and second, it's a lot smaller than it looks. Compounding this is the fact it's often positioned against an expanse of jet-black sky, further confusing metering systems.

The brightness issue is easily resolved. To avoid an overexposed, featureless white disc, forget about your auto or semi-automatic modes and turn to Manual exposure mode instead. I'd recommend starting off with an exposure of 1/100 at f/5.6 and ISO 100 then adjusting the shutter speed up or down form there to achieve the desired brightness.

This starting-point exposure information will apply regardless of the size of the moon on your image, but you can't get around the fact that if you want it to appear large on the frame, you need to use a very long focal length. If you'd like the disc to virtually touch the sides of the frame, you'll need to be shooting at an equivalent of around 2000mm.

I mounted my camera on a 540mm telescope here with a 2x Barlow converter and used a Micro Four-Thirds body, which applies a further 2x reduction, so an equivalent of 2160mm. That said, a 70—300mm set at 300mm can still deliver a great result on a cropped body, and high-resolution sensors provide plenty of opportunity for subsequently cropping in on the image. If you only have shorter focal lengths to work with, shoot the moon when it's low enough to include some of the landscape in the image.

If you are shooting at very long focal lengths, the focusing becomes more critical. If your camera allows it, use magnified focusing assistance to confirm. Also be aware that, at very long focal lengths, you'll notice the moon slowly moving across the frame. This is actually the effect of the earth turning, but photographically, the issue remains. You may need to increase your shutter speed to avoid motion blur.

TIP Many people are drawn to the full moon, but it occurs when the moon is facing the sun and subsequently has no shadows and little detail on the surface—it's like shooting at mid-day on earth. For me, the drama takes place on the limb between light and dark, where you'll see a line of mountains and craters defined by shadows, which means shooting during any other phase like first or last quarter. I also prefer shooting the moon in black and white as it better matches how I perceive it in real life.

The neon corridor

EXIF Data

📷 Fujifilm X-T1

🎞 Fujinon XF 10–24mm *f*/4

◁ 10mm (15mm equivalent)

🔆 *f*/4

⬤ 1/5 second

▦ 0 EV

ISO 800

Velvia

When composing a photo, always look for leading lines — lines to guide your eye across the frame. They could be found in a river snaking its way across a landscape to a copse of trees; they could take the form of dead-straight architectural lines converging at the vanishing point. Leading lines give interest to a composition and also help guide the viewer to a desired area of focus. Here, I've used them to give the surroundings a dramatic appearance and draw your eye to the people in the distance for scale.

It wasn't the lines that originally attracted me to this subject though. I was walking along the wonderful High Line in New York, a disused elevated railway converted into an urban park and walkway along the lower west side of the city, when I came to this covered section under a building. During the day it looks interesting, with some nice architectural views through the openings on the left and sometimes a scattering of food vendors. Returning at night, however, revealed a very different look and feel, with the neon lighting casting a cold blue-and-white glow onto the walls and flooring.

Compositionally, I liked how the lines of neon lights mirrored the lines on the floor and I knew I wanted to shoot it with an ultra-wide lens to amplify the drama and perspective. I tried it square on, with the vanishing point in the center of the image, but ended up preferring the view from one side.

Shooting from the sidewall also gave me something to lean on, which in addition to the optical stabilization in the lens, allowed me to handhold a relatively slow exposure without having to increase the sensitivity too much. To further accentuate the color, I also switched my camera's processing to apply more saturation. On the Fujifilm camera models, this is the Velvia film simulation selection.

I took several shots from this position, some bereft of people, others with groups or individuals near and far. While classic wide-angle composition would suggest something is needed nearby in the lower right corner, I liked positioning people in the distance for architectural scale.

TIP When shooting with wide-angle lenses, it's easy to generate converging lines, but some you want and some you don't. In this instance, I wanted the lines of the lights and flooring to converge at the vanishing point, but I didn't want the walls on the sides to be misaligned with my composition. The key is to angle your camera up and down carefully, noticing how lines on either side bend in or out. For a geometrically square result, adjust it until lines on both sides of the frame are parallel to the edges. Sure, geometry can be corrected later, but a little care at the point of capture means your shot is good to go straight out of the camera.

The North Beach

EXIF Data

📷 Panasonic Lumix GX1

🎞 Panasonic/Leica 25mm
f/1.4

◁ 25mm (50mm equivalent)

◌ f/8

⬤ 10 seconds

⊠ 0 EV

ISO ISO 160

◉ Tungsten white balance

Here's a view from North Beach in San Francisco — my favorite neighborhood in one of my favorite cities. I was on a photo walk organized by my good friend Thomas Hawk, whose lifelong project to photograph and document all the US cities is resulting in one of the most consistently attractive and compelling social streams out there. Check him out if you don't already follow him.

When visiting a city, I'm always looking for compositions that give a good flavor of the place and what makes it unique. I'm fascinated by the topography of San Francisco, with its steep hills lined with relatively low-rise housing. I also love how the layout of hills and architecture mean you enjoy regular glimpses of the larger iconic structures, including the Bay Bridge and the Transamerica Pyramid. If I can include most of this in a photo, I'm happy.

As an aside, I remember being inspired by an exhibition and book by Chris Steele-Perkins, which featured Japan's Mount Fuji in every image. I loved how its instantly recognizable cone would appear in unexpected reflections, out of windows or between buildings as well as in the more usual landscape compositions. His images reinforced my own enjoyment of featuring well-known buildings as glimpses rather than the main focus.

The elevation of the road afforded not just a nice view looking down one of the city's steep streets, but also a face-on view of the Transamerica Pyramid and financial district, avoiding perspective issues. All I had to do was shuffle sideways to frame the peak between a nearby tree and fire escape. Immediately following this shot, I met another photographer on the walk, Daniel Krieger, whose excellent Instagram account is an inspiration for anyone into shooting food and drink.

TIP The headlight trails at the bottom of the shot reveal a longish exposure here of ten seconds. I shot from a tripod with a standard 50mm equivalent lens for natural perspective, and waited for cars to climb the hill. I have some views with and without the light trails and ended up preferring those with them. I always recommend capturing as many variations as possible, as you may end up liking an unexpected version best.

The northern crown

EXIF Data

📷 Fujifilm X-T1

🎞 Fujinon XF 10–24mm *f*/4

◁ 15mm (22mm equivalent)

◐ *f*/16

● 120 seconds

▣ 0 EV

ISO ISO 100

◉ Monochrome with red filter

Here's my X-T1 on location in Liverpool just after taking the shot opposite. The red cable is from Triggertrap and connects the camera to my phone to control long exposures.

Here's Liverpool's Metropolitan Cathedral, a modern church building that always reminds me of the carousel in the film *Logan's Run*. As a man comfortably beyond his thirties, I'm understandably nervous whenever I'm nearby in case a jewel in my palm starts flashing. (If you don't know what I'm talking about, check out this seminal sci-fi movie immediately!)

Anyway, back to the photo. Like The radio tower on page 178, the Metropolitan Cathedral is a subject I feel works well with a long exposure in black and white. Also like the Radio Tower, I have a go at it every time I visit Liverpool.

The wind was blowing, causing the clouds to fan out as they approached. To blur them for an ethereal effect, I used a neutral-density filter to reduce the amount of light entering the camera, allowing a much longer shutter speed. I stacked my Lee Big Stopper with a second ND filter, totalling 13 stops and allowing me to deploy a two-minute exposure even under direct sunlight. It's amazing to think that, without the filters, I'd have been looking at an exposure of around 1/60.

Like with so many of my long exposures I used my Fujifilm X-T1, partly for it's great out-of-camera JPEG quality, but also because it delivers clean results even with long exposure noise reduction disabled. This means I didn't need to wait around for another two minutes after this shot just for a "dark frame" to be captured and applied.

I fitted the camera with the XF 10–24mm lens, zoomed to 15mm for a 22mm equivalent field of view and closed the aperture down to *f*/16. An aperture of *f*/16 is almost as small an opening as this lens allows and will cause some softening due to diffraction on this system, but it was necessary to achieve the desired exposure. Luckily, there's not a great deal of very fine detail here, so the negative impact of diffraction isn't particularly visible.

The black-and-white conversion was done in camera by simply selecting a monochrome preset. I went for the Monochrome film simulation with the digital red filter to darken the blue in the sky.

TIP For exposures longer than 30 seconds, I use a Triggertrap cable. This connects the suitable port on your camera (USB in the case of the X-series bodies) and the headphone socket on your smartphone. A free app is then used to set the desired exposure, or even a time-lapse sequence. It's a powerful system, but you may want to invest in a grip, which can hold your smartphone to your tripod to prevent it from falling during a session. This is particularly handy in dimmer dusk or night conditions.

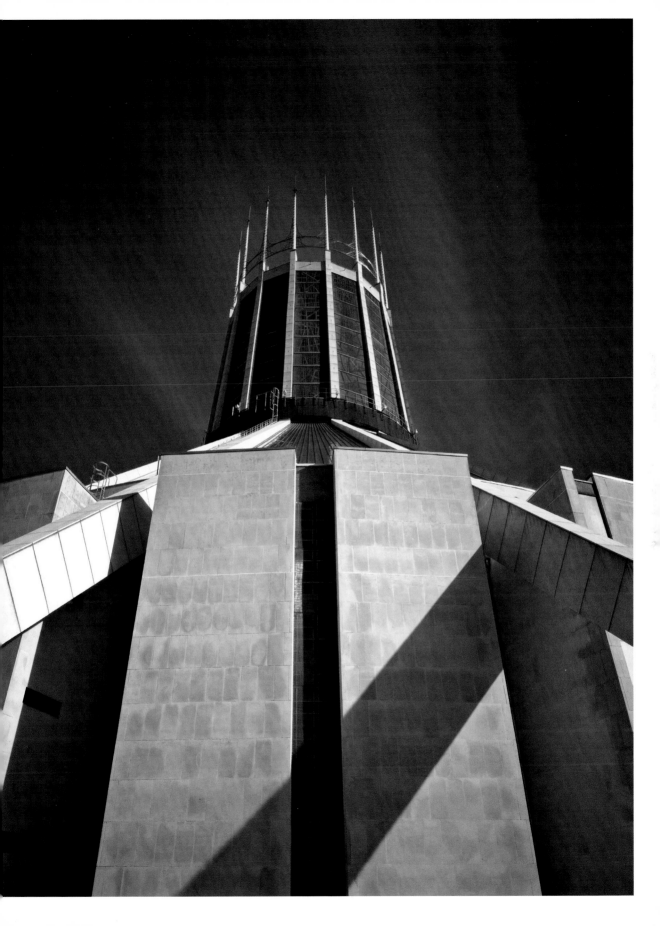

The observer

EXIF Data

📷 Olympus OM-D EM-1

🎞 Lumix G 7–14mm ƒ/4

◁ 14mm (28mm equivalent)

⚙ ƒ/5.6

● 1/50 second

⊞ + 0.3 EV

ISO ISO 200

◉ Natural

I love art galleries as much for their buildings as for the actual works within. Indeed, many modern art galleries are architectural works of art themselves, with high-profile designers bringing worldwide attention to regenerating areas. I can think of no more perfect example than the Guggenheim in Bilbao, Spain, designed by Frank Gehry and transforming a relatively rundown city into a highly desirable place to visit. It really works, too; the Guggenheim was the catalyst for my first trip to Bilbao, but upon arriving I discovered a vibrant city with a buzzing food and drink scene that has drawn me back several times since.

While you can't take photos of the actual art at the Guggenheim, you are welcome to photograph the building itself from within. There's loads to shoot, especially around the enormous atrium, which really lends itself to wide-angle photography. I shot wide, I shot ultra-wide, and I also shot fisheye images, but my favorite here was at the milder end of the scale — a 28mm equivalent.

I was drawn to what looked, from my viewpoint, like a giant capital H with lovely sweeping curves and subtle shades. I composed the shot with a square crop in mind for Instagram so wasn't that bothered about the slightly distracting structure at the top of the image. While I enjoyed the abstract nature of the shot, however, it lacked any sense of scale. As if on cue, a figure appeared on the opposite balcony, dwarfed by the scale of the architecture and suddenly made it all the more interesting. Sometimes, as photographers, we become obsessed with eliminating people from a shot when in fact they're what it really needs.

TIP This image would work well in black and white as it's already almost monochrome, but I've left it in color for a slightly cream-colored appearance. If you're unsure, you can shoot multiple versions using different modes, or shoot in RAW and apply different effects later. No need to do this on your computer either, as many camera bodies now offer in-camera RAW processing, allowing you to generate multiple versions of an image by applying different color or filter effects in playback. I find myself doing this often these days.

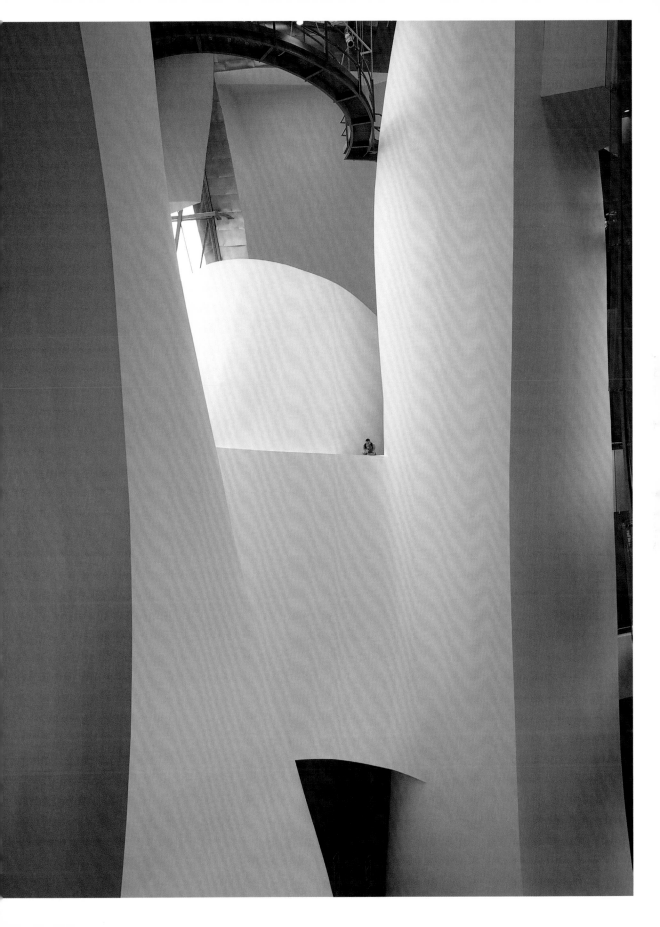

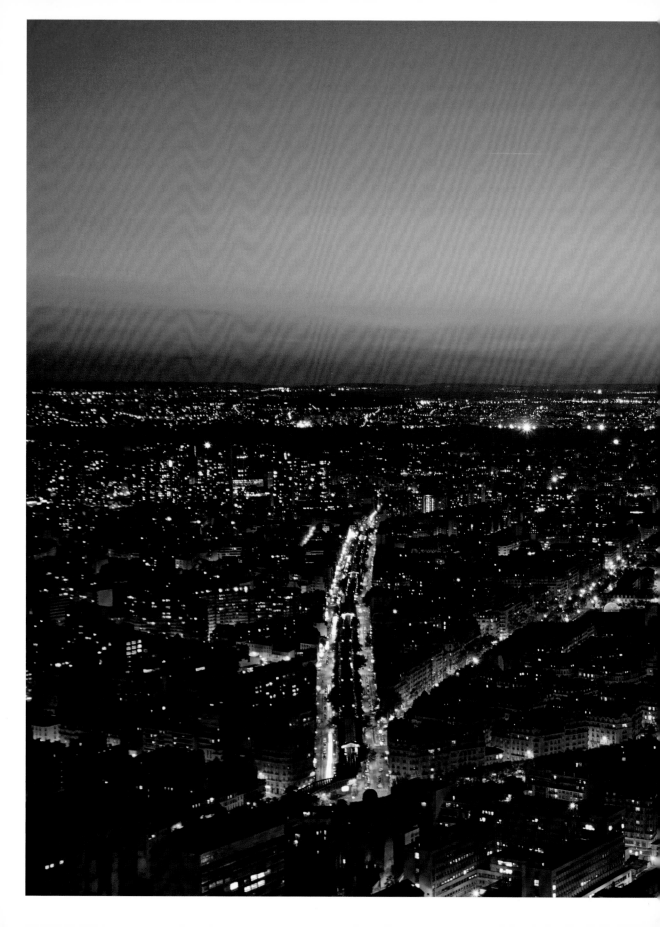

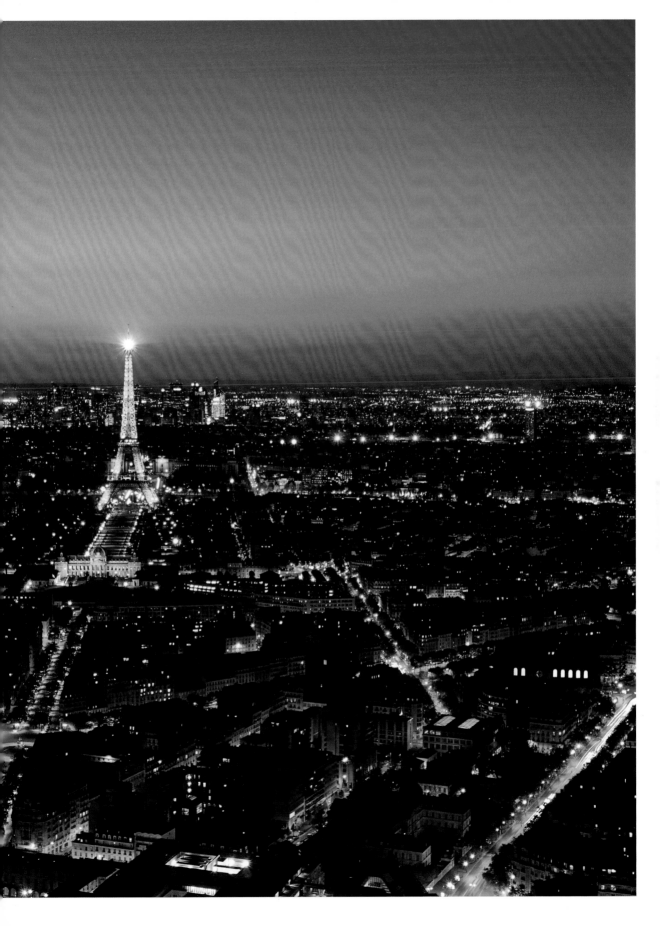

The Parisian tower

EXIF Data

Sony α6000

Sony E PZ 16–50mm
f/3.5–5.6

22mm (33mm equivalent)

f/8

6 seconds

0 EV

ISO 100

Standard

If you're looking for a big view of Paris, you can't beat Montparnasse Tower. Not only does it give you 360° views of the city from an unusually high position for the center of Paris (the only other big tower being Eiffel's), but it also considerately leaves a number of strips in the glass windows open for you to poke your lens through. Amazing! Why can't all city towers be like this? Before moving on, I'd also like to thank travel photographer Elia Locardi for reminding me of this location.

The view from Montparnasse works well with a variety of focal lengths. Fit a mid-telephoto and the Eiffel Tower will almost fill a shot taken in the portrait orientation, with the few skyscrapers of the city positioned neatly behind it. Alternatively, go wide for a bigger view that really shows the city's wide and carefully planned boulevards. I opted for the latter here, shooting with the Sony α6000 and its basic 16-50mm kit zoom at 22mm for a 33mm equivalent field of view.

I'd timed my arrival to catch sunset and the "Blue Hour" beyond and brought my tripod to handle the slightly longer exposures later in the evening. For this shot, I knew I wanted sharp details up to the edges of the frame, and I also knew the Sony 16-50mm kit zoom needed to be stopped down to deliver them. So, I closed the aperture to f/8 in Aperture Priority, at which point the camera metered six seconds at ISO 100.

Six seconds is no problem with a tripod, but my slightly compact travel model didn't quite reach the strip with the legs positioned wide for stability. By angling them in though, my camera just about made it to the edge, like an infant on its tip toes — not ideal, but it was sufficiently steady to capture the image. As the searchlight in the Eiffel Tower turned, the beam was visible reaching sideways into the sky. It looked good pointing left or right, but I preferred it face on so I kept taking shots until one shone straight into the camera.

TIP As you'll see throughout this book, I like to shoot cities during the "Blue Hour" following sunset when the lights have come on in the buildings, but the sky still has some natural color remaining. Shoot any earlier and the buildings won't have their lights on; leave it until any later and the sky will be overcome by unattractive light pollution from streetlamps. Get the timing right, though, and you'll enjoy a combination of manmade and natural light, and if you're really lucky, some nice-colored clouds, too.

The Prague bridges

EXIF Data

📷 Sony α7R Mark II

🔲 Sony FE 70–200mm *f*/4G OSS

◁ 182mm

⚙ *f*/11

⬤ 25 seconds

▣ –0.3 EV

ISO 50

◉ Shaded white balance

Elsewhere in this book I've mentioned how you sometimes have to go for the money shot, the famous view that everyone takes. If you're in Prague in the Czech Republic, you could take photos of the Astronomical Clock or the Charles Bridge, but the really big view is of all the bridges over the river Vltava as viewed from Letna Park. I wanted to capture it just after sunset, when the lights were on but there was still color in the sky.

When shooting during the "Blue Hour," I highly recommend taking shots at regular intervals for as long as you can, as you never know what might happen and which moment will end up being best. As darkness approached, I expected the bridges to become brightly illuminated, but it never actually happened. Dim lamps came on, but nothing dramatic. I kept shooting, but never saw the view I expected. As the blue sky faded into blackness, I knew my chance to capture any color had gone, so I reviewed the images I'd taken and found that those just after sunset looked the best.

As for the technical side, I knew the view would be fairly distant and would need a longer lens. I shot this with the Sony α7R Mark II and FE 70–200mm *f*/4G OSS at 182mm. I wanted a long exposure to blur the water, but without an ND filter that fitted the lens, I was forced to choose the lowest ISO value and as small an aperture as I dared (to avoid diffraction). The result was a 25-second exposure. While I was a little disappointed the bridges weren't illuminated the way I expected, I was still very happy with this shot. Sure, almost every visitor to Prague has the same view, but it doesn't mean it's not worth capturing for yourself.

Here you can see my Sony α7r II on location in Letna Park earlier that evening. This spot affords a clear view of the bridges, but their distance really demands a longer lens.

TIP Letna Park is within half an hour's brisk walk of the old town. If you're starting in the Old Town Square, just walk along Parizska then continue straight over the Czech Bridge. At the end of the bridge, you'll see paths leading up to the Prague Metronome. Head upward and after a few minutes you'll be up in Letna Park. Turn left, walk along for about 50 meters, and you'll come across various openings to the big view of the bridges. Scores of tourists and locals will come and go, but it's easy to find a corner to place a tripod and wait for the perfect light of sunset or sunrise. I also felt safe there even when the park became quite dark.

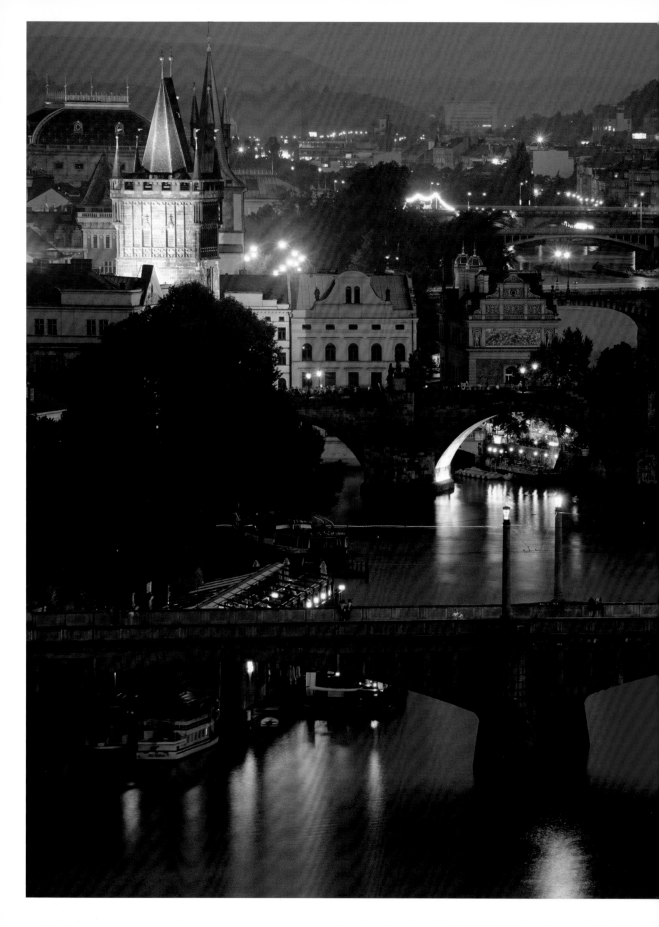

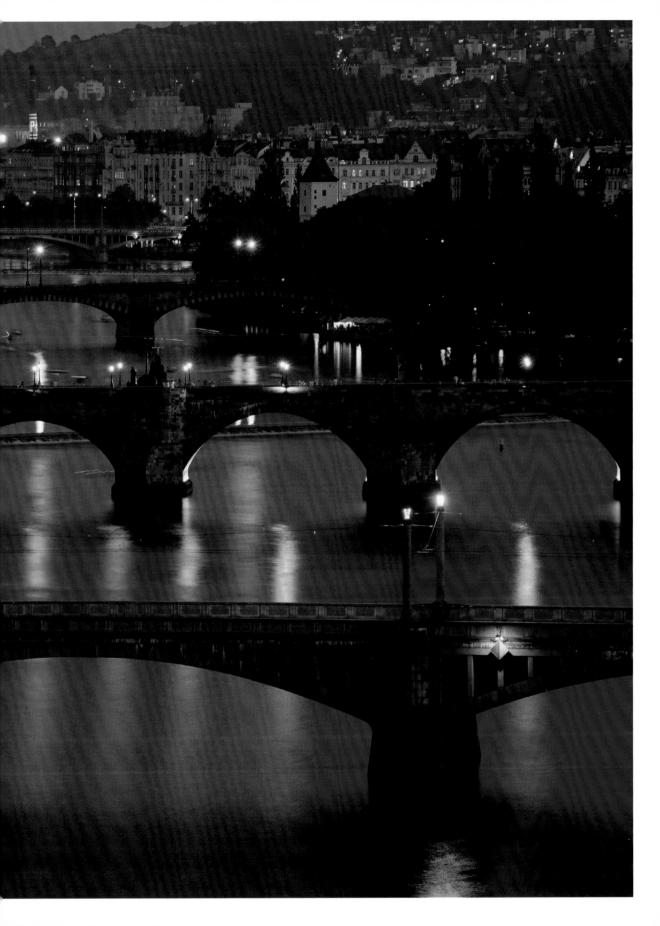

The pavilion's bite

EXIF Data

📷 Fujifilm X-Pro2

🎞 Fujinon XF 10–24mm *f*/4

◁ 14mm (21mm equivalent)

◇ *f*/5.6

● 1/450 second

⊞ 0 EV

ISO ISO 200

◉ Provia

One of my favorite things about photography is the way it makes you look at things. Rather than walking around with our heads down, photographers are always looking for potential subjects, be they interesting people, an attractive landscape, an unusual shape, or a contrast of some description. It's a great hobby for kids, encouraging them to take in their surroundings, whether at home or on holiday, and find creative ways to capture what they see.

I took up photography when I was in my single digits and much of the philosophy and technique I use today I picked up early on, particularly the importance of trusting your instincts. If you notice something different or unusual in your day-to-day travels, it's probably worth further investigation for a possible photo.

Here, you're looking at one of the enormous gateways to the Royal Pavilion Gardens in Brighton. It's housed within an arch with curved cutouts. I walk past it almost every day, but this time noticed the shadow of the arch cast against the interior of the gatehouse. The shape reminded me of teeth in a giant mouth, and it was this double take that made me know I should try a photo.

The large scale and close range meant I needed to go wide, so I fitted the Fujifilm X-Pro2 I was testing with my XF 10–24mm lens. I wanted to capture the entire shadow, but have it come close to the edge of the frame as if you were in the mouth looking out. I started at the widest coverage, then zoomed in gradually until it looked good in the frame. In the end, I used 14mm for a 21mm equivalent field of view.

TIP I shot this with the standard color mode of the X-Pro2, but the subject would also work well with a more muted profile. On the Fujifilm cameras, the Classic Chrome film simulation is an option well worth trying, although on other models you could simply try turning down the saturation a little to reduce the color vibrancy. I encourage you to try out the different color styles in your camera, as they may deliver the effect you're after without any post-processing.

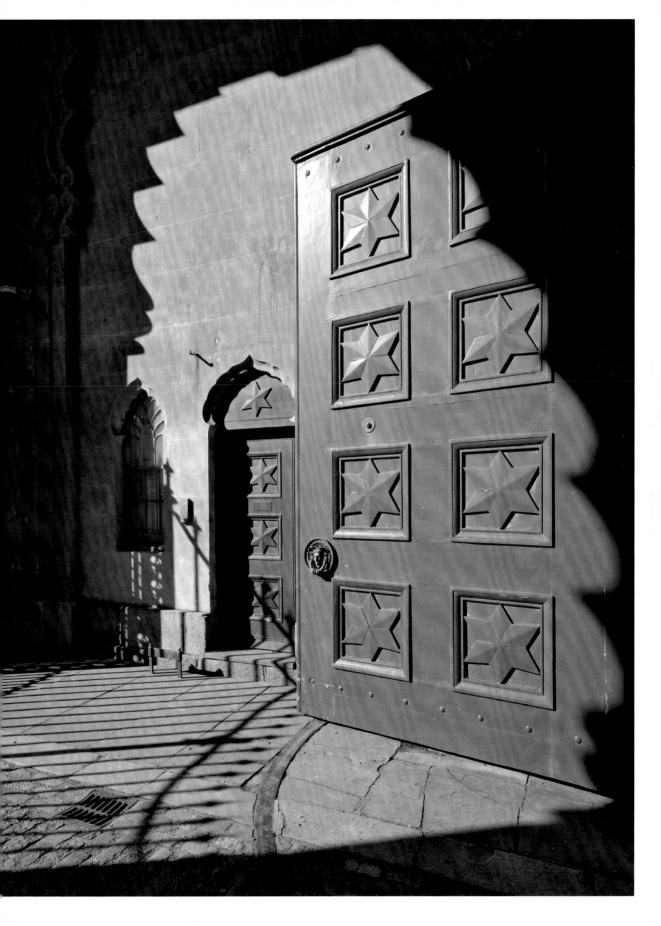

The pulpit rock

EXIF Data

📷 Olympus OM-D EM-5

🎞 M.Zuiko 17mm *f*/1.8

◁ 17mm (34mm equivalent)

⚙ *f*/8

⬤ 6 seconds

▣ 0 EV

ISO ISO 200

◉ Natural

It's true what they say: You never stop learning. I'd been taking photos for over 30 years before I dabbled in long-exposure landscape photography, and now it's one of my favorite techniques for capturing attractive and ethereal images under a variety of conditions.

As you'll know from the other long exposure photos in this book, the technique blurs areas of the composition that are in motion, most notably clouds and water. Shorter exposures of a few seconds will turn lapping waves into spooky-looking steam, but give them a couple minutes (with the help of a neutral density filter to soak up most of the light) and they could be transformed into an eerily calm, flat surface.

Meanwhile, any clouds will blur into long streaks, all adding to the atmosphere. And of course, anything that's still, such as a building or the landscape, stays perfectly crisp. This is why long-exposure fanatics get excited around interesting coastal features, be they manmade or natural — all those waves lapping or splashing against static piers, poles, rocks, or cliffs!

The location in this photo is ideal for long exposures — Pulpit Rock, on the Isle of Portland. As sunset approached, I found a nice spot, framed my composition and settled down to taking shots at regular intervals. I used my Olympus OM-D EM-5 and M.Zuiko 17mm *f*/1.8 lens (for a 34mm equivalent view) and experimented with various combinations of ND filters for different exposures. In this case, I actually preferred my shorter exposures of a few seconds compared to those of several minutes, so I removed my Lee Big Stopper ND filter and used only my "hard grad," which darkened one half of the image but left the other untouched; I used it to darken the sky above the horizon a little to better retain cloud detail.

The six-second exposure allowed a little blurring on the waves, but left some definition, too, which I preferred to the completely smooth versions of several minutes. The moral, as with so many photographs, is to take several different versions as one technique may end up preferable to another, and it may not be the one you expected.

TIP Photo walks are a great way of meeting other photographers, comparing techniques, and learning new ones. It's easy to find one in your area using social media. I took this photo at one of the annual Euro photo walks, organized by Athena Carey, John Dunne, and Andy Bitterer, and I'd encourage you to look them up on social media or search the #europhotowalk hashtag to see more images or details of upcoming meetups!

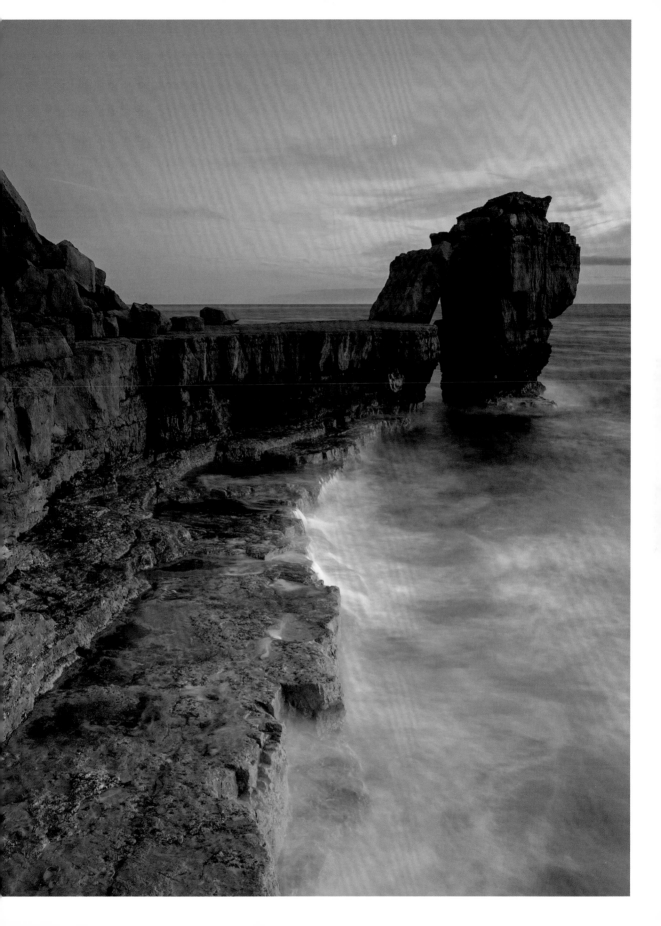

The radio tower

EXIF Data

📷 Fujifilm X-T1

🎞 Fujinon XF 10–24mm *f*/4

◁ 24mm (36mm equivalent)

✦ *f*/18

⬤ 26 seconds

▣ 0 EV

ISO 100

◉ Monochrome with red filter

Here's the Radio City tower in Liverpool's city center. It's a long exposure of almost half a minute, allowing the clouds to drift and blur, an effect accentuated by the in-camera Monochrome processing with high contrast. I shot alongside my friend Anthony Owen-Jones, who's an inspiration for long-exposure photography.

Towers make great subjects for long exposures, and I've long had my eye on Liverpool's Radio City tower, but the conditions had to be right. Without sufficient wind, there'd be no blurring of the clouds; if it were too windy, a long-exposure capture could result in the clouds having no definition to their shape. To be perfectly honest, you don't really know how successful a long-exposure photo will be until you take it. The trick is to simply keep shooting and keep your fingers crossed.

I captured this with my Fujifilm X-T1 and XF 10–24mm zoom set to 24mm for a 36mm equivalent field of view. With the sensitivity dialed to the minimum ISO 100 and the lens aperture closed almost as small as it would go at *f*/18, the camera metered an exposure of around 1/30. That's way too quick for the effect I was after, so I fitted my Lee Big Stopper, a neutral density filter rated at 10 stops. This reduced the incoming light to require an exposure of almost 30 seconds under the same conditions, which in turn gave the clouds a chance to blur. Since I was already at the lowest aperture, if I'd wanted an even longer exposure I would have either had to add another ND filter or wait for the light to get dimmer.

Exposures up to 30 seconds can be set with almost any camera and triggered by the self-timer without the need for additional accessories. For longer exposures, you'll need to set your camera to Bulb mode and hold the shutter open, typically using a cable release accessory. I use a Triggertrap cable, which connects to your smartphone and lets you enter the desired exposure there.

I used the X-T1's Monochrome film simulation with an additional red filter. This increased the contrast and darkened the blue sky. Most modern cameras offer good-looking black-and-white modes; it's well worth trying them out.

TIP Neutral density filters reduce the amount of light entering the camera without (in theory, anyway) changing the color. They're popular with anyone who likes to use large apertures or long exposures in bright conditions. Most ND filters are described by the number of stops by which they reduce the light. A one-stop filter would double the required exposure, two stops double that again, and three stops double it once more. Three-stop filters are fine at dusk, but during daylight you'll really need around 10 stops, which can turn 1/30 into 30 seconds.

The rainbow birdcage

EXIF Data

📷 Olympus OM-D EM-1

🎞 M.Zuiko 8mm *f*/1.8 Fisheye

◁ 8mm (16mm equivalent)

◌ *f*/1.8

⬤ 1/8 second

🄴 0 EV

Ⓘ ISO 200

◉ Vivid

This is the IFO, or Identified Flying Object: a giant, nine-meter-tall birdcage housed between Kings Cross and St Pancras railway stations in London since 2011. Designed by Jacques Rival, it houses a swing that hangs from its center, proving irresistible to passersby. It certainly brightens up a commute in the city.

I photographed it here during the Lumiere London festival of light, although it's actually there all of the time and illuminated every night, too. I love how the bars pulsate between different colors as bemused visitors enjoy the swing within. The installation is a conventional shape, with straight bars pointing vertically upward, but they've been bent here by my fisheye lens, which applies considerable geometric distortion to squeeze a 180° field of view across the frame.

Fisheye lenses are a specialized choice and their extreme effects can prove too much for many subjects. For others, though, they're ideal. I fitted mine near the start of a tour around the Lumiere light festival and found I left it on pretty much all night (see The ethereal creature and The festive street on pages 112 and 138). It proved perfect for capturing the surreal and often large-scale installations across the city.

I'm particularly fond of the Olympus 8mm fisheye, as its unusually bright *f*/1.8 focal ratio allows you to use it in very low light, especially when coupled with the built-in stabilization of the OMD and later Lumix bodies. Wide open, it allowed me to shoot this at the base sensitivity of ISO 200 with an easily handheld exposure of 1/8. As for the exposure itself, I trusted the camera's metering in this case.

TIP Beginners to photography often worry about exposure, but I find the metering systems in modern cameras do a remarkable job at getting it right. I mostly shoot in Aperture Priority to control depth of field and I let the camera work out the rest. The beauty of shooting in Live View with mirrorless cameras or DSLR screens is you get a real-time preview of what you're going to record. If it doesn't look right, simply make corrections before shooting. There's really no reason to get it wrong. I very rarely override the suggested metering, but when I do, a little exposure compensation to deliberately under- or overexpose does the trick. The only time I venture into full Manual mode is when shooting very long exposures or doing astrophotography.

The rainy rail bridge

My X-T1 is seen here on location in the rain for the shot opposite, wearing my beanie hat to minimize light leaks and with a filter case balanced on top to shield the ND filters from raindrops. Oh, the glamor!

Some subjects or styles of photography require perfect timing and conditions. Others can be much more forgiving. A handful can even benefit from dreary conditions. That's one of the many things I love about long-exposure photography in the daytime, as you can capture very satisfying images even under weather and lighting that would have most sensible folks staying indoors.

Take this photo of Scotland's Forth Rail Bridge, for instance. It's located in the small town of Queensferry, just a few minutes drive outside of Edinburgh. I'd earmarked a visit for the morning following a photo walk weekender, just before flying back home. I was hoping for a colorful sunrise, but the forecast recommended I stayed in bed. It doesn't take much persuading to keep me under the covers, but I decided to drive along later in the morning for a peek regardless.

As I wandered between views under steady drizzle, it's fair to say my expectations were low. I snapped a couple of shots with my phone, but initially kept my camera firmly in my backpack. Later, the rain slowly began to ease up and it occurred to me that in the absence of much wind, it was mostly falling straight down. I thought I could successfully shield my camera from the rain, so decided to set it up.

I shot this with my Fujifilm X-T1 fitted with the XF 10–24mm zoom at 24mm for a 36mm equivalent field of view. It's a three-minute exposure at *f*/10 and ISO 200, made possible by the combination of my Lee Big Stopper and an additional three-stop ND, for a total of 13 stops. So what started as an unfiltered exposure of about 1/50 ended up at 180 seconds, timed by Triggertrap. I had initially been tempted by a graduated filter to darken the sky, but there was little to no detail on that mass of gray and no clouds to blur, so I opted for an overblown effect. Meanwhile, I balanced the padded filter case between the top of the X-T1 and the filter mount to shield both from the relentless drizzle. In the end, I managed to grab a few nice, long exposures that day during the rain.

TIP I shoot most of my long exposures with my Fujifilm X-T1, as I simply love the images straight out of the camera with their Film Simulations. I used Velvia here to boost what little color was present. The X-T1 also delivers nice, clean images without the need for long-exposure noise reduction—an important consideration if you've just shot a three-minute exposure, as I did here, and don't fancy waiting around for another three minutes just to record a "dark frame." Fujifilm deploys the same sensors and image processors in many of its cameras, so if you like the X-T1, you'll also get the same output from the X-T10, X-E2S, and even the X-70 compact.

The rock

EXIF Data

📷 Olympus OM-D EM-1

🎞 M.Zuiko 7–14mm *f*/2.8

◁ 12mm (24mm equivalent)

◎ *f*/8

● 25 seconds

☒ 0 EV

ISO ISO 100

◉ Vivid

Say hello to Dinant, a small town in the heart of Belgium that punches above its weight for attractions and claims to fame. I was drawn in by the lovely reflections of its 14th-century church and the rock formations in the River Meuse, captured here with my Olympus OM-D EM-1 and M.Zuiko 7–14mm *f*/2.8 zoom, but I subsequently found much more besides.

For starters, the rocky backdrop concludes at one end of town with the Bayard Rock, a spectacular spiked pinnacle. Meanwhile, atop the rock back in the center of town, behind the church, and visible in my photo is a citadel. Dinant was also home to Adolphe Sax, inventor of the saxophone, and is still home to Maison Leffe, the headquarters of the famous Belgian beer. Phew!

I'm always on the lookout for nice reflections when visiting towns with rivers passing through them. While attractive during daylight hours, the views often spring to life as the sun sets, the sky darkens, and the city lights are switched on. For me, it all comes together just after sunset when there's still some blue left in the sky, a period known as the "Blue Hour."

I particularly liked the bonus addition of the large rock in the background, which when reflected in the river, was turned into a large oval, framing the buildings and adding geometric interest. I'd have liked it even more if the church had been illuminated as brightly, particularly the spire, and if the white containers at the front of the building were off the frame to one side. Even so, all were part and parcel of the scene when I was there, and I prefer a faithful recording.

I used my Olympus OM-D EM-1 fitted with the M.Zuiko Digital 7–14mm *f*/2.8 lens, set to 12mm for a 24mm equivalent field of view. I was shooting from a tripod, so to smooth the water, I chose an aperture and sensitivity to result in a long exposure: *f*/8 at ISO 100, which the camera metered at 25 seconds. I don't think anything longer with an ND filter would have made much difference here and there were few lights bright enough to aim for any diffraction starbursts with a smaller aperture.

TIP Shooting urban scenes during the "Blue Hour" is all about timing. Shoot too early and you'll miss the city lights. Shoot too late and the sky will become at best a boring black, or at worst, tainted with orange from street-lamp pollution. Get the timing right though, and you'll enjoy a deep blue sky as a backdrop for your reflected city view. Here it's already a bit too dark, but I grabbed the shot just before the color was lost to the night.

The rock formation

EXIF Data

📷 Sony α7R Mark II

🎞 Sony FE 28mm *f*/2

◁ 28mm

✺ *f*/16

● 2.5 seconds

☑ −1 EV

ISO ISO 200

◉ Monochrome

No tripod, no problem! I found a handy log nearby to use as a support and placed my sunhat underneath the camera to fine tune the position.

I love photographing abstract shapes, especially those with a high contrast between light and shadow, and there were certainly plenty of opportunities around the national parks on the borders of Poland and the Czech Republic. I took this in Poland's Bledne Skaly park, where the path wound around a series of narrow slots between canyon walls. There were photo opportunities around every corner.

In these environments, I like to shoot wide and try to include some kind of line crossing the image. In this instance, the dark wall on the left cut into the illuminated surface on the right to leave a narrow crack of light roughly dividing the image in half. I deliberately left a huge chunk of blackness to one side as negative space to give an imposing feel to the composition.

The left wall was already dark, but to ensure it was completely black, I dialed in −1 EV of exposure compensation to deliberately underexpose that area of the scene. The moss-coated walls looked quite nice in color, but I wanted a moodier appearance so I set the camera to its black-and-white mode, slightly increasing the contrast again to darken the shadows and boost the rock details.

You can, of course, turn any image into black and white after the fact on your computer, tablet, or phone, but most cameras now offer very respectable monochrome options with a variety of digital filters to further increase the contrast if desired. If your subject includes a lot of green or blue, consider applying a red filter to darken them. If your camera offers RAW processing in playback, you can also shoot in this format and experiment with different filters and effects after shooting, but again without having to rely on an external device.

I took this with the Sony Alpha α7R Mark II and FE 28mm *f*/2 lens; with a full-frame body, the coverage of the lens wasn't reduced. I set the sensitivity to ISO 200 and the aperture to *f*/16 to ensure rock details near and far would be sharp; the camera metered an exposure of 2.5 seconds. This was too long to safely handhold, so I employed a nearby tree trunk as a stand.

TIP If an exposure is too long to handhold, you'll need to find somewhere steady to rest or mount your camera. A tripod is ideal, but you may not always have one on hand. Elsewhere in this park, I exploited natural ledges nearby, but for the composition I wanted here, I needed the camera to be positioned at chest height in a clearing. I look around and noticed a log that had been cut down. The flat cuts allowed me to stand the log on its end and, to the amusement of passersby, use it as a handy stand. In the absence of any support, you'll just need to increase the sensitivity until the shutter speed is one you can comfortably handhold.

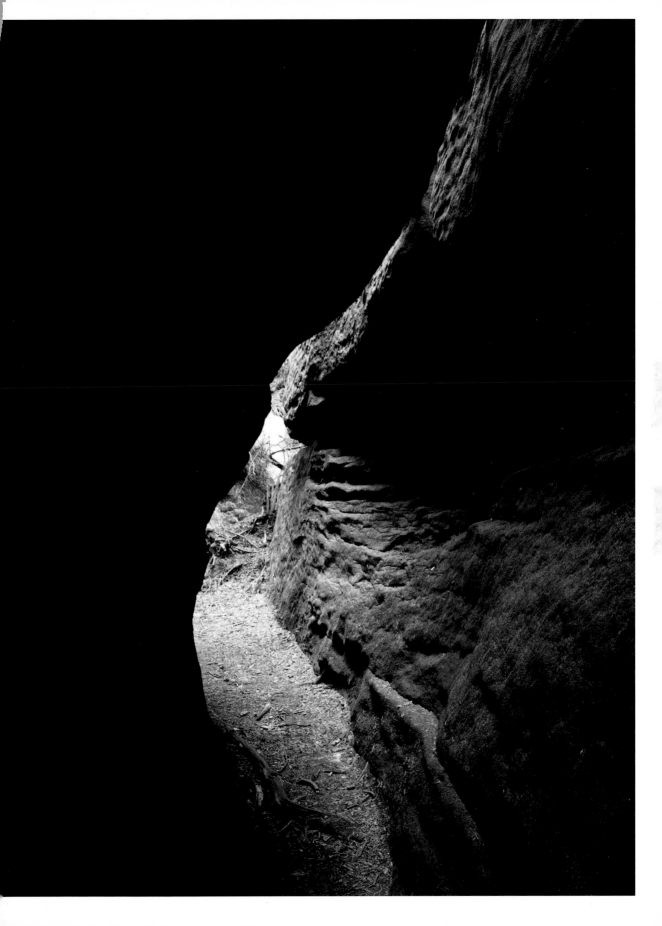

The sand dune

EXIF Data

📷 Panasonic Lumix GX1

▤ Panasonic/Leica 45mm
f/2.8

◁ 45mm (90mm equivalent)

⚙ f/16

⬤ 1/100 second

▥ -0.33 EV

ISO 160

◉ Standard

I've always been drawn to abstract natural landscape images where the absence of a horizon really allows focus on the shapes, contrasts, and colors rather than the scale or context. As such, it's no surprise I love photos of sand dunes taken just after sunrise or just before sunset when the light is golden and the shadows provide stark contrasts between the edges of a ridge.

I had this as my goal on the morning after an overnight camel trek into the Sahara desert in Morocco. I was staying with Auberge du Sud, which had a private camp with about 25 guests when we visited and only half of them made it up for sunrise, and all but four quickly sliding down the dunes as soon as the solar disc popped up over the horizon. The remaining four of us spread out over the dunes to find some private space and views as the sun crept upward.

Annoyingly, I just couldn't find the clean composition I was after and the golden light was quickly disappearing after only a few minutes. I switched from a wide to a tighter view with a short telephoto 90mm equivalent lens and tried a few new angles on a nearby ridge. I snapped off a few shots before the contrast between light and dark dissipated with the steadily rising sun.

I trudged down the dune to breakfast feeling a little disappointed, but felt confident I'd get the shots I really wanted at sunset that evening back near the Auberge, or perhaps the following morning. As it transpired, those times would be marred by less-than-virgin dunes (see The desert ripple on page 188), but as luck would have it, I actually managed to achieve pretty much the result I was after that first morning. Upon reviewing my shots, I found this one, which may not have been exactly the shape I wanted, but still has a pleasing abstract quality.

I shot this with a Panasonic GX1 and Lumix/Leica 45mm f/2.8 lens, delivering a 90mm equivalent field of view. The longer focal length and fairly close proximity to the subject meant I had to be careful about depth of field. To ensure everything would be in focus, I closed the aperture down to f/16. Normally, I'd avoid such a small aperture with a Micro Four-Thirds camera, as it typically results in diffraction and softening of the image, but it doesn't have a negative impact on this type of subject.

TIP It's easy to become blinded by the type of lens you think you need for a particular subject. I assumed I'd be shooting expansive dunes with a wide angle, but couldn't find a stretch that was sufficiently untouched by visitors. So instead, I went for a short telephoto here to crop into a virgin area of sand. The abstract nature of the subject means it's hard to tell the size and distance, but it actually only represents a few meters of sand shot from fairly close range.

The shock and awe

EXIF Data

📷 Panasonic Lumix GX1

🎞 Lumix G 7–14mm *f*/4

◁ 10mm (20mm equivalent)

⚙ *f*/14

● 6 seconds

⚡ 0 EV

ISO 160

◑ Standard

This was the view when the clock struck twelve on New Year's Eve in Reykjavik, Iceland: Fireworks were going off in literally every direction all around the church, even bouncing off it. Some were undoubtedly launched professionally, but most were fired off by locals with seemingly minimal regard for safety but maximum regard for fun!

Iceland is famous for its New Year celebrations. All the locals I spoke with assured me the place to be was outside the modern Hallgrímskirkja church, a famous icon of the city. Having scoped out the area earlier, I knew I'd be quite close to the church, so I opted for a wide-angle lens, the Lumix 7–14mm on my Panasonic GX1, which delivers an equivalent field of view of 14–28mm. This gave me the flexibility of adjusting the coverage depending on the height of the fireworks explosions.

For the photos, I employed my tried-and-trusted fireworks technique. First, I composed the shot with some foreground interest — in this case, the church and the statue of explorer Leif Eriksson. Second, I manually focused on the church using magnified Live View assistance, as it's almost impossible for autofocus to work under low-light conditions. Third, I set the exposure mode to Manual, choosing the lowest ISO sensitivity, a relatively small aperture of *f*/11, and a shutter speed of four seconds.

These settings were a starting point that I expected to adjust as the display progressed. They may sound at odds with other types of night photography, but fireworks are a special exception. They're a lot brighter than they look, so to record any color, you'll need to close the aperture to typically between *f*/8 and *f*/16 with a nice low ISO. The shutter speed has little or no impact on the brightness of the fireworks, only on how long the trails are and how many of them you capture in a single frame. I find *f*/11, four seconds, and ISO 100 to be a great starting point, after which you can make adjustments for trail length (shutter speed) and trail brightness (*f*/number and ISO).

I was lucky enough to grab a few winners from the show simply because there were so many explosions across the sky. I liked this one best as it illustrates the sheer chaos of the display.

TIP When shooting fireworks, you may prefer to switch off long-exposure noise reduction, as this will otherwise take a duplicate exposure after the main one. This second "dark frame" is used to subtract noise from the image, but effectively ties up your camera for the same exposure time. For exposures of more than ten seconds, this can get annoying and could result in missed moments. Turning it off may result in more visible noise depending on your camera, but at least it keeps you operational.

EXIF Data

📷 Fujifilm X-T1

🎞 Fujinon XF 10–24mm

🔊 13mm (20mm equivalent)

⚙ f/8

⬤ 90 seconds

🖻 0 EV

ISO 200

⊙ Velvia

The unassuming pier

Sometimes the most unassuming subject can deliver your favorite photo of a trip. During a photo weekend, I had minimal expectations for the final stop of the day at Portencross Pier in West Kilbride, Scotland, a small concrete and wooden structure dipping into the Firth of Clyde. We'd arrived in time for sunset, but steady drizzle had consumed any potential color from the sky, further cementing my belief it'd be a washout.

However, three guys fishing at the end of the pier caught my eye: one on the left, one on the right, and one in the middle. It was pleasant symmetry, so I walked along a little to grab a shot with my phone. As I adjusted my position, I noticed what at first had looked like a broken surface, but turned out to be a large gaping hole with the water visible below. I quickly put my phone away and extended the legs of my tripod to prepare for a long exposure.

I shot this with my Fujifilm X-T1 and XF 10–24mm, set to 13mm to avoid vignetting with my compact ND filter system. With my Lee Big Stopper fitted, I first tried a "quick" exposure of 30 seconds at f/8 and ISO 200. Like most cameras, the X-T1 allows you to dial in a 30-second exposure without the need for Bulb mode or any timers, so it meant I could get away as quickly as possible. The result ended up being too dark, but the image was tantalizingly promising. I couldn't bring myself to walk away with this result, but I knew I only really had one more chance before annoying my friends behind me waiting for their turn.

I connected a Triggertrap cable to my phone, set it to 90 seconds, and kept my fingers crossed. As soon as the exposure ended, I quickly retreated, apologizing for getting in the way for so long. I had a quick glance at the shot and it looked promising, but with rapidly deteriorating conditions, I dispensed with the chimping and got on with some additional compositions.

Later, I was delighted to discover the image contained a sufficient tonal range to be used without further adjustment. So here it is, straight out of the camera using the Velvia film simulation. Two out of the three fishermen that had initially caught my eye may be blurred, but it's become my favorite shot of the trip.

TIP Normally, this kind of composition would cry out for a portrait aspect ratio to me, but I stuck with landscape for two reasons: First, I wanted it to work in the square format for Instagram, and in order to protect the top and bottom from cropping, it's easiest to frame in the landscape orientation. Second, I was conscious that the rest of the group was behind me and I wanted to get in and out as quickly as possible to get out of their compositions.

EXIF Data

📷 Sony α6300

🎞 Sony E 16–70mm $f/4$

🔊 16mm (24mm equivalent)

⚙ $f/4$

⬤ 1/60 second

▣ –0.67 EV

ISO 6400

◉ Standard

The cocktail mixer

Some shots need to be sought out; others come to you. After a long day of shooting that started at sunrise, I took a break at a restaurant and the fatigue suddenly hit me. So there I was, literally propped up by the bar, waiting for a table to be prepared.

As I sat there, I was hypnotized by the cocktail mixer behind the bar, studiously measuring, shaking, and pouring drinks for a large group. She was working quickly but precisely, concentrating on nothing else but the job at hand. I then noticed the line of glasses placed right in front of me, being filled from one side to the other, before being taken away and immediately replaced by more. I'm no professional street photographer, but even in my exhausted state this was too good an opportunity to miss.

I wanted a wide-angle composition where the glasses and cocktail shaker dominated the frame, so I shot at close range with a 24mm equivalent focal length using a Sony α6300 and 16–70mm at 16mm. To further separate the glasses from the background using a shallow depth of field, I shot in Aperture-Priority mode at the maximum value of $f/4$ for this lens; you're never going to get much background blurring with a wide lens, but you'll maximize your chances when focusing close.

In order to be discreet, I set up the camera on the bar top. I really liked how the low angle looked, so I kept it low and tilted the screen up for easier framing. I also shot square onto the glasses in front of me so that one wasn't bigger than another.

I then moved the single-AF area over the glasses to focus on them rather than the background and waited for the perfect moment when the mixer entered the frame. Shots like this work best when you can see both eyes of the subject; I love how she's concentrating on nothing other than pouring the drinks. It ended up being one of my favorite shots that day and it didn't even involve moving from my seat!

TIP I'm a big fan of face detection on modern cameras as they do such a good job of identifying and focusing on human subjects anywhere on the frame. But here I wanted the glasses to be the focused subject, so disabled face detection and manually repositioned a single AF area over them instead.

The snowy park

EXIF Data

📷 Fujifilm X-T1

🎞 Fujinon XF 10–24mm *f*/4

◁ 12mm (18mm equivalent)

⬡ *f*/8

● 1/120 second

⊞ +0.67 EV

ISO ISO 800

◉ Monochrome

During a recent trip to New York, I was treated to four seasons in one day, waking to a blizzard and fresh snow. I've always wanted to capture some snowy New York scenes, but with only an hour spare before a flight, my range was limited. Fortunately, the nearby Chelsea neighborhood provided lots of opportunities (you can see one of my other shots in The Chelsea chill on page 58).

While wandering around, I was surprised to find most of the parks temporarily closed, presumably due to the risk of slipping, but it did mean that what little snow had fallen lay undisturbed and without a bunch of footprints spoiling the scene. The only issue at that point was to figure out how to shoot the inside of a park when you can't actually get inside!

Easy: You shoot through the railings. I particularly liked the look of Clement Clarke Moore Park on 10th Avenue, between 21st and 22nd Streets, and walked alongside the railings to find a good angle. I then simply poked my camera through to frame and take the shot. The beauty of shooting in Live View (or with a mirrorless camera) is you can frame the shot using the screen with the camera held away from you. If it's articulated, it's easy to shoot at high or low angles, too. I find myself doing this all the time, and would now avoid a camera with a fixed screen.

The problem with shooting through railings though is you may not be able to get close enough to anything in the foreground for some nearby interest in a wide shot. Here, I adjusted my position and angle to exploit a tree on the left side as a frame and for negative space. Without it, the shot felt a bit empty. If I had access to the interior, I could have gone for any number of compositions; through the railings, my options were limited. Considering I was behind bars here, I'm happy with the result. Oh, and I'd recommend using a lens hood to protect the lens as you slide it through the railings.

TIP Like my other snowy shot in New York, I shot this in the camera's Monochrome mode, choosing the high-contrast option to ensure deep blacks and bright whites. You can turn any image into black and white on your computer or device, but I've grown fond of the simulations in modern cameras, which do a great job. If you're not sure, try shooting in RAW, as many cameras now let you create new JPEGs in camera from a RAW file using different effects. It's a fun way to explore different treatments risk free and all in camera.

The tea clipper

EXIF Data

📷 Olympus OM-D EM-5

▦ Lumix G 7–14mm *f*/4

◁ 7mm (14mm equivalent)

◈ *f*/4

⬤ 0.3 seconds

⊡ 0 EV

ɪꜱᴏ ISO 400

◉ Natural

This is the underside of the Cutty Sark in Greenwich, London. It's a handheld shot taken with the Olympus OM-D EM-5 fitted with the Lumix 7–14mm lens, set to 7mm for a 14mm equivalent field of view. The Cutty Sark was a tea clipper, a sailing boat designed to transport tea between China and Great Britain as quickly as possible. Built in 1869, she was one of the last clippers, as wind power was replaced by steam, but this also made her one of the most technologically advanced and fastest sailing boats around.

During the 1900s, the ship traded hands and went through various restoration processes before settling in dry dock in Greenwich as a museum piece in 1954. Unfortunately, during further renovation in May 2007, a fire broke out. Luckily, about half the materials of the ship were already dismantled and safely offsite. In April 2012, the Cutty Sark was reopened to visitors.

One of the most dramatic aspects of the most recent restoration was to raise the ship by several meters from the ground and suspend it from the sides, allowing visitors to walk underneath it. Meanwhile, the underground gallery would be sealed from the elements with a steel and glass skirt connecting about half way up the hull, leaving the upper half of the ship open to the elements. While considered a controversial design by many at the time, I think it's really successful.

I visited the Cutty Sark prior to the fire and after the reopening and the new experience is much better in my view. It's still great to explore the upper deck in the open air, peek into the various cabins, and check out the surprisingly large storage capacity below. Now, being able to actually get underneath the boat definitely adds an extra dimension. It also presents a really nice photo opportunity, particularly if you have an ultra-wide lens. Standing underneath the hull at one end, you can capture the entire length of the ship and the glass roof around it, holding it in place. The crisscross pattern of the steel and glass is reminiscent of The British Museum.

TIP For this kind of shot, symmetry and square geometry is critical, which means positioning yourself exactly underneath the center of the boat and using viewfinder or screen gridlines to carefully line up the shot. The fine tuning necessary is best done with a tripod, but I didn't have mine with me at the time (and I'm not even sure they're allowed down there), so I just kept an eye on all sides of the frame and tried to ensure everything was square. Luckily, the built-in stabilization of the OM-D let me handhold at a slow shutter speed allowing a nice, low ISO for good quality. If you are allowed to use a tripod, consider closing the aperture to, say, *f*/11 to turn bright lights into spiked starbursts.

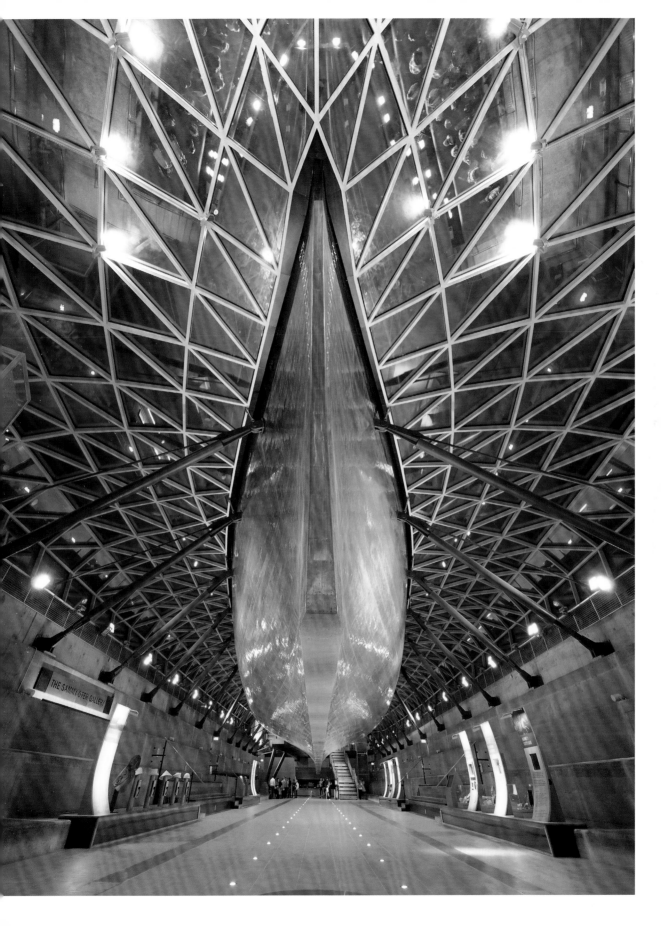

The tidal monastery

EXIF Data

📷 Fujifilm X-T1

🎞 Fujinon XF 18-55mm
 f/2.8–4

◁ 40mm (60mm equivalent)

⚙ f/11

● 25 seconds

🔲 0 EV

ISO ISO 100

◉ Daylight white balance

Here's Mont Saint Michel in northwest France, taken with the Fujifilm X-T1 and 18-55mm kit zoom. It's a 25-second exposure on a very dull, overcast day using a pair of neutral density filters. I've long been fascinated by St Michael's Mount in Cornwall in southwest England and its twin, Mont Saint Michel in Normandy, France. Both are tidal islands topped by medieval buildings, connected to the mainland when the sea retreats, but cut off every time it returns. I love that connect and disconnect, the way you can so easily get to somewhere before finding yourself potentially stranded, temporary helplessness through nature.

The biggest problem on my visit to Mont Saint Michel in February was the weather, a solid gray overcast sky that threatened (and indeed delivered) rain throughout the day. The timing of my visit around lunchtime also ruled out any sunrise or sunset action, not that they'd have delivered anything more attractive on that day. So, faced with flat midday lighting and an uninspiring gray sky, there's only one approach I could take: moody.

While visiting Le Mont, I'd spotted a modern footbridge by the barrier in the near distance, which looked like a good vantage point. Upon returning, I was pleased to find some watery channels winding their way to Le Mont, providing foreground interest and the chance for some blurring during a long exposure. I was equally happy to find the footbridge was equipped with a nice, wide, flat handrail upon which I could easily place my camera.

I zoomed to 40mm for a 60mm equivalent field of view, closed the aperture to f/11, and reduced the sensitivity to ISO 100, at which point the camera was metering an exposure of around 1/30. I then fitted my Lee Big Stopper ND filter, which soaked up enough light to require an exposure closer to 15 seconds. The upper sky was already dark and foreboding, but I also slid a hard graduated filter in front of the Big Stopper and adjusted its position to accentuate the upper section of the image. I liked the preview in the viewfinder, so I fired off a few shots, which at this point were 25 seconds long. This is the result, with no correction for the colorcast of the filters.

TIP Neutral Density filters, by definition, should absorb all light evenly, forcing a longer exposure with no impact on color. A truly neutral filter with a high density is, however, hard to manufacture, and earlier samples of the Lee Big Stopper suffered from a blue colorcast. It was easily corrected with a white-balance adjustment or ignored by shooting in black and white. I tried both approaches here, but ended up preferring the unmodified version with the blue cast, so that's what you see here.

The yellow jersey

EXIF Data

📷 Sony α6000

🎞 Sony FE 70–200mm *f*/4G OSS

◁ 70mm (105mm equivalent)

⬡ *f*/4

⬤ 1/2500 second

▦ 0 EV

ISO 1000

◉ Standard

The yellow jersey is worn by the leader of the Tour de France — the rider with the quickest overall time to date. If you're the rider wearing it on the last day in Paris, you've won the event. Here's Chris Froome, hurtling up the Col de la Croix de Fer on Stage 19 of the 2015 Tour (which he won a few days later), closely followed by Nairo Quintana, Alberto Contador, and the other main contenders. I took this not with a high-end DSLR, but with an affordable, consumer-grade mirrorless camera, the Sony α6000. I chose the α6000 because it has a killer combination for sports photography: effective continuous autofocusing and fast burst shooting. Its successor, the α6300, is even better in this regard.

The Tour de France is easy to access as it's totally open and un-ticketed. You can literally stand a couple of feet away from the world's greatest cyclists with nothing between you and them, completely free of charge. On the other hand, it can be logistically complex to view thanks to remote regions and road closures. The trick is to study the route on the official letour.com website, then choose a rough viewing location based on the profile or surroundings. I like the steep hairpins on the mountain stages, as they're the only time the riders slow down.

Get as close as you can with your car on the day of the shoot then park and walk to the desired bit of roadside. Or, you can arrive the night before when the road is still open, sleep in your vehicle, and later watch the race go right past. I've gone into much more detail in several Tour de France articles at cameralabs.com if you'd like more information.

Here, I deliberately chose a viewpoint that would include some mountains in the background, giving the location some context. I had the camera set to its continuous AF mode with Zone AF concentrating the AF points in a central area. The exposure was set to Manual with a sufficiently quick shutter speed to freeze the action and the largest aperture selected in an attempt to blur the background, leaving the camera to take care of differences in brightness with Auto ISO. When the riders approach, simply fire off bursts and keep your fingers crossed!

TIP If your camera's continuous autofocus isn't good enough to track fast action, simply choose manual focus instead and pre-focus on a spot where the action will pass through. In this case, this spot was the middle of the road in front of me. As the subject approaches the preset distance, start shooting and you will end up with at least one perfectly focused image. Of course it may not be at a decisive moment; the athlete could be blinking, looking away, or even obscured in some way, but as with all sports photography, just shoot as many frames as possible and the odds of capturing a winner will increase.

Index

Acknowledgments

Thank you Nicki — you find the best locations, seek out the tastiest food, and provide the greatest company. Thanks for encouraging me to do what I love and joining me on the journey.